BOTANICAL
ILLUSTRATION

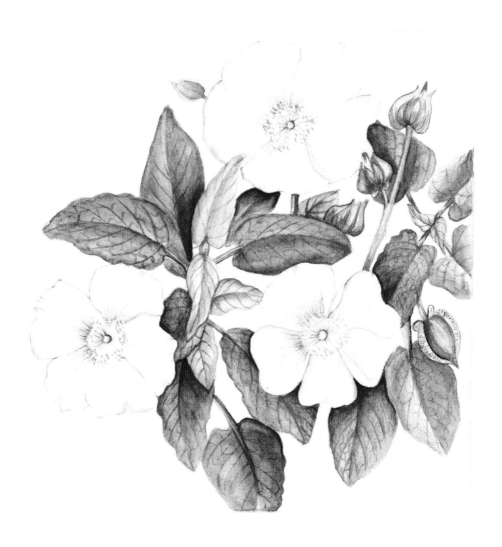

A study of the white flowered
Cistus x hybridus. The flowers open in the
morning and the petals start to fall late
afternoon, so time to paint the plant's
portrait is limited. (Valerie Oxley)

BOTANICAL ILLUSTRATION

VALERIE OXLEY

THE CROWOOD PRESS

First published in 2008 by
The Crowood Press Ltd
Ramsbury, Marlborough
Wiltshire SN8 2HR

www.crowood.com

This impression 2009

DEDICATION
This book is dedicated to my grandchildren, Thomas and Benedict

Line drawings on pages 37–41 and 66–70 by Charlotte Kelly.

British Library Cataloguing-in-Publication Data
A catalogue record for this book is available from the British Library.

ISBN 978 1 84797 051 0

ACKNOWLEDGEMENTS
Thank you to all the artists, friends and colleagues around the world who have generously allowed their drawings to be included in this book, whether they have been exhibited masterpieces or simply sketches:
to James J. White, Curator of Art and Principal Research Scholar, Hunt Institute for Botanical Documentation, Pittsburgh and Malcolm Beasley, Botany Library Collection Development Manager, Natural History Museum, London, for their continued support in all things botanical; H. Walter Lack, Director of the Botanic Garden and Botanical Museum Berlin-Dahlem, for assisting in the quest for an image of Linnaeus' floral clock; Alison M. Paul, Curator of Pteridophytes, Department of Botany, the Natural History Museum, London for the naming of *Dryopteris x uliginosa*; Emma Pearce, formerly of Winsor and Newton, for technical advice on watercolours, and Donna Richards and colleagues at Daler Rowney; Lee Callaghan at Peak Imaging for his calm professionalism; Wendy Harvey, Cyril and June Stocks, Peter Mitchell and Peter Gravett for checking that I was on the right track and with particular thanks to Jill Holcombe for her attention to detail, sensible advice and friendship; my husband Michael and all my family, for their unstinting support, love and encouragement; and not forgetting Jane Coper, the delightful lady who said 'yes'.

Typeset by Simon Loxley

Printed and bound in Malaysia by Times Offset (M) Sdn Bhd.

CONTENTS

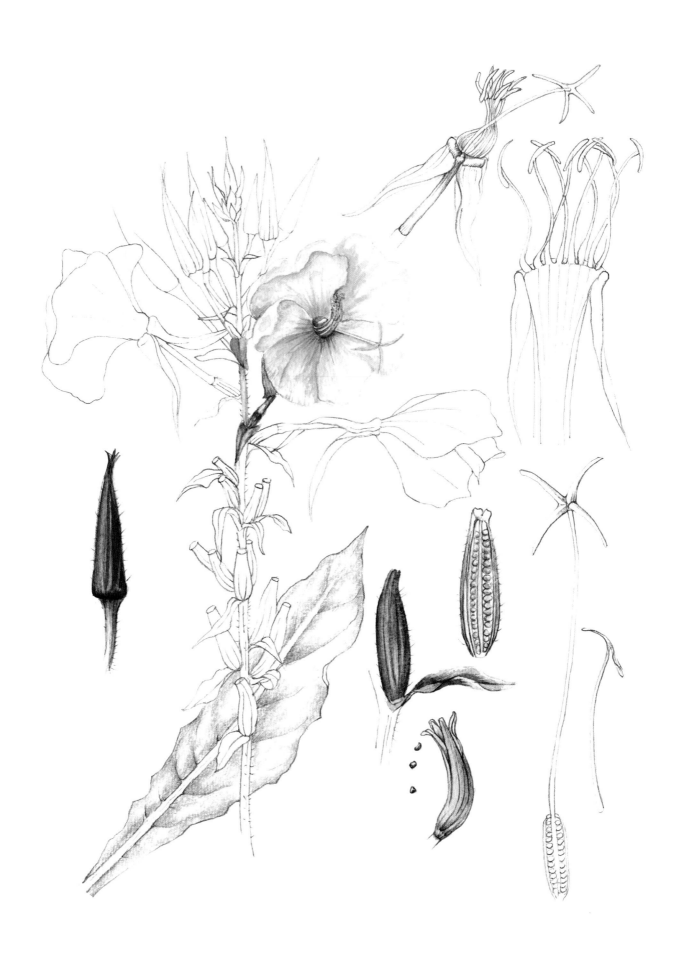

INTRODUCTION

Brought up on the edge of Northampton, I have always been passionate about the countryside. From an early age I collected and pressed wild flowers, identifying them with the help of the *Wild Flower Guide* by R.S.R. Fitter and the *Observer's Book of Wild Flowers* by W.J. Stokoe. I organized a nature club for my junior school friends and turned the redundant coalhouse in our back garden into a nature museum. A child's life in the 1950s was something of an adventure. There was so much to discover in the natural world, so much to find, to collect and to treasure. We could roam more freely than children do now. I knew where all the birds nested in the hedgerow and when the first wild flowers were likely to appear. I was frequently admonished for arriving home late from an expedition, often with wet feet, the water having flooded over the tops of my wellingtons when trying to gather marsh marigolds or lady's smock from the water meadows by the tranquil River Nene. When not collecting wild flowers, I would be hurrying home with a jam jar of frogspawn, eager to watch the eggs develop into tadpoles and small frogs in an old tin bath in the garden. Getting into trouble, nettled, scratched and wet seemed to be a necessary part of my whole experience of growing up.

There was never a time during my childhood when my sisters and I did not draw. This pleasurable activity was encouraged by both our parents. The natural world was close at hand, and studies of wild flowers always followed excursions into the countryside. I could smell the violets under the hedges on country walks. I was glued to the window of the car when we travelled, and my father always answered my calls to stop by pulling onto the grass verge (the roads were quieter then). An old book was carried for immediate flower pressings; otherwise they were placed between newspapers and put under the carpet when we returned home.

A sketchbook study of *Oenothera glazioviana* which was found growing wild near the sea in Dorset. Sketchbook studies provide useful information for identification, and for the understanding of plant growth and form. (Valerie Oxley)

Later, much of my spare time was spent exploring the inland waterways. On journeys through the canals and rivers of England and Wales, I always marvelled at how plants could be seen growing in the most inhospitable surroundings, particularly in the middle of large cities. Plants could be seen tenaciously clinging to a lock gate or growing from a crack in the wall of a derelict factory by the water's edge. I remember seeing a swathe of rosebay willow herb on a bank in the middle of Birmingham at dusk and thought how suited it was to its folk name of fireweed, as it glowed in the dwindling light of the setting sun.

I began to share my interest with others. One thing led to another, and before long I found myself tutoring classes in botanical illustration at the University of Sheffield. The classes started in 1989 with weekly meetings for beginners. By 1997 they had developed into a Diploma in Botanical Illustration, level two of a university degree, comprising four years part-time study. The programme was unique in that botanical art was taught alongside botanical science. It was an exciting time, with botanists and artists teaching and learning together. The classes were always oversubscribed, and the dedication and enthusiasm of the students unequalled.

As students progressed through the classes and completed their studies it became clear that something was missing. A place was needed for people to meet and talk, somewhere for them to share a common interest with added opportunities to continue learning and to exhibit their botanical artwork. As a result, The Northern Society for Botanical Art was founded in Sheffield in 1993.

Another exciting venture was the formation in 2002 of The Florilegium Society at Sheffield Botanical Gardens. The society was established to create an historical archive of drawings of plants in the gardens, which will be a lasting gift to the people of Sheffield.

For me, a childhood interest has become a lifelong passion, and I feel fortunate that I have met so many wonderful people along the way and shared with them the joys and challenges of botanical illustration that I have experienced, where each leaf is a landscape and each tiny flower a voyage of discovery.

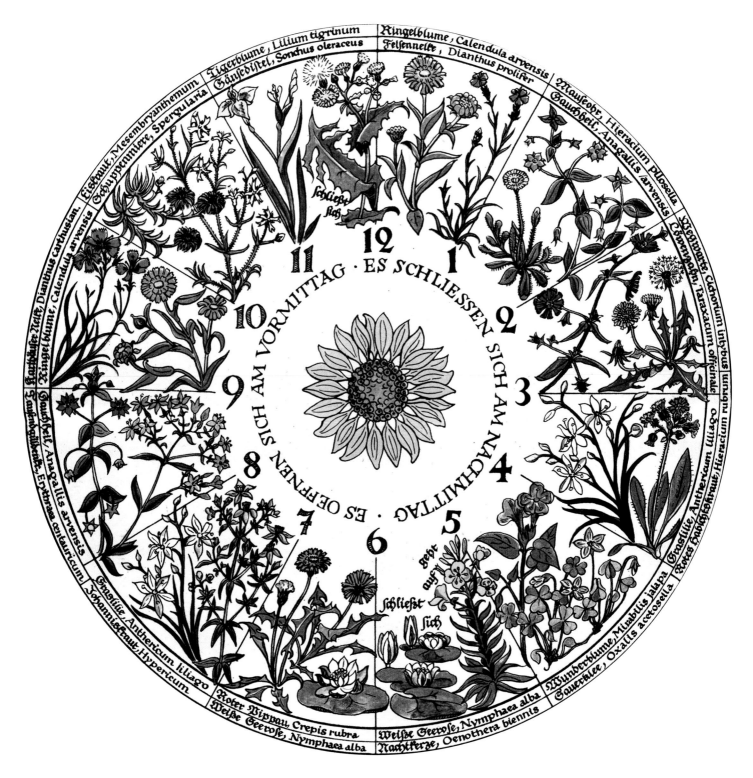

The Swedish botanist Linnaeus observed that flowers opened and closed at particular times of the day. He suggested these could be planted in the form of a clock that would complement the sun-dial and could be used on dull days. This dial was painted by Ursula Schleicher-Benz in 1948.

(Ursula Schlecher-Benz, Eine Blumen-Uhr aus: F. Boer (Hrsg.), Lindauer Bilderbogen, Lindau/Reutlingen. By kind permission of the Bayerische Staatsbibliothek, München and © Jan Thorbecke Verlag, D-Ostfildern)

THE HISTORY OF BOTANICAL ILLUSTRATION

Botanical illustration has a long and varied history. The excellent book, *The Art of Botanical Illustration* describes the history and art of botanical illustration as it developed through the ages. The original book was written by Wilfrid Blunt and William Stearn in 1950. It was revised by Stearn and republished in 1994 to include a new chapter about twentieth-century illustration. The book deals with the discovery of the earliest collection of plant drawings, or *florilegium* at the Great Temple of Tuthmosis III at Karnak about 1450BC. The story of botanical art continued to unfold until the revival of interest in flower portraiture in recent times. The book makes fascinating reading, and I thoroughly recommend searching it out.

In my own quest for knowledge about the early illustrators I have discovered a number of artists whose adventures have been inspiring. I would like to share some of these stories with you in this chapter, and I hope there will be something in the following lines that will capture your imagination and encourage you to set out on your own voyage of discovery, to learn more about the intriguing and talented artists and their associates in the history of botanical illustration.

An Early Herbal

Elizabeth Blackwell's *A Curious Herbal* was one of the first early botanical books I saw in its original binding – and a surprisingly large book it was. The pages brought to life the story of Elizabeth and her herbal, which I had first read about in the pages of *The Art of Botanical Illustration*. Elizabeth was born in 1700. In 1728 she secretly married a cousin, Alexander Blackwell, who worked as a medical practitioner in Aberdeen. All was well until a dispute arose about his medical credentials, and when an investigation was instigated the couple fled to London. Soon after their arrival in London, Alexander attempted to set himself up as a printer. Unfortunately, because he had neither been through a recognized apprenticeship nor belonged to a guild, other printers in London made it difficult for him to obtain work.

He soon fell into debt and was placed in a debtors' prison. It was left to Elizabeth to try and raise the money for his release.

Elizabeth, a dutiful but desperate wife, approached Sir Hans Sloane (1660–1753) an eminent physician and scientist, for advice. He told her that a new book on medicinal plants was required. Elizabeth, who had some early training in art, decided

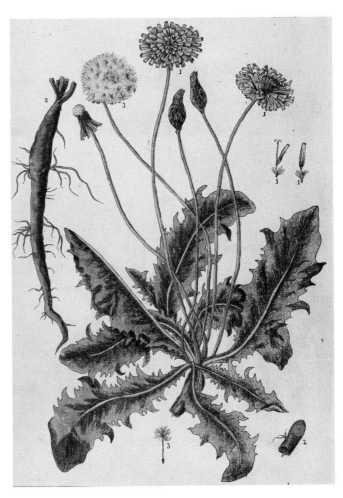

Hand coloured engraving of a dandelion by Elizabeth Blackwell from *A Curious Herbal* 1737–1739.

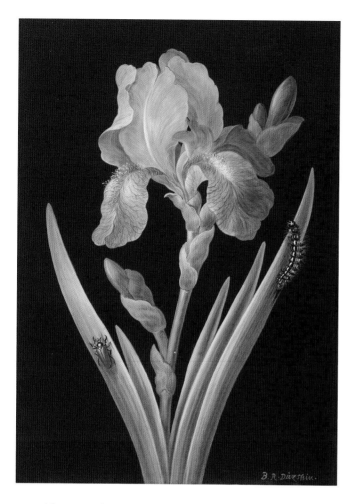

Iris germanica on a prepared dark brown background
on vellum painted by Barbara Regina Dietzsch 1706–1783.
(Fitzwilliam Museum, Cambridge)

Paper Mosaics

Another inspirational woman was Mary Delany who was also born in 1700. Mary created paper mosaics that are both intriguing and beautiful. At first glance they look like the work of the Dietzsch family of Nuremburg, who painted plant portraits in watercolour and bodycolour on prepared dark brown backgrounds. Closer inspection of Mary Delany's work reveals the true construction of her delightful pictures. The mosaics were designed from carefully cut pieces of coloured paper, many of which were obtained from sailors returning from China. Tiny pieces were attached to paper that was first washed with Indian ink. Small details such as the stamens and veins were sometimes added later in paint. I often wonder if Elizabeth Blackwell and Mary Delany ever met. They were of a similar age, but it is probable that for some of the time Mary was in Ireland whilst Elizabeth was in London.

Patron of Artists

Mary Delany became a frequent visitor to Bulstrode, in Buckinghamshire, the home of Margaret, Duchess of Portland. The two ladies shared a common interest in artistic and intellectual pursuits. When Mary's husband died her friendship with the Dowager Duchess blossomed, and she stayed at Bulstrode for six months each year for the next seventeen years. There were many visitors to Bulstrode, including Jean Jacques Rousseau the French Philosopher, Joseph Banks and his assistant Daniel Solander. The Duchess was highly respected for her intellect and knowledge of natural history. She invited many eminent men to Bulstrode and built up vast natural history collections, which she asked Daniel Solander to catalogue. Solander was a pupil of Linnaeus. Phillip Miller, the chief gardener at the Chelsea Physic Garden, was a frequent visitor to Bulstrode. It was probably through him that the Duchess met the botanical artist George Dionysius Ehret, whom she patronized and employed to instruct two of her daughters in the art of flower painting.

I have barely touched on this fascinating circle of people who met together at Bulstrode during the mid-eighteenth century. Close your eyes for a moment and imagine the conversations amongst such an erstwhile and passionate group of people caught up in the age of enlightenment, an era of discovery, new ideas and classifications of plants. It ended tragically however, for the Duchess's collections were sold soon after her death, a sale which took nearly forty days to complete. Had the collections remained intact they would have been one of the most important natural history collections of all time, rivalling those of Sir Hans Sloane, which formed the basis for the founding of the Natural History Museum.

she would undertake this monumental task. She took rooms near the Chelsea Physic Garden and with the support of Isaac Rand, the Director of the Garden, started preparing drawings and engravings. From his prison cell Alexander was able to offer help with the naming of the plants. The joint enterprise was successful, the herbal was released in weekly parts and the money was raised. Alexander was released from prison two years later. The herbal contains 500 engraved plates that Elizabeth hand-coloured for the first edition. Despite her heroic efforts, Alexander fell into further disrepute. He decided to build a new life in Sweden, but became embroiled in a conspiracy involving the succession to the Swedish throne. He was arrested and hanged for treason in 1748.

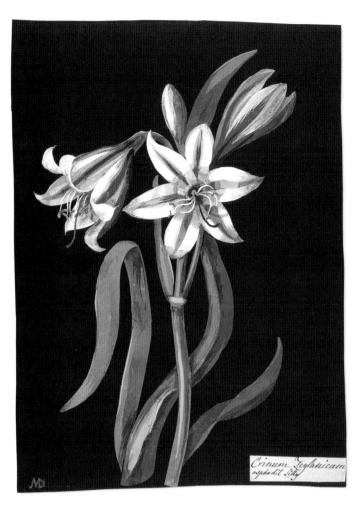

A paper collage of *Crinum zeylanicum* by Mary Delany.
(© The Trustees of the British Museum)

Mary Delany by John Opie.
(National Portrait Gallery, London)

Linnaeus's Illustrator

One cold and frosty morning I received an unexpected phone call from a gentleman who had links with Welbeck Abbey, the Nottinghamshire seat of the Dukes of Portland. I was invited to inspect a little bundle of papers packed in brown paper and tied with string. My fingers trembled as I opened the parcel. Revealed inside the package were a few sketches of flowers with a list of prices, merely shillings. It was another step back in time, back over the centuries, for within the brown paper package was original work of Georg Dionysius Ehret.

Ehret was born in Germany, the son of a gardener. He was taught to draw by his father, who died whilst Georg was still a young boy. He was taken out of school with his brother and the two boys were apprenticed as gardeners to an uncle. Georg continued to draw, encouraged by a cousin who supplied him with flowers as subjects. His efforts were recognized by a future employer, the Margrave Karl III Wilhelm of Baden-Durlach. In a curious turn of events, it was through the Margrave's interest in

the young man's drawings that Ehret left the Margrave's garden to seek work elsewhere. The reason for his departure was that the other gardeners employed by the Margrave were jealous. Arguments arose because they felt he had received preferential treatment, when he had only been employed as a journeyman gardener. This event was fortuitous, the start of a fruitful journey for Ehret, a journey which at some time may have brought him to Welbeck Abbey, with the depositing of a bundle of sketches that I was privileged to look at that frosty morning.

Ehret met the Swedish botanist Carl Linnaeus in Holland and collaborated with him by providing drawings to explain his new classification of plants. One day when I was listening to Radio 3, the presenter stated that the piece of music about to be played was based on Linnaeus's floral clock. The music, *L'Horloge de Flore*, composed by Jean Francaix, ended with a piece representing the night-flowering catchfly which blooms at nine o'clock. I had not heard of the floral clock or the music associated with it. On further investigation I discovered that in his *Philosophia Botanic*, Linnaeus noted that plants open and close for various reasons: they can be affected by the weather or the length of day. Furthermore, there are plants that open and close regularly despite the weather conditions or the day length. Linnaeus speculated that if certain aequinoctal plants, those which

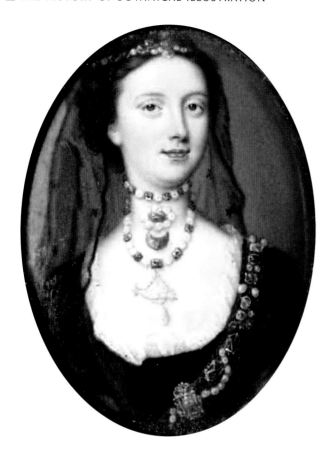

Lady Margaret Cavendish Holles Harley,
Duchess of Portland 1715–1785. A miniature portrait c.1750,
painted by Christian Frederick Zincke.
(Private collection)

work could be seen and enjoyed by a wider public, bringing him early recognition, fame and fortune. The fortune did not last long, and he was painting and teaching until the day he died. Redouté taught many of his female pupils by using a set of prepared lithographs. They coloured the plates to his instructions, including the order and use of particular colours. Many of these young ladies hoped to find work as colourists, so their work needed to be accurate. Redouté's early work shows a fine degree of scientific accuracy, composition and draughtsmanship. In later life demands for illustrations and increasing debts forced him to resort to a more flamboyant painting style.

Artistic Adventures

Ferdinand Bauer (1760–1826) was equally meticulous but not at all flamboyant in his interpretation of plants. I once saw a note from the botanist John Sibthorpe on one of Bauer's original drawings declaring 'Pray correct this gross blunder!' Such a violent response might be used to indicate a leaf which looks as if its midrib has been broken, or a contorted flower which does not fit onto a stem. In Bauer's case it was for the incorrect drawing of a fruit.

Ferdinand Bauer and his brother Franz (1758–1840) were born in Austria and came to England separately. Franz worked at Kew at the invitation of Sir Joseph Banks, who was looking for an artist to draw the many new plants that were arriving in England at that time. He was followed by Ferdinand, who went to Oxford, recommended by Nikolaus Joseph von Jacquin to the Sherardian Professor of Botany, Dr John Sibthorpe, as a suitable draughtsman to accompany him on an expedition to Greece. It appears that Sibthorpe treated Bauer as no more than a servant, which probably accounts for the sharp comment written on his work. When the *Flora Graeca* was eventually published it was the botanist who took the credit; the artist was hardly acknowledged.

Later, Sir Joseph Banks suggested Ferdinand as the draughtsman to accompany the botanist Robert Brown on a voyage to Australia. They were to sail in the *Investigator* under the command of Matthew Flinders, an epic voyage which took several years to complete. The ship was in a poor state for such a long journey, and shortly after arriving in Australia it was condemned. Flinders decided to return to England to obtain another ship in order to complete his survey of the north and west coast. The artist and botanist decided to remain in Australia to continue their work, but over a year later Flinders had not returned, and it is possible that neither Brown nor Bauer knew the reason for his long absence.

Flinders had been given command of another ship, the *Cumberland*, for the return journey to England. The conditions

followed their own rhythm to open despite the external conditions, were to be planted in the shape of a clock one could simply tell the time by looking out of the window.

Benefits of Printing Technology

Some years ago, on a further quest to discover more about Ehret, I visited Knowsley Hall, near Liverpool, which has been the home of the Earls of Derby since 1385. After viewing the work of Ehret I was privileged to see some original work of another of the great masters of botanical art, the Belgium-born Pierre-Joseph Redouté (1759–1840). Redouté followed Ehret in the golden age of botanical art. His work is more widely known because he benefited from advances in the techniques of printing at the time he was working. Stipple engraving had become highly developed on the continent and was used to reproduce subtle changes in tone to describe the shape and form of a plant. This more advanced process meant that copies of Redouté's

Portrait of Georg Dionysius Ehret 1708–1770
by George James in which Ehret is looking intently at
a sprig of *Cestrum diurnum*.
(By permission of the Linnean Society of London)

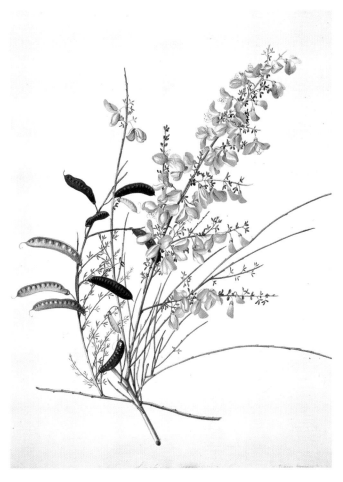

Cytsus scoparius painted by Georg Dionysius Ehret.
(© Natural History Museum, London)

on board were gradually worsening. The pumps had to work continually to remove water from the decks and in desperation Flinders put into an island occupied by the French (present-day Mauritius), thinking he would receive a safe passage home despite hostilities between the French and the English. Unfortunately the safe passage applied only to the *Investigator* and not to the *Cumberland* and consequently Flinders and his crew were interned. Flinders was not released until 1810, six years later.

Meanwhile Bauer and Brown returned to England in 1805, on the repaired *Investigator*, a journey that took five months. A large number of drawings were undertaken by Bauer during the expedition, but some were not completed until some two years after their return. In an astonishing feat, he was able to ensure the exact colouring of the plants by using a colour code that he had prepared earlier; his drawings were covered in numbers to enable him to match exactly minute areas with the shades of his painted code, an early form of painting by numbers.

Botanist's Assistant

My first encounter with an elephant-sized book was *Orchidaceae of Mexico and Guatemala*. Amongst the named illustrators were Mrs Augusta Withers and Miss Drake. More information is known about Augusta Withers, but even Wilfrid Blunt seems to have drawn a blank about Miss Drake, and she has remained a mystery for many years.

Sarah Anne Drake (1803–1857) was employed by Professor John Lindley to assist him with his illustration of plants. He probably gave her drawing instruction, and she was invited to live with the family at Acton Green. It is thought she may have taken on the role of governess to his three children. There is no evidence to suggest that the arrangement was not harmonious, and Sarah was affectionately known by the family as 'Ducky' Drake. Professor John Lindley was secretary to the Horticultural Society of London. He was a highly regarded botanist and was influential in recommending that the Royal Botanic Gardens,

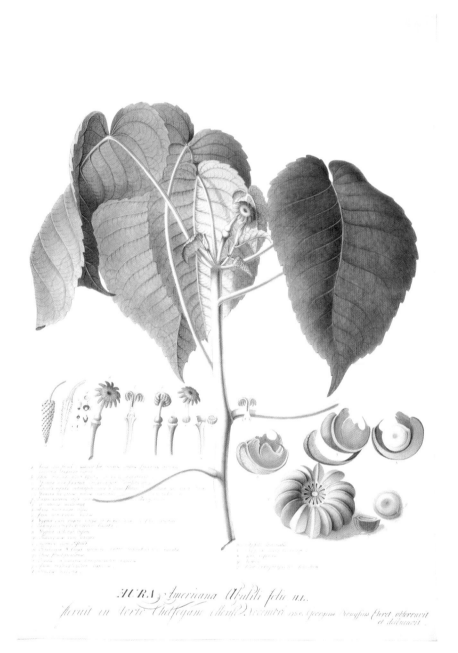

ABOVE: *Paeonia suffruticosa* in watercolour on prepared vellum painted by Pierre-Joseph Redouté in 1812.
(Fitzwilliam Museum, Cambridge)

LEFT: *Hura crepitans* by Georg Dionysius Ehret. This drawing shows the influence of the Swedish botanist Linnaeus and his sexual system of plant classification.
(Fitzwilliam Museum, Cambridge)

Kew be taken over by the Government as a centre for studying the economic plants of the Empire. Sarah prepared illustrations for him for about fifteen years and was the main artist of *Sertum Orchidaceum*. She also contributed half the illustrations for James Bateman's *Orchidaceae of Mexico and Guatemala*. John Lindley must have thought highly of her work because he named an Australian orchid 'Drakea' in her honour. Diabetes was stated as the reason for her early death aged fifty-four, but with the advance of medical knowledge it is now thought she may have died from poisoning following her years of intensive painting with toxic watercolours. It was a sad ending to such an industrious life, but at long last she has received the recognition she deserves and has come out of obscurity.

Nature-Printed Images

On a visit to Sheffield Central Lending Library some years ago I was shown a beautiful book called *The Nature-Printed British Seaweeds* published between 1859 and 1860 by Thomas Moore and John Lindley. The colours of the seaweeds were clear and bright. At first I thought they were pressed and stuck onto the page but on closer inspection I discovered the images were somehow raised from the paper. On another occasion, while in Oxford, I was shown *The Ferns of Great Britain and Ireland* (1855) by the same authors. Both books contained lifelike impressions of plants, three-dimensional nature printing, a process discovered in the fifteenth century and perfected in

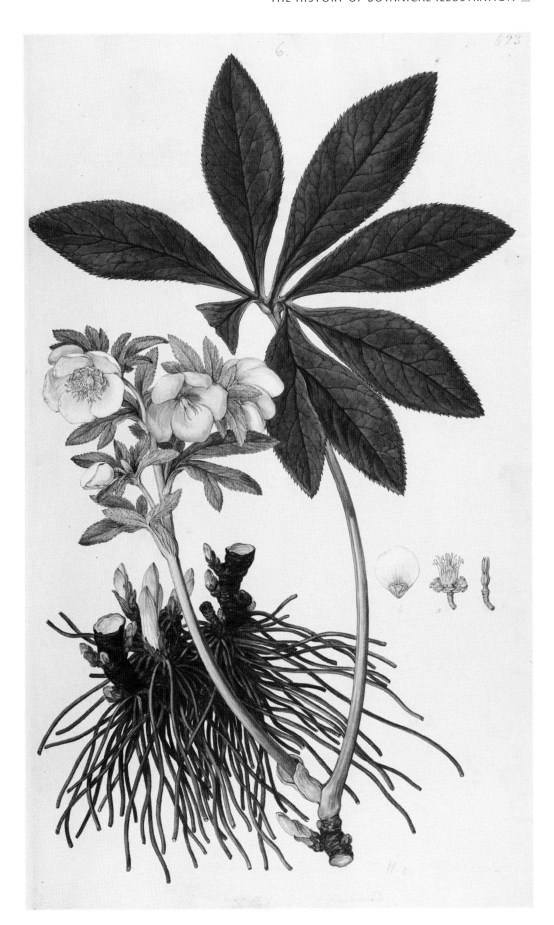

Helleborus officinalis by
Ferdinand Bauer.
(*Flora Graeca Drawings*.
Volume 1 Ms Sherard 241 f.6S.
Plant Sciences Library, Oxford
University Library Services)

Asphodelus ramosus by
Ferdinand Bauer.
(*Flora Graeca Drawings*.
Volume 5 Ms Sherard 245 f.99.
Plant Sciences Library, Oxford
University Library Services)

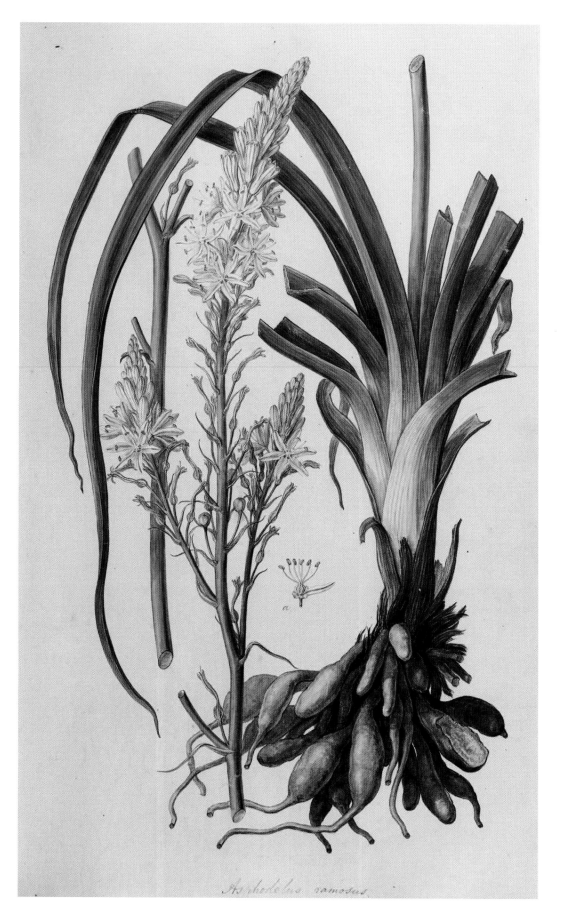

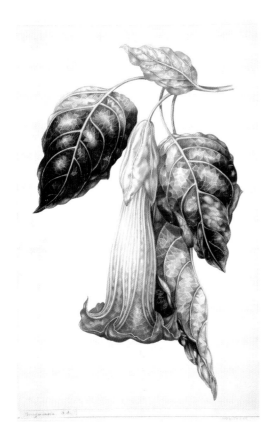

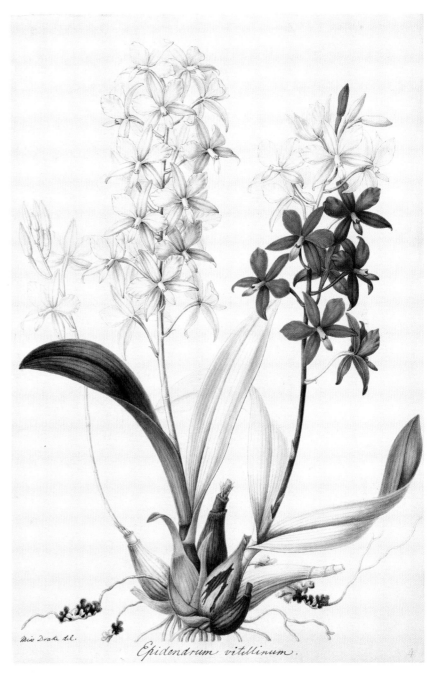

ABOVE: A lively illustration of *Datura rosei* painted by Augusta Innes Withers who was active in London from 1827–1865.
(Fitzwilliam Museum, Cambridge)

RIGHT: An illustration of *Epidendrum vitellinum* by Sarah Anne Drake.
(© Royal Botanic Gardens, Kew)

Austria. Nature printing involved pressing actual seaweeds or ferns into soft lead. The object was placed between plates of lead and steel and pressed tightly together so that an impression was made in the soft lead from which an electrotype could be made for printing. Several colours could be applied during the inking of the plate. The main exponent of the technique was Henry Bradbury, who may have heard about the method whilst working as a pupil at the Imperial Printing Office in Vienna. Bradbury had ambitious plans for extending the range of books to include fungi and trees. Tragically his ideas never materialized because he committed suicide at the age of only twenty-nine.

Recently, I read a book about the plant-collecting adventures of George Forrest, who started work at the Royal Botanic Gardens, Edinburgh and endured the most difficult challenges in his quest for plants. Lilian Snelling was working at the Royal Botanic Garden, Edinburgh as an artist during the time that George Forrest was sending plant material to the Regius Keeper, Sir Isaac Bayley Balfour (1853–1922). A recent exhibition at Inverleith House in Edinburgh showed pressed specimens that George Forrest brought back from his visits to China, along with some of the drawings that Lilian had made from the plant material he collected. Lilian did not stay at Edinburgh; she was enticed away to work at the Royal Botanic Gardens, Kew becoming the main artist for the Kew journal, the *Curtis Magazine*.

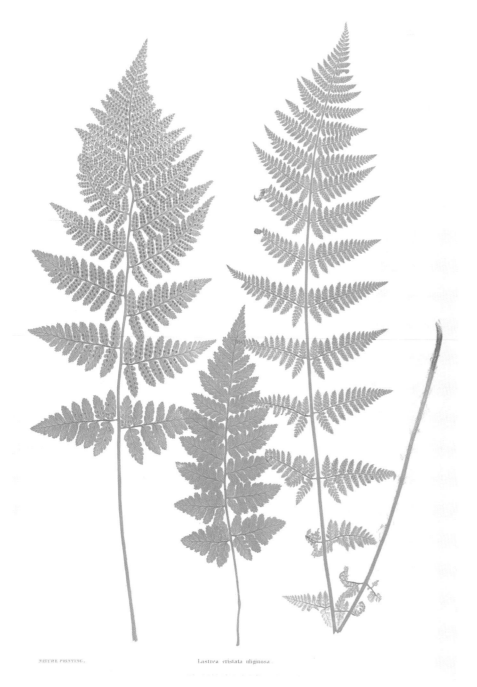

Nature-printed fern named as *Lastrea cristata uliginosa* from *The Ferns of Great Britain and Ireland* (Moore and Lindley, 1855). This fern is now identified as *Dryopteris x uliginosa*.
(© 1995-2008 Missouri Botanical Garden)

Beatrix Potter's Bequest

A lady who had a brush with Kew was Beatrix Potter. Her illustrations for the adventures of Peter Rabbit are widely known, but she was also a remarkable amateur scientist, ahead of her time in her investigations into growing fungal spores. She was badly received by the then Director of Kew, William Thistleton-Dyer, whom Beatrix regarded as rather cynical and boastful. In later life when Beatrix moved to the Lake District she became a member of the Armitt Library, a small subscription library created by the three Armitt sisters Sophia (1847–1908), Annie Maria (1850–1933) and Mary Louisa (1851–1911). Beatrix gave the Armitt Trust many hundreds of her natural history drawings including most of her illustrations of fungi.

Botanical illustration is woven around a living history, tales of adventurers, collectors, naturalists, philanthropists and artists. *The Art of Botanical Illustration* is full of characters and personalities which will take you on a journey culminating in beautiful illustrations, many of which still lie in the archives of some of the greatest institutions of the world.

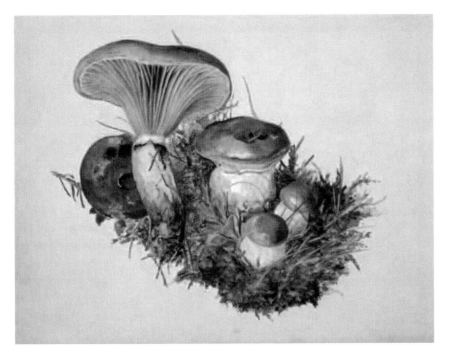

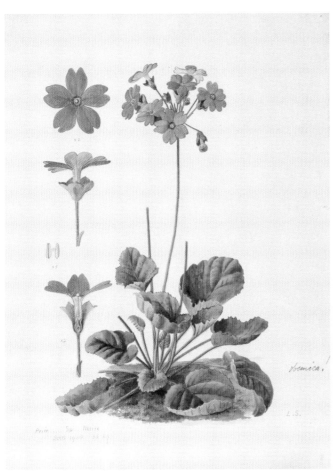

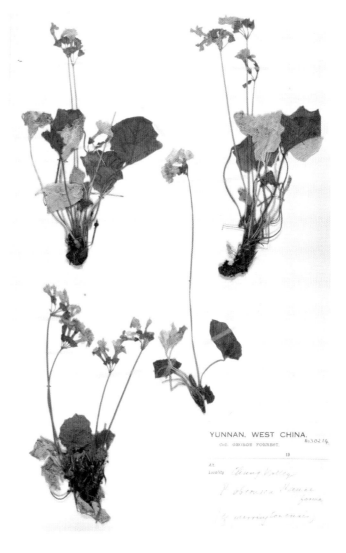

YUNNAN, WEST CHINA.
Coll. GEORGE FORREST.

ABOVE: *Primula obconica* painted by Lilian Snelling in 1918
from a specimen collected by George Forrest.
(Reproduced by kind permission of the Royal Botanic Garden, Edinburgh)

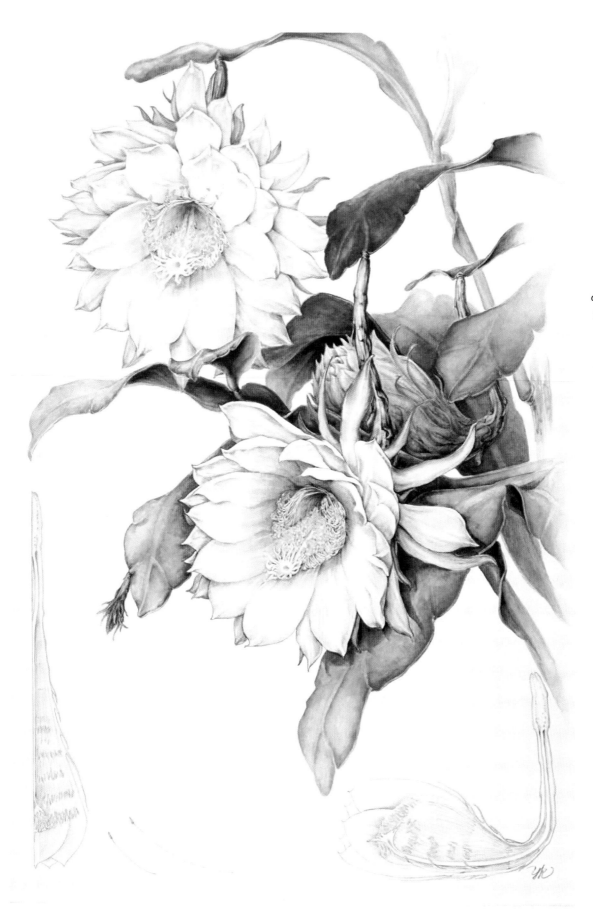

A painting of *Epiphyllum oxypetalum*, which flowers after dark and is pollinated by bats.
(Yoko M. Kakuta)

SIMPLE BOTANY OF PLANTS AND FLOWERS

In order to make an accurate drawing of a plant it is important to confirm its identity and check the diagnostic features of the family to which it belongs. This information will help you to know and understand the plant, its habit and its structure. It will also enable you to recognize when a particular plant is not typical of its kind. Informed decisions can be made whether to continue with the drawing or to search for a more acceptable specimen if the plant is not showing the correct diagnostic features. It is distressing to spend some time on a drawing only to find it is not typical of its species. The specimen may have too many or too few petals, it may be too tall or too small, or the leaves may not be the correct shape, making identification difficult from the completed drawing. Plants are affected by light, shade and moisture during their growing season, and it is not always possible to find the perfect specimen. Plant guidebooks will help to identify your specimen and will enable you to find out about its diagnostic features.

To help understand where plants fit in to the living world, we need to know some background botanical information.

The Plant Kingdom

Plants that produce seeds are called spermatophytes. The spermatophytes are divided into two groups: the gymnosperms and the angiosperms. The gymnosperm group produce naked seeds. These are seeds which are not enclosed but may be found within a cone; typical examples are the seeds of coniferous trees. The majority of plants that are drawn by botanical artists are angiosperms. These produce seeds which are enclosed within a fruit formed from the ovary.

The angiosperms can be further divided into flowering plants that are either monocotyledons or dicotyledons. These terms are usually abbreviated to monocots and dicots. The straightforward explanation of these terms is to remember *mono* for one and *di* for two, and *cotyledon* for seed leaf. When they germinate, the monocotyledonous seeds produce one seed leaf and the dicotyledonous seeds produce two seed leaves. The main features of monocotyledons and dicotyledons can be compared as follows:

MONOCOTYLEDONS AND DICOTYLEDONS

MONOCOT	DICOT
produces one seed leaf	produces two seed leaves
usually three or six flower parts	usually four or five flower parts
perianth not usually divided into calyx and corolla	perianth usually divided into calyx and corolla
leaves usually narrow and strap-like with parallel veins	leaves usually broad with branching veins
usually has fibrous roots	usually has a taproot

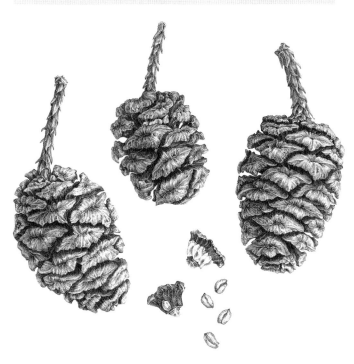

Sequoia cones and naked seeds. (Julie Small)

Drawing of a
monocotyledonous
plant seedling.
(Valerie Oxley)

Plants in the monocotyledonous group are generally easy to recognize because of their long straight leaves with parallel veins and flower parts based on multiples of three. Many are bulbous plants; examples are lily, narcissus, crocus and amaryllis. There are nearly always exceptions in nature, as in the case of the arum, which is a monocotyledonous plant although the leaf veins are branched.

There is more variation in numbers of parts when we look at plants in the dicotyledonous group. The veins are branched, and flower parts can be in fours or fives. An exception is the plantain, where the veins of the leaves are parallel.

Plant Structure

A plant usually consists of an underground root and an above-ground shoot.

The Root

In flowering plants the part below ground is generally a root. The main functions of the root are to anchor the plant, to take up water and minerals from the soil and to conduct them to the base of the stem for further transport towards the leaves.

Root hairs are usually present in a concentrated area just behind the root tips. They are single cell structures that are extensions of the outer root cells. Their function is to increase the root's absorptive surface area and thus increase the uptake of water. New root hairs are formed behind the tip of the root as it grows, replacing older ones further back which gradually wither. The hairs are easily broken when plants are removed from the ground.

ROOT SYSTEMS

Root systems develop either as the fibrous adventitious roots of the monocotyledons or as a vertical taproot with lateral roots growing out from it, typical of the dicotyledons.

ROOT ADAPTATIONS	
Prop roots	supportive roots growing from an above-ground stem that help to stabilize the plant, e.g. maize.
Contractile roots	thickened roots that help pull bulbs, corms or rhizomes deeper into the ground
Adventitious roots	may appear from unexpected positions: on a stem such as the ivy where they help to anchor the plant so it can climb; on a rhizome, which is an underground stem; or on the tip of a bramble shoot when it touches the ground
Aerial roots	appear above soil level, e.g. some species of tropical, epiphytic orchids, which grow on other plants to gain height, use their aerial roots to absorb moisture from the atmosphere
Root tubers	adventitious roots swollen with food reserves during the first year and used for growth at a later stage; formed in plants such as dahlias and lesser celandine

Mycorrhizal associations are relationships between fungi and the roots of almost all species of flowering plants. These associations can help the plant to take up nutrients and water from the soil. In exchange the fungi extract the sugars they need from the plants. This is known as a symbiotic association where both fungi and plant flourish.

Root nodules on leguminous plants such as clover and broad bean contain nitrogen-fixing bacteria. The nitrogen compounds which the bacteria produce are beneficial to the plant.

Stem

The above-ground part of the plant, called the shoot, usually consists of the stem, leaves, flowers and fruits. The stem of the plant supports flowers and fruits and holds them upright to enable fertilization and seed dispersal respectively to take place. Stems usually bear buds and leaves at intervals. At the tip of the stem is the terminal bud, which is responsible for the elongation of the stem and initiates the growth and arrangement of branches and leaves. Axillary buds appear in the angle between the points of attachment of the leaf to the stem; this angle is known

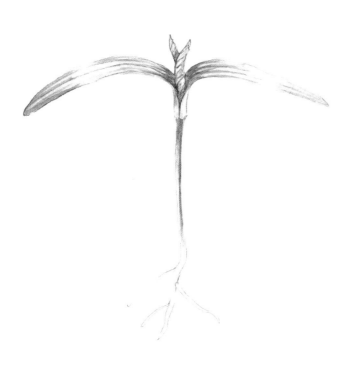
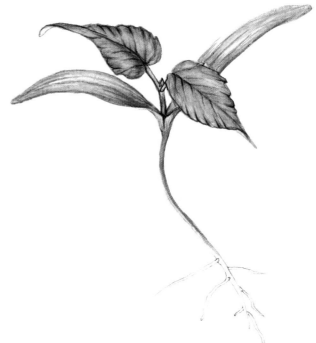

ABOVE LEFT AND RIGHT: Drawings of a dicotyledonous plant seedling. (Valerie Oxley)

as the axil. The point of emergence of the leaf and bud is called a node, and the distance between two nodes is called an internode. Stems can be herbaceous or woody. Woody stems may have a layer of bark on the outside, as with trees. Stems also perform the important function of transporting water and other materials through the plant.

Stems may show adaptations, for example they could appear as runners in the strawberry plant, rhizomes as in the iris, tubers as in the potato or corms as in the crocus.

Plants have evolved prickles, spines, thorns and hairs as a form of protection and defence. It is important that these structures are recorded carefully in a drawing, as they can be a form of identification of the plant.

An amazing variety of shapes will be found if you look closely at the hairs on stems and leaves with a hand lens or magnifying glass. Hairs can be simple one-celled structures or branched, forked, star-like, cobwebby, rough or smooth, long or short. They are usually for the protection of the plant from animals or

STEM ADAPTATIONS

Runner	a creeping stem; new plantlets develop at the nodes, the places on the stem where leaves usually develop
Rhizome	a root-like creeping stem that lies horizontal to the ground, often just under soil level, and sometimes partly on the surface, e.g. iris. Rhizomes have contractile and adventitious roots and can also give rise to new buds
Stem tuber	an underground food-storing swollen shoot, usually bearing buds that can give rise to new shoots, e.g. potato, Jerusalem artichoke
Corm	a swollen stem which usually renews itself each year

STEM STRUCTURES

STRUCTURE	POSITION	FUNCTION
Prickle	sharp outgrowths emerging from the outer surface of the stem; they break off easily from the surface of the plant, e.g. wild and cultivated roses.	scrambling and protection from animals
Spine	modified leaves, e.g. cacti, or modified stipules, e.g. gooseberry.	protection from animals
Thorn	modified branch with a woody point, e.g. blackthorn and hawthorn	protection from animals

HAIRY TERMS

Trichome	technical term for a hair-like outgrowth
Arachnoid	cobwebby
Floccose	soft downy or woolly hairs
Hirsute	covered with rough, coarse hairs
Hispid	bristly
Indumentum	covered all over with hairs
Pilose	soft and hairy
Pubescent	covered with soft hairs
Stellate	star-like
Tomentose	densely covered in soft hairs
Glabrous	without hairs

from the sun; they can also catch moisture from the air. In many cases the presence or absence of hairs helps with the identification of the plant. The Latin name of the plant can often give a clue to its surface covering.

Leaves

The main function of the leaf is to make food for the plant. Leaves can be adapted to protect the plant, and they can be coloured to help attract pollinators, as in the cornus. Leaves usually consist of a stalk known as a petiole, which leads to a flattened area known as the leaf blade or lamina.

Look carefully at the leaves on your plant before starting to draw. In many monocotyledonous plants the petiole does not exist, and the base of the leaves form a sheath around the base of the stem, as in tulips and daffodils. Some leaves have laminas that do not have a stalk, and the lamina joins the stem directly; these leaves are said to be sessile: some species of oak have sessile leaves. Leaves can be simple or compound and made up of two or more leaflets. Compound leaves can be palmate or pinnate. The leaf tip is called the apex, and the bottom of the leaf is called the base. The edge of the leaf is called the leaf margin. The leaf margin can show many variations: it can be serrated or smooth; leaves can be hairy or without hairs (leaves without hairs are said to be glabrous); leaves can be subtended by outgrowths from the node known as stipules: these are a diagnostic feature of the rose family.

Leaves can vary in size and shape. On individual plants the smallest leaves are usually found at the top of the shoot and the largest at the base. Although they may vary in shape, size and colour there are recognizable characteristics that link the leaves together. Leaves can vary in colour, with the new young yellow green leaves at the top of the plant and the older blue green ones at the base. Leaves are not always green, and there can be variations: some leaves are green on the topside and red under-

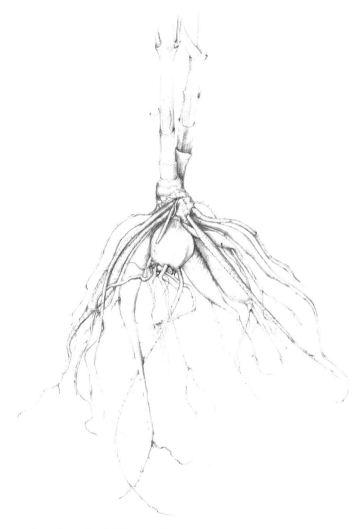

Drawing of a dahlia root showing root tubers. (Sylvia Ford)

neath, as in some cyclamen. Leaves of deciduous trees often change colour in the autumn before they fall from the tree.

The arrangement of the leaves on the stem should be carefully observed. Look for different presentations; single leaves can be arranged alternately or opposite, and three or more leaves can appear in a cluster or whorl. Occasionally leaves are perfoliate, where two opposite sessile leaves join and the stem seems to go through the leaf blade.

The leaf buds of trees in winter are an important aid to the identification of individual trees. They can be alternately arranged along the stem, opposite, whorled or they may be clustered at the tip. They can vary in size, shape and colour and in the number of visible bud scales.

Flowers

Flowers are the reproductive structures of the plant. The plant is designed so that its flowers, which are usually conspicuous, occupy the most advantageous position to attract the

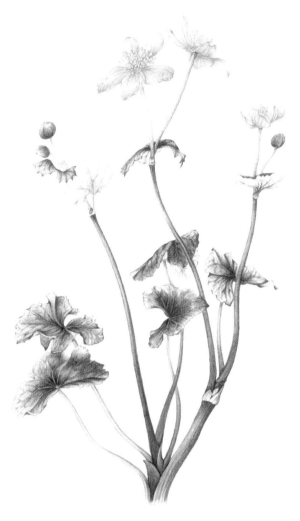

A flowering shoot of *Caltha polypetala*. (Pamela Furniss)

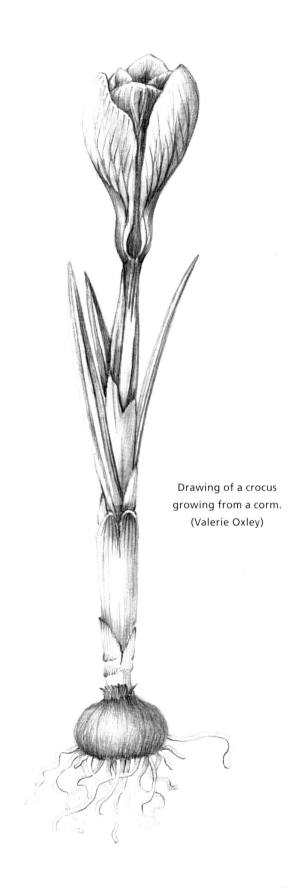

Drawing of a crocus growing from a corm. (Valerie Oxley)

appropriate pollinators. Where plants have more than one flower they may open in succession, thus extending the opportunities for pollination to take place.

Flower parts are usually arranged into four whorls. The outermost whorl is the calyx, made up of a collection of sepals; the next whorl is the corolla, made up of the petals; the third whorl is the androecium, made up of the stamens – the male part of the plant, and the central whorl is the gynoecium, made up of the carpels – the female part of the plant. The whorls sit on top of a receptacle or pedicel that bears the flowers, at the top of the stem.

Flowers in which both male and female parts are functional are known as perfect. Staminate flowers only contain the male parts, the stamens. Pistillate flowers only contain female parts, the pistil, which is made up of the ovary, stigma and style. When staminate and pistillate flowers are on separate plants the plant is said to be dioecious and when on the same plant monoecious.

Flowers can be produced singly, or they can appear in a group or in a cluster known as an inflorescence. There are many different arrangements of inflorescence all with a common purpose: to attract pollinators. Some inflorescences, particularly in

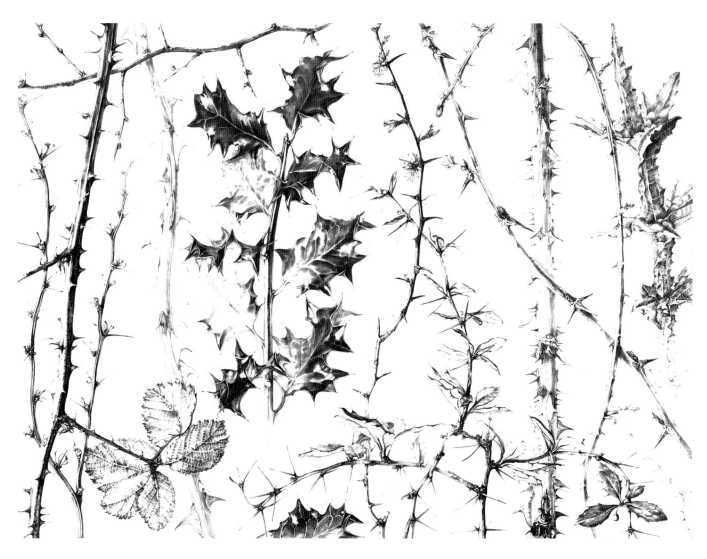

A variety of stems showing a range of plant defences.
(Jo Edwards)

the daisy family, appear so closely packed together that they look like a single flower with petals around the outside, but they are an inflorescence composed of numerous florets.

The calyx consists of a number of fairly tough sepals which surround the petals and protect the developing bud. Sepals can be fused or free; there may be more than one layer of sepals forming a double calyx as in the mallow family: this structure is known as an epicalyx. In some plants such as the common poppy *Papaver rhoeas*, the sepals fall once the flower opens. Flowers such as the cultivated flax *Linum usitatissimum* open and close each day, and the sepals are retained to protect the flower when it is closed. The sepals in most plants remain green, but in some cases they form a dual function and become coloured and attractive to insects. The sepals may replace the true petals as in the winter aconite and the hellebore.

The function of the petals is to protect the reproductive part of the plant and also to attract pollinators such as insects, birds or animals. Petals can be free or united; they are collectively known as the corolla.

The calyx and corolla, the outer non-reproductive parts of the flower, are known collectively as the perianth. Where parts of the perianth resemble each other, as in the tulip, they are known as perianth segments or tepals. In the tulip the perianth segments are green in the bud stage and colour up in the flowering stage.

The androecium is the male part of the flower: it consists of the stamens. A stamen is made up from an anther, which produces the pollen, and a stalk known as a filament. The pollen is shed when mature anthers split under tension and open to reveal the pollen grains.

The gynoecium or pistil is the female part of the flower; it consists of one or a number of carpels which may be fused. Each carpel typically consists of a stigma, style and ovary. The ovary may contain one or more ovules waiting to be fertilized; once fertilized the ovules become seeds and the ovary wall the fruit. The function of the stigma is to provide a suitable surface to receive pollen grains that will fertilize the ovules. The surface of the stigma is usually slightly sticky. Pollen lands on the sticky

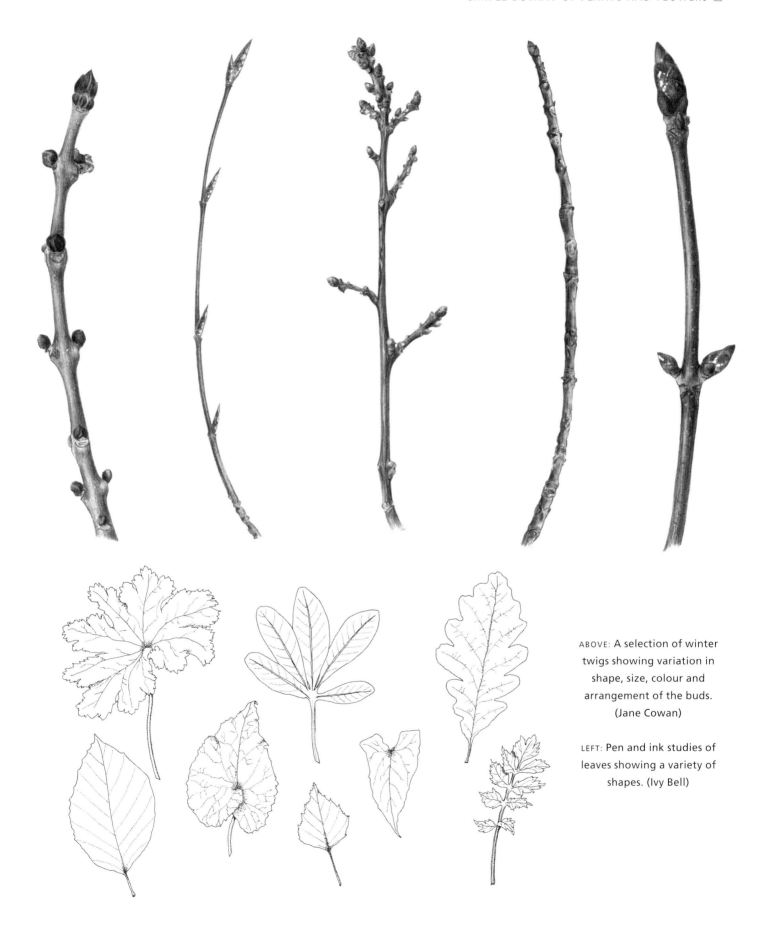

ABOVE: A selection of winter twigs showing variation in shape, size, colour and arrangement of the buds. (Jane Cowan)

LEFT: Pen and ink studies of leaves showing a variety of shapes. (Ivy Bell)

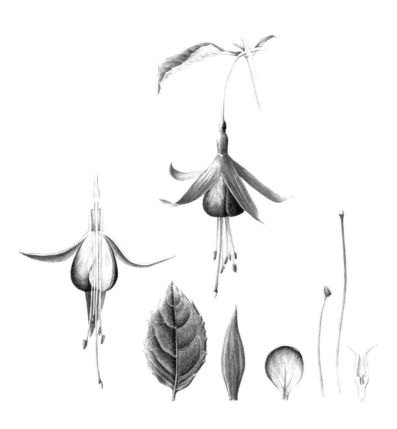

Study sheet of a fuchsia flower and leaf. The half flower shows the arrangement of the inner parts. Personal observations like this provide excellent reference sheets that can be kept together in a file for future use. (Jenny Harris)

A study of the newly opening flowers of the *Nectaroscordum siculum*. There is a delay in the opening of the individual flowers thus extending the overall flowering time. Once fertilized, the perianth segments close and turn upwards. (Judith Pumphrey)

surface, and a pollen tube grows down to the ovary through the style. There are many variations of this structure, for example in the tulip the style is shortened and the stigma sits directly on top of the ovary. The position of the ovary can vary widely. Ovaries can be superior or inferior. A superior ovary is positioned on top of the receptacle above the other flowering parts. An inferior ovary appears below the other flowering parts and seems embedded within the pedicel.

Pollination

The main function of a plant is to reproduce itself to ensure continuation of the species. One of the ways a plant can do this is by producing viable seeds which are then dispersed away from the parent plant by wind, water, humans or animals. The process of pollination involves the transfer of pollen from an anther, the male part of the plant, to a stigma, the female part. Cross-pollination occurs when this procedure takes place

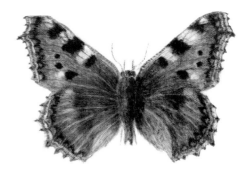

The tortoiseshell butterfly is an excellent pollinator and visits a large number of flowering plants. The pollinator is part of the plant's life cycle; many early illustrations include them, although sometimes only for decorative purposes. (Helen Cullen)

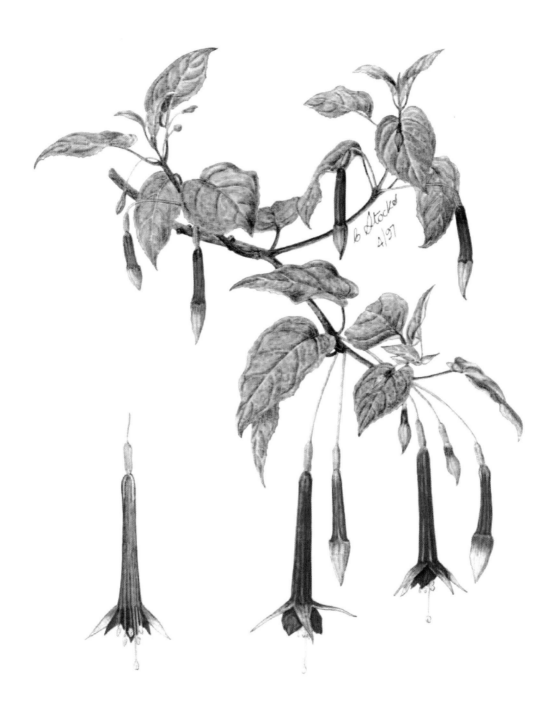

Fuchsia fulgens, a plant that is pollinated by
humming birds. (Cyril Stocks)

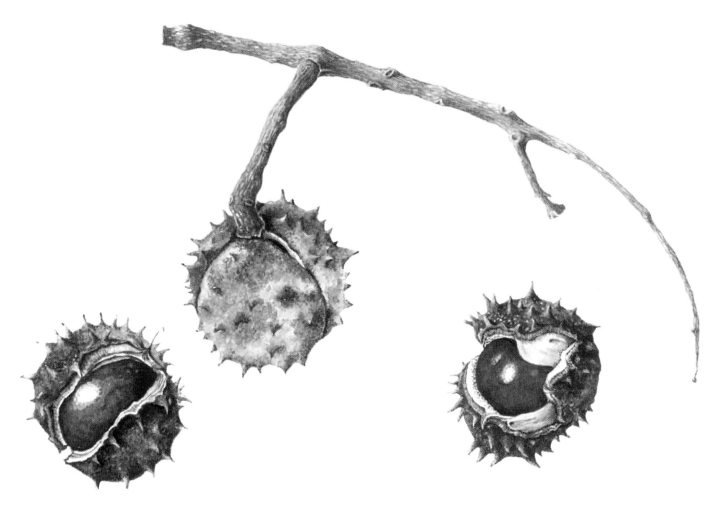

The fruit of the horse chestnut *Aesculus hippocastanum*. (Alison Watts)

between two individual plants from the same species. Some flowers are self-pollinated, but in order to produce the continuation of healthy plants cross-pollination is more desirable. The stigmas and pollen on the same plant often mature at different times, to aid cross-pollination. In some cases plants and their pollinators have evolved together; in others flowers have evolved to attract a particular pollinator.

Insect Pollination

Insect pollinators visit plants to collect pollen or nectar for food. They are usually guided to the flower by colour and smell and the presence of markings on the petals known as bee-lines. Plants which are pollinated by beetles and bees need platforms on which the insect can land. Some flowers are opened by the weight of the insect.

Pollen is rich in vitamins and minerals and contains protein and other nutrients which are essential for insects and bees. Where it is taken by the insect as food large amounts of pollen

will be produced. Some of the pollen will become attached to the insect's body and subsequently transferred to the stigma of the next plant visited. Roses and poppies are examples of flowers that produce large amounts of pollen but no nectar.

Plants offering nectar as a reward usually produce it in small amounts; this means the insect will have to visit many flowers for food, and the opportunities for fertilization are increased. Nectar is rich in carbohydrate and is produced from nectaries, which can be positioned anywhere in the plant. The winter aconite *Eranthis hyemalis* has small cup-like structures just inside the sepals containing nectar. The common mallow exudes nectar from the base of its petals, and the insect disturbs the pollen in its search. Honeysuckle *Lonicera periclymenum* flowers have long filaments and styles, as they are pollinated by hawk-moths that hover over the flower without actually landing on it.

Wind Pollination

Many trees, grasses and other plants are wind pollinated. It is thought that the flowers of these plants were probably originally insect pollinated but have evolved and adapted to accommodate wind pollination. Petals are reduced or absent, but the

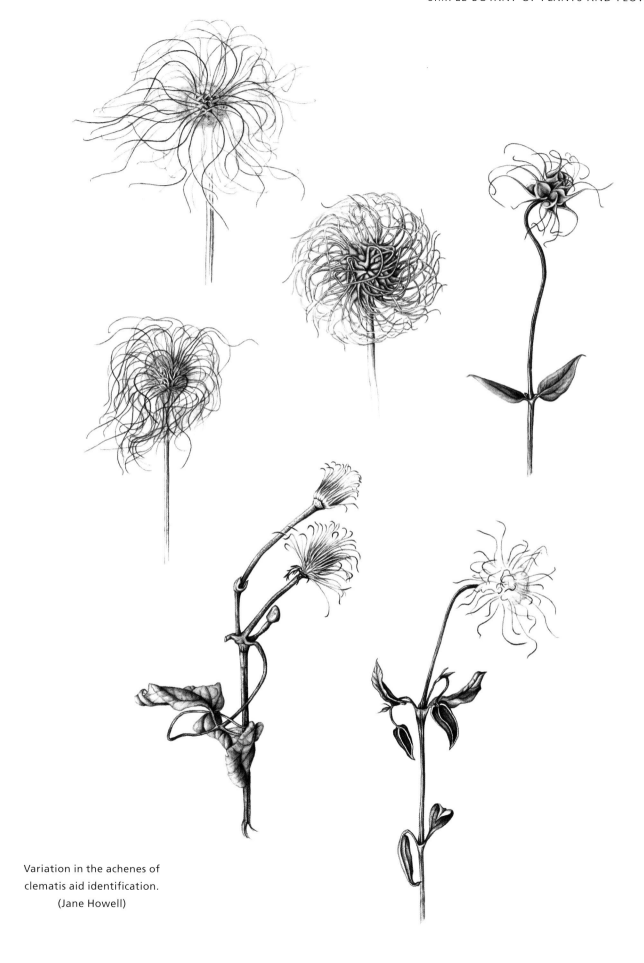

Variation in the achenes of
clematis aid identification.
(Jane Howell)

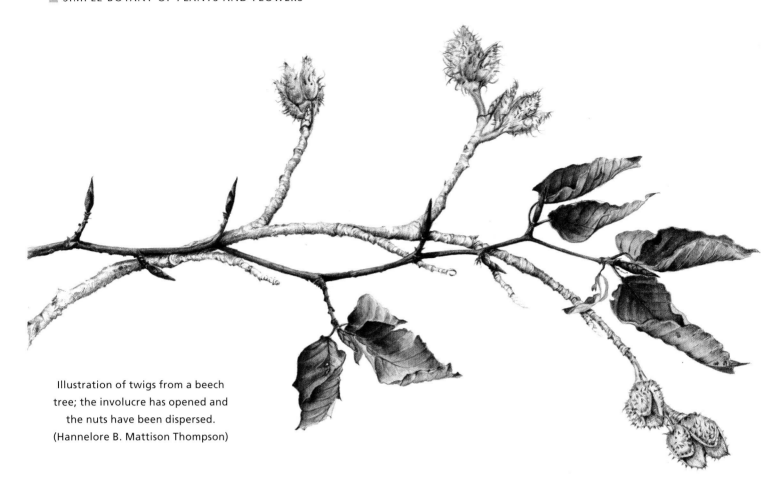

Illustration of twigs from a beech
tree; the involucre has opened and
the nuts have been dispersed.
(Hannelore B. Mattison Thompson)

pollen-bearing stamens may have longer filaments and are more numerous. Stigmas are often feathery, to catch pollen as it floats by on the wind currents.

Pollination by Birds

A number of tropical plants are pollinated by birds. Flowers that need to attract birds are often red, as birds see the colour red particularly well. Red can be seen at a great distance by birds on a migratory run. In North America the presence of fuchsia flowers assures food in the form of nectar for humming birds on migratory routes. Bird-pollinated plants usually hang downwards and have long filaments and styles. They usually have copious amounts of nectar and no scent.

Pollination by Bats

Bats are the pollinators of a number of tropical plants, including eucalyptus, mango and banana. The flowers of plants pollinated by bats are usually open bell or dish shapes with numerous stamens; sometimes they emit a musky bat-like smell. The bats

that are attracted to these flowers usually have a highly developed sense of smell. Some types of bat are able to hover in front of the flowers and extend their long tongues to extract the nectar. More frequently the bats alight on the flowers and grip the petals with their claws, leaving telltale marks of their visits. The bat pushes its head through the mass of stamens to search for nectar; pollen is caught on the bat's fur and is transferred to the next flower. It is interesting to discover that some night-flowering cacti do not develop spines until after the flower has been pollinated so that the bats do not become impaled. In some cases bat-pollinated plants produce flowers before the leaves appear so that the bats do not get caught up in the foliage.

Self-Pollination

Some plants are able to fertilize themselves if cross-pollination has not taken place. In the case of the British bee orchid *Ophrys apifera* pollen is held in structures called pollina, which are situated at the top of the flower. When ripe they fall forwards and downwards on tiny threads until they dangle at the same level as the stigma. Within a short time they become attached to the stigma and self-pollination takes place.

The marsh marigold *Caltha palustris* is self-pollinated. The flowers stay open in the rain, and as water collects within the cup-shaped petals, the pollen is released and neatly floats over to the stigma, which is on the same level.

The late flowers of some plants are able to self-pollinate within the bud, and the flower does not open. At first sight one might suppose the structure is a seed case or undeveloped bud. The flower does not produce petals and nectar; examples are sweet violet *Viola odorata* and wood-sorrel *Oxalis acetosella*. These plants are said to be cleistogamous.

Members of the dandelion family are able to produce seeds without fertilization or apomixis. They form a clone of the mother plant. The result of this process can be observed by looking at the seed head of the common dandelion. The seed heads are usually completely round, showing that each individual flower within the inflorescence has produced a viable seed.

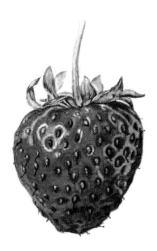

Detailed painting of a strawberry showing the small hard achenes on the outside of the fruit. (Sheila Thompson)

Fertilization

Fertilization occurs when the nuclei of the male and female reproductive cells fuse. The pollen grain falls onto the sticky stigma and a tube grows from it, through the stigma, down the style, into the ovary and towards an ovule. It enters the ovule via a small pore, the micropyle. The male nucleus of the pollen grain divides to give two male nuclei, which travel down the tube and are released into the embryo sac of the ovule.

One enters the egg cell and fuses with its nucleus to form an embryo, and the other fuses with nuclei deeper within the embryo sac to form the endosperm. The endosperm nourishes the developing embryo. Once this double fertilization, a feature of flowering plants, has taken place the ovule develops into a seed. The ovary wall, and sometimes other parts of the flower, develops into the fruit. The time between pollination and the fusion of cells can take from a few hours in flowering plants to a year in some trees.

The Fruit Holds the Seeds

The term fruit is applied to a structure that contains seeds, whether it is edible or not. Once pollination and fertilization have taken place fruits and seeds begin to develop. A fruit develops from the ovary, and a seed develops from an ovule within the ovary. The parts of the flower which are no longer needed fall from the plant, and the stigma and style wither. In the true fruit the ovary swells, with the outer wall, known as the pericarp, becoming soft and fleshy or dry and hard. The pericarp may develop in three layers. The outer layer is the exocarp, which is usually a single layer of cells. The middle layer is the mesocarp

and is usually fleshy. The inner layer is the endocarp, which can be like skin or jelly, thick and fleshy or hard and woody.

The simplest way to classify the different fruits is to describe them as dry or fleshy. Dry fruits can be further divided into dehiscent, which split open to release the seeds, and indehiscent, which remain closed.

Dry Dehiscent Fruits

In the columbine *Aquilegia vulgaris*, the fruit is formed from a group of carpels which dry when mature to form a group of follicles. Tension builds up along the ventral side of each follicle and it splits, or dehisces, to expose the seeds.

Fruits of the pea family, the leguminosae, are similar to follicles but they split along two sides of the fruit and are known as legumes. A lomentum is a legume which breaks into single seeded segments when it matures. An example is the common laburnum *Laburnum anagyroides*.

The fruits of the white campion, poppy and evening primrose are formed from a group of carpels which have become united. When they dehisce slits are formed and the seeds are dispersed through the openings. In the poppy the slits are formed under the cap, which is the remains of the stigma. These multicarpel fruits are called capsules.

Some plants have specialized capsules. In the wallflower and honesty both sides of the fruit separate leaving a framework to which the seeds are attached. When the shape of the capsule is long and thin, as in the wallflower, it is known as a siliqua, and if it is shorter and rounder it is known as a silicula.

Dry Indehiscent Fruits

There are a number of dry fruits which do not split open. The buttercup develops fruits of one carpel clustered together to form a seed head. The thin carpels fit tightly around the seed and together they form a hard fruit, which falls from the plant when ripe. This type of dry, one-seeded fruit is formed from a superior ovary and is called an achene. In the clematis the achenes have a feathery plume.

The fruit of grain is also an achene in which the seed has become fused to the pericarp. It is difficult to distinguish where the fruit ends and the seed begins. This type of indehiscent fruit is known as a caryopsis.

Members of the *Asteracea*, the daisy family, have fruits which are single-seeded. They are formed from an inferior ovary, and many have feathery parachutes. This kind of fruit is known as an inferior achene or cypsela.

Another plant that has developed a hard non-opening fruit is the ash tree. The fruits of the ash have an extended wing which twists as it dries enabling the fruit to spin to the ground when blown from the tree. This type of fruit is known as a samara. The sycamore has a double samara.

The fruit of the *Apiaceae* family separate into two halves; each half carries one seed. They hang from a central axis. This type of fruit is known as a schizocarp.

Beech and oak trees have fruits that are similar to achenes but classified as nuts. They are enclosed by a ring of hard bracts called an involucre. On drying the bracts shrink or open and the nut falls out and lands at the base of the tree; they are often dispersed by squirrels and buried.

A nutlet is a small nut; the term is applied to the achene-like seeds of the mint family.

Pyramidal orchid in pen and ink showing the spiral structure of the inflorescence. (Cate Beck)

Fleshy Fruits

The fruits of the wild arum and tomato are examples of the simplest forms of a fleshy fruit known as a berry. The entire pericarp becomes soft and succulent surrounding the hard seeds. The outer layer of the fruit, the epicarp, may be a thin tough skin.

Cherries, plums and almonds are drupes which have a two-layered fruit wall. The outer layer is similar to the berry and may have a thin tough epicarp and a fleshy interior or mesocarp. The next inner layer, the endocarp, is hard and woody. Enclosed inside this woody layer is the seed or kernel. A blackberry is a collection of small drupes or drupelets. The fruit develops from a single flower which has numerous carpels; these become fused to form an aggregate fruit.

False Fruit or Pseudocarp

Apples and pears are pomes, which is a special group where the receptacle has become enlarged and completely surrounds the ovary. A strong membrane encloses the seeds in the centre of the fruit, known as the core.

In the strawberry the receptacle becomes swollen and enlarged, with the fruits on the outside; these ripen into small hard achenes. The strawberry is known as a false fruit; however, the achenes are the true fruits.

In the rose hip the fleshy receptacle becomes urn shaped, and the achenes are on the inner wall. The fruit reddens as it ripens and becomes attractive to birds, thus the seeds are dispersed.

Mulberries, pineapples and figs are examples of a multiple fruit where the fruit is made up from the carpels from separate flowers.

The Fibonacci Sequence

The structure of plants is an ordered affair. The structure of the flower, the position of leaves on a stem and the way branches are formed often fall into a mathematical series of numbers which continually reoccur. Monocotyledons have flower parts based on three; buttercups have five petals as do geraniums, mallows and wild roses. Ragwort has thirteen petals; chicory has twenty-one petals; and michelmas daisies have fifty-five petals.

These numbers relate to the Fibonacci sequence, which is a series of numbers 1, 2, 3, 5, 8, 13, 21, 34, 55, etc. Each number from three upwards is the sum of the previous two, for example 5 + 8 = 13. The sequence was discovered by an Italian mathematician called Leonardo of Pisa (*c*.1170–1230). He was given the nickname Fibonacci in the eighteenth century by the French mathematician Guillaume Libri. Fibonacci means the son of Bonaccio. Fibonacci was a creative mathematician who studied numbering systems used by Arabs and Hindus, which were different to the Roman system. Fibonacci published a book called *Liber abaci* in two versions in1202 and 1228, which explained his mathematic theories.

The Fibonacci sequence can be counted on the spirals of plants. Spirals appear in fruits and seed heads. Examples are sunflowers, pinecones and pineapples. You can count the spirals in each direction on a pineapple; the usual arrangement is eight in one direction and thirteen in another, both Fibonacci numbers.

Many plants show the Fibonacci series in the arrangement of leaves around a stem. Look down on a plant you will see that the leaves are arranged so that they do not overshadow the leaves below. This allows the leaves to catch the greatest amount of sunlight, and raindrops are caught on the leaves and spiralled down to the root.

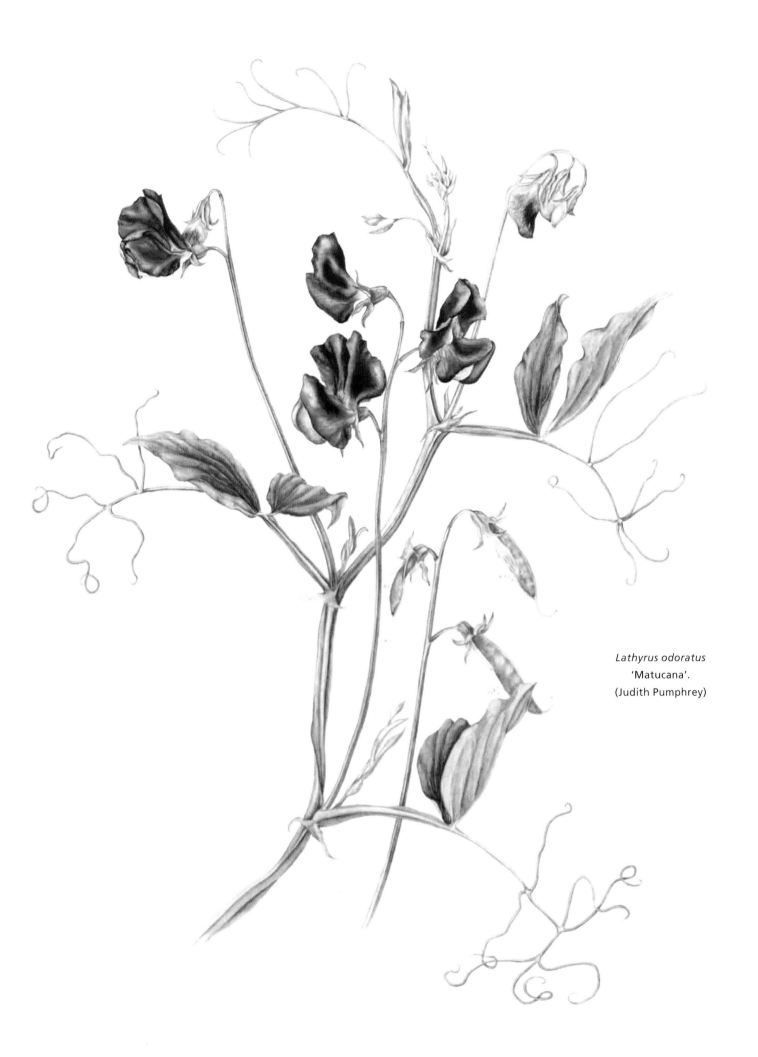

Lathyrus odoratus
'Matucana'.
(Judith Pumphrey)

MATERIALS AND EQUIPMENT

Setting up the Workspace

The most suitable room for a botanical artist is one which is north facing, away from the glare of the sun. Colours can be matched more accurately in north light.

The Table, Drawing Board and Easel

Unless you have a floor standing drawing board, a table can be used for your workspace. Right-handed artists should place the table near the window so that natural light falls onto it from the left. Left-handed artists should arrange their working area with light falling from the right. *Please note that right to left adjustments apply throughout this book.*

You will need a drawing board with a smooth surface; a convenient size is 50cm x 40cm (20in x 16in). It is advisable to round off any sharp corners on homemade drawing boards. A manufactured table easel that can be adjusted to the angle required for drawing would be useful. A table easel will enable you to work in a more upright position; continual bending over your work can cause problems with posture later. Your chair should be the correct height for the table; a cushion can be used to adjust the height if necessary. Try to avoid sitting in the same position for more than thirty minutes, and rest your eyes regularly by looking out of the window or across the room.

The drawing board can angled towards the artist by placing a brick underneath the far edge if a table easel is not available. Cover the brick with fabric or felt to avoid unwanted scratches. Wooden blocks can be used for the same purpose or a lightweight table cushion similar to those used by calligraphers. Another suggestion is to sit slightly away from the table so that the drawing board can rest on the table edge with the bottom edge on your knee.

All materials should be placed on the right-hand side of the artist to avoid stretching across the artwork to pick up water or paint. Even drops of clean water can cause noticeable marks on the surface of watercolour paper.

Plant material should be placed in water as soon as possible after collection. It should be repositioned for drawing to show its natural growth habit with the main focal point of the plant material at eye level. Holding the plant in one hand, whilst drawing with the other, is not a satisfactory method of working as the plant will soon wilt.

The plant should be placed either directly in front of you or slightly to the right. Place a backing board or card alcove behind the plant so you can see it more clearly. An Anglepoise lamp positioned to the far left of the plant, and shining from an angle of 45 degrees, will help you to see the highlights and shadows more clearly. Highlights and shadows will be too sharp if the lamp is too close to the plant. The lamp should be fitted with a daylight simulation bulb.

Magnifiers and Microscopes

Optical aids will help you to see plant material or your painting more clearly. Magnifiers enlarge structures so that parts of the plant material can be seen in more detail. There are various types of magnifier; some are hand held while others are free

A home made table cushion filled with polystyrene balls can be used to angle the drawing board towards the artist.

Plant material should be placed in water and set up in front of a card alcove so the artist can see structures clearly.

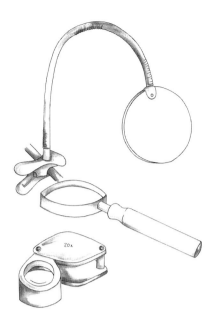

A range of magnifiers, which will enable you to see plant material more closely.

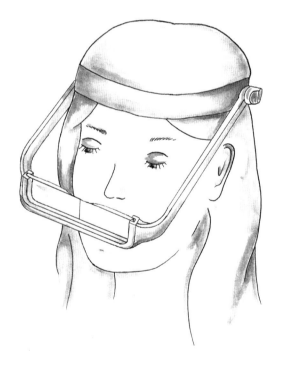

A head magnifier helps you to see detail more clearly, leaving both hands free.

Field Hand Lens

A field hand lens is a device for looking at botanical structures in detail. Make sure you are looking at the specimen in good light. Hold the hand lens close to your eye with one hand and bring the specimen up to the lens with the other hand.

Head Magnifiers

These are binocular magnifiers which are worn on a band around your head. The visor is adjustable and it can swing up or down or it can be locked into place. Magnifiers that clip onto your own glasses and give two to three times magnification are also available. The advantage of these products is that both hands are free.

Stereo Microscope

A stereo microscope is for looking at small structures in greater detail. The most useful stereo microscope for botanical work has a magnification of between x10 and x30. These microscopes are straightforward to use and do not require the preparation of slides. Unless you are required to produce drawings of dissections for scientific institutions a stereo microscope will be adequate. Remember that whenever you look through a microscope it is to see the material more clearly; there is always the desire to see more detail.

standing. Some magnifiers have a flexible arm that can be clamped to your table and adjusted, leaving your hands free. Illuminated table magnifiers can be used to see work in progress more clearly.

Light Box

A light box is a simple way to transfer a preliminary drawing from sketching paper to watercolour paper. It is a device for projecting an image from drawing paper through to water-colour paper using a light source. Manufactured light boxes tend to be expensive; a light box can be made at home using a wooden box, opaque glass, and a cool florescent tube for light-ing. Alternatively you could tape your drawing to a window so that the bright daylight will shine through from the back.

Equipment for Measuring

Accurate measurements are essential to show correct botanical structures.

Ruler

A ruler can be used to measure your plant, but it may be easier to use a pair of dividers.

Dividers

Use a simple pair of dividers to measure your plant accurately. Place your plant at arm's length. Sit upright in your chair, and each time you take a measurement of the plant make sure you are sitting in the same position. Leaning forward or slouching in your chair will alter the measurements you are recording. Imag-ine there is a sheet of glass immediately in front of your plant; take each measurement on the same plane as the imaginary glass. To ensure accuracy do not turn the dividers into the plant; take all measurements in the same plane.

Reference points are the marks on the paper that relate to the measurements you have taken. Extend the arms of the dividers to the required measurement on the plant, and make two light pencil marks on the paper where the measurement is to be recorded.

Proportional Dividers

These are used when a drawing has to be scaled up or down. They are particularly useful when enlargements are required to record a structure more clearly. Individual parts can be scaled independently at x2, x3, x4 and so on.

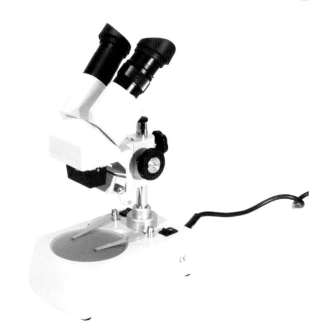

A stereomicroscope is useful for examining structures in detail. The one illustrated is manufactured by Brunel Microscopes and is ideal for all natural history applications.

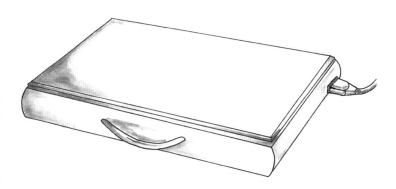

A photographic light-box is a very useful piece of equipment for transferring drawings.

Materials for Drawing

Papers
CARTRIDGE OR SKETCHING PAPER

Cartridge paper is a type of strong paper used in the manufac-ture of gun cartridges. The name cartridge paper has been retained by the industry to indicate its strengths. Generally made of cellulose, it can take a variety of media but botanical artists use it mainly for initial sketches and preliminary drawings.

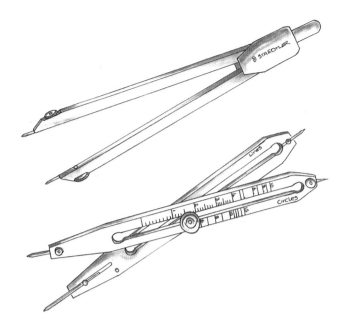

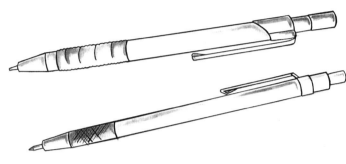

A pair of dividers is essential to measure your plant accurately. Proportional dividers are used for scaling a drawing up or down.

Clutch pencils and propelling pencils can be sharpened to a fine point or have fine leads.

TRACING PAPER

Tracing paper is used to transfer a preliminary drawing from drawing paper to watercolour paper; it can be used for initial drawings.

DETAIL PAPER

This thin semi-opaque paper is useful as an alternative paper for preliminary drawings.

PAPER FOR EXHIBITION WORK

Hot pressed watercolour papers are the most suitable for finished drawings which are to be exhibited.

PROTECTIVE PAPER

A grubby halo will appear around the work if a pencil drawing is smudged. The effect is more discernable with the darker and softer B grade pencils. A piece of clean paper placed under your hand but on top of the artwork will help to alleviate this problem.

Pencils

The word pencil is derived from the Latin *penicillum*, which means fine tail or brush; this was the name given to a brush-like instrument used by the Romans for writing. Before the discovery of graphite, which readily makes marks on different surfaces, artists used a sharp pointed instrument called a stylus for drawing. The stylus was made from a mixture of tin and lead. The combination of the term *penicillum* and the lead used for the stylus gives us the term 'lead pencil'. Modern day pencils are made from a mixture of amorphous graphite and clay; lead is no longer used but the term lead pencil is still in common use.

PENCIL GRADES

Pencils are graded from 9H to 9B, with the HB and F pencils in the middle of the range:

9H 8H 7H 6H 5H 4H 3H 2H H **F HB** B 2B 3B 4B 5B 6B 7B 8B 9B

An easy way to remember the hardness or softness of an individual pencil is to think of H for hard and grey, and B for soft and black. The hard and grey H pencils have more of the clay type binding and less graphite as the numbers increase from H to 9H. The soft and black B pencils have less of the clay type binding and more graphite as the numbers increase from B to 9B. Every individual pencil has its own a tonal range from light to dark depending on the pressure placed on the point of the pencil as it moves across the paper. For initial drawings and sketches use an HB pencil.

The F pencil, so named to indicate it can be sharpened to a fine point, is useful for botanical studies as it is able to produce a good range of tonal marks from light to dark. Sometimes it is called a shorthand pencil because it was used for dictation.

MECHANICAL PENCILS

Clutch pencils are mechanical pencils with plastic casings and metal jaws to grip the lead at the desired length. They are usually sold fitted with an HB lead, but other pencil grades are available. These were known as magic pencils when they first appeared in my classes because they can be trimmed to a fine point using specially designed pencil sharpeners. The lead can be retracted within the casing at the end of the day for safe keeping.

Another range of mechanical pencils is available known as propelling pencils or pump pencils; these have very fine leads from 0.3mm upwards. These are useful for drawing fine light lines. They do not need sharpening, but if the tip of the lead is scratchy rub it gently on a piece of spare paper. A range of grades is available, but an HB is satisfactory for any fine outline drawing.

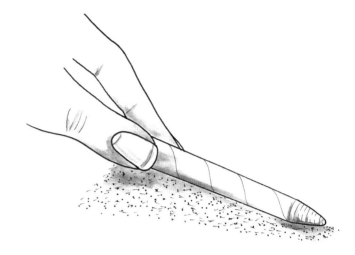

To reinstate the point of a paper tortillion or stump rub on very fine sandpaper.

PENCIL SHARPENERS

The traditional way to sharpen a pencil is to use a craft knife. The wood is whittled away with the knife at an angle of about 45 degrees to the lead point. The process is continued until the lead is exposed to the length required, usually 0.5–1cm (3/$_{16}$–3/$_8$in). The knife is then turned at right angles to the tip of the exposed lead and the end trimmed to a fine point. Sometimes the point will require further refining by gently rubbing it on fine sandpaper. All these procedures should take place away from the drawing paper to avoid it being spoilt by debris and fine graphite dust.

A hand-held pencil sharpener can be used to sharpen a pencil, but the blade becomes blunt quite quickly and graphite wastage can be high. Purchase spare blades where appropriate to replace those which have become worn out with use. Two-holed pencil sharpeners, with one opening to shave the wood and the other to trim the point, are useful if you require a long and sharp point to your pencil. Pencils that continually break as you sharpen them could be the result of having dropped the pencil causing the lead to break inside the casing. Sometimes a lead will break because it is not aligned properly inside the casing. Sharpening with a craft knife is the only remedy for this problem. Mechanical and battery-operated pencil sharpeners can be used to sharpen wooden cased pencils.

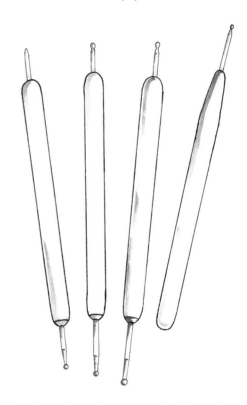

A blunt indenting tool can be used with pencil or coloured pencil. It can be particularly effective in creating hairs on a stem.

Erasers

Before the modern eraser, people used fresh bread to erase unwanted marks on artwork; the soft inside of the bread was rolled up into the required shape to remove the offending mark. Natural rubber began to replace bread during the eighteenth century. Most erasers are now made from plastic.

An eraser is more than a corrective tool. A plastic eraser can be cut to a sharp edge and used to pick out structures such as veins. A putty or kneadable eraser can be used with a dabbing action to lighten a shaded area, and small pieces can be moulded with the fingers to form points to take out tiny details.

Small pieces of putty erasers seem attracted to carpets, and if trodden into the surface they can be very difficult to remove. Try placing an ice cube on the top of the offending material and

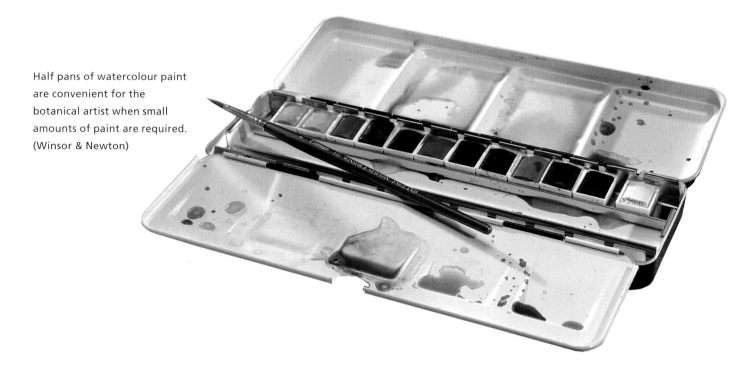

Half pans of watercolour paint are convenient for the botanical artist when small amounts of paint are required. (Winsor & Newton)

when it has hardened chip it away from the carpet with a rounded butter knife.

Battery-operated erasers are effective for removing unwanted smudges or to create highlights; the eraser moves lightly over the paper and there is little surface disturbance.

To make sure your eraser is clean; rub it on a clean piece of scrap paper before applying it to your drawing. Any debris from your erasing should be removed by lightly dusting with a clean feather or soft brush. Sweeping your hand across the paper could cause smudging and the transfer of grease from your hand to the paper.

Stumps and Tortillions

Paper stumps and tortillions are used for pushing areas of graphite to extend the tonal range. Stumps can be cleaned by rubbing the point on rough paper and removing any loose debris. To reinstate the point of the stump rub the tip on fine sandpaper using a rolling action.

Indenting Tools

A pointed tool with a blunted end is the ideal instrument to indent the paper. Embossers used for parchment work, small knitting needles, bodkins or blunt darning needles are all suitable for making marks in the paper. A sharp instrument will cut the paper. This technique can be used to establish veins on leaves and create hairs

on stems, but care has to be taken as the indentation cannot be removed easily if the mark is in the wrong place.

Ruler

A ruler should be used to draw a margin on your paper to enclose the image and create a border. An ideal width is 2–3cm (1–1^{1}/$_{2}$in). Information about the plant can be written in the margin, and it is a useful testing space for colours.

Materials for Painting
Paper

Botanical paintings are usually executed in watercolour. Paper for finished paintings should be of archival standard and acid free. There are three surfaces of watercolour paper: hot pressed (HP), NOT or cold pressed (CP) and rough. Papers are in weights from 190g/m^2 (90lb) to 638g/m^2 (300lb). The imperial weights of the paper refer to the weight per ream.

Without sizing, paper would act like blotting paper and simply soak up the watercolours. All watercolour papers are internally sized at the pulp stage; some papers are also externally sized with gelatine and this helps to make the paper surface stronger.

A selection of sable brushes suitable for botanical painting. (Winsor & Newton)

HOT PRESSED PAPER

This is the most popular paper for detailed work and is ideal for botanical illustration.

COLD PRESSED OR NOT (NOT HOT PRESSED) PAPERS

This paper has a slight texture and is used by botanical artists; the paint can be moved around and lifted from the surface more easily than on the smooth, hot pressed papers.

ROUGH SURFACED PAPER

This paper is not suitable for detailed botanical work as it is too deeply textured to show the fine details of botanical structures.

WHICH IS THE WORKING SIDE OF THE PAPER?

Most watercolour papers are highly finished so that both sides can be used. Paper which is mould-made has a felt side and a mould side. During manufacture the mould side touches the wire mesh of a cylinder which is known as a mould, while the felt side touches the woollen felts. The felt side is generally considered to be superior and is the working side of the paper. Slight markings of the wire mesh may be seen on the mould side. The correct side can be identified by the watermark which can be read on the felt side.

When a watermark cannot be found cut a strip from the edge of the paper, turn it over and place it next to the larger sheet of paper so the two pieces are touching. Paint across both pieces; if there is a discernable difference use the side which you consider superior. When watercolour paper is sold the felt side is usually uppermost.

PAPER GUM STRIP

Brown paper gummed strip is used for stretching paper. The lighter weights of paper, particularly $190g/m^2$ (90lb) will require stretching so that they will not buckle with the application of watercolour washes. Gummed paper strips are used to hold the paper in place whilst this process is taking place. Masking tape is not suitable for this procedure.

Watercolour Paints

Watercolour paints are manufactured from coloured pigments and gum arabic which helps the pigment to adhere to the surface of the paper. The colours are diluted with water and applied to the paper with a brush. Most watercolour paints can be purchased in either a tube or a pan. Half pans are more convenient for the botanical artist as the colours are immediately available without the bother of squeezing paint out of a tube. Often only small amounts of paint are required at a time. A number of colours can be fitted into a small watercolour box, which makes them easier for transporting.

The disadvantage of pans is that they can attract dust. Colours become contaminated with other colours in the box if the artist picks up paint without washing the brush first. Tube

A porcelain mixing palette with sloping depressions. (Winsor & Newton)

paints are useful for areas where large washes of strong colour are required.

There is a wide range of artists' watercolours; they contain concentrated pigments and give greater transparency. Well-known manufacturers often produce a cheaper range of colours as an alternative to the more expensive artists' colours; the pigments are not so concentrated, and for botanical work artists' colours are recommended.

GOUACHE
White gouache is opaque watercolour and can be used for painting details such as spines or hairs.

MATERIALS FOR ERASING WATERCOLOUR MARKS
Light rubbing with very fine sandpaper may remove some unwanted dry watercolour marks; the paper surface will be raised in the process and can be smoothed with the back of a fingernail. Some staining pigments may be difficult to remove.

A soft sponge known as a Magic Eraser Block will remove some unwanted watercolour marks; it is manufactured by Lakeland for cleaning enamel. The sponge needs to be dampened before using on paper. Test a small patch before attempting to erase paint marks on an illustration.

Brushes

Brushes made from natural hairs are highly regarded because scales along natural hairs trap and hold the paint in the belly of the brush; the paint is released when the brush is pressed onto the watercolour paper. Brushes made from hairs from members of the weasel family are known as red sable. The finest hairs for brushes come from the tail of the male kolinsky, found in cold areas of China and Siberia. These hairs are long and strong and taper to a fine point.

Sable brushes are made by hand by skilled brush makers. The hairs are dressed and sorted and eventually fed into a metal ferrule to which a wooden handle is attached and held securely in place by a process known as crimping.

It is important to remember that the hairs taper naturally and are not cut to shape. It is the skill of the brush maker to create the tapered point. Attempting to regain the shape of a worn-out brush by cutting with scissors will not be successful as the naturally tapered point will have worn away.

Sable brushes are expensive but well worth the investment; they hold more moisture and one brushload can cover a good area of the paper in one application. This prevents telltale marks on the paper when the brush is dipped back into the paint mix during the application of a wash. Brushes are available in a range of sizes; always use a suitable size to match the area to be painted. For fine detail and dry brushwork try brushes manufactured for miniature work; the hairs are usually shorter in length and wider in body, and they hold a good amount of paint. Brushes for miniature work are available in sizes 0 to 9.

Synthetic brushes are less expensive, and they are easier to clean because paint cannot become trapped in the scales of the hairs. They can vary in quality depending on the materials used in their manufacture.

Synthetic hairs mixed with natural hairs combine the absorbency of the natural hair with the spring of the synthetic hairs.

Use a cheaper or old brush for mixing the colours because the tip of the brush is worn down in the process of removing paint

from the pan. Mixing colours together also spoils the tip of the brush.

Brushes should be carefully washed with mild soap by rubbing the hairs gently with the fingers to remove the remains of any pigment. They should be rinsed in clear water, wiped on a cloth to regain their original shape, and placed upright with hairs uppermost in a jar until dry. When travelling store your brushes in a fabric roll rather than in a tube type container where bushes can roll about. Damage can occur to the tip of the brushes when they are stored loosely.

Do not leave your brush in the water jar as this could cause damage to the tip of the brush resulting in a curl or hook. To restore the point of a brush with a hooked tip hold it in the steam of a kettle and turn it around slowly for a few seconds, taking care not to touch the metal ferrule until it has cooled. This remedy is not suitable for brushes made from natural hair such as sable brushes.

Brushes suitable for botanical work are round tipped. A selection of sizes is available; the smallest is 0000, which has few hairs, and the range continues to a size 8 and beyond. One or two small brushes for fine detail will be useful as well as a 3 and a 6.

Mixing Palette

An artist's white porcelain palette with depressions is suitable for mixing watercolour paints. A palette with sloping depressions is ideal for the application of dry brushwork where only a small amount of almost dry pigment is required. A white tin camping plate or ordinary large white china plate can also be used. I find the cheaper plastic palettes frustrating as the paint separates into blobs rather than puddles, which makes colour mixing very difficult.

Water Containers

Two large squat water containers will be required, one to wash the painting brush and the other to pick up clean water for mixing the watercolour paints. Ideally the water jars should be made of glass so that the state of the water can be seen easily. Water should be changed frequently; otherwise dirty water will be transferred to the mixing palette and muddy colours will result. Use large water jars so that the water will not need changing so

regularly. Distilled water should be used for mixing colours; alternatively use boiled water.

Watercolour Media

There are various media that can be used with watercolours.

GUM ARABIC
Gum arabic can be added to the watercolour wash to give increased transparency; it gives the paint an added shine or brightness when dry. Under very dry conditions, the surface of the paint could crack if too much gum arabic is used.

OXGALL
A few drops of oxgall can help the flow of the first water colour washes on hard sized papers.

Masking Fluid

Masking fluid or liquid frisket is usually cream or blue/grey in colour. It can be used to mask out areas of paper which the artist would like to remain white. It has the consistency of rubber cement and can be peeled away from the paper once it is dry. It is used in botanical art where fine detail needs to be retained such as for the stamens in the centres of flowers.

Once the fluid is dry, watercolour washes can be placed over the top. When the washes are dry the masking fluid can be removed by rubbing with a clean finger or eraser. Old brushes with a thin coating of liquid soap can be used to apply the masking fluid to the paper. Dip pens and ruling pens of the type used by draftsmen are equally successful. The nib of the ruling pen holds a lot of masking fluid, and the thickness of the line can be controlled by adjusting a small screw on the side of the pen. The masking fluid is rubbery when it is dry and it can be pulled from the pen nib.

Do not be tempted to use your best brushes, as the masking fluid could stick to the hairs and the brush will be ruined. Masking fluid is not successful on damp paper or paper which is not gelatine surface sized. Do not leave the masking fluid on the paper for a long period of time; it should be removed as soon as the painted area is dry.

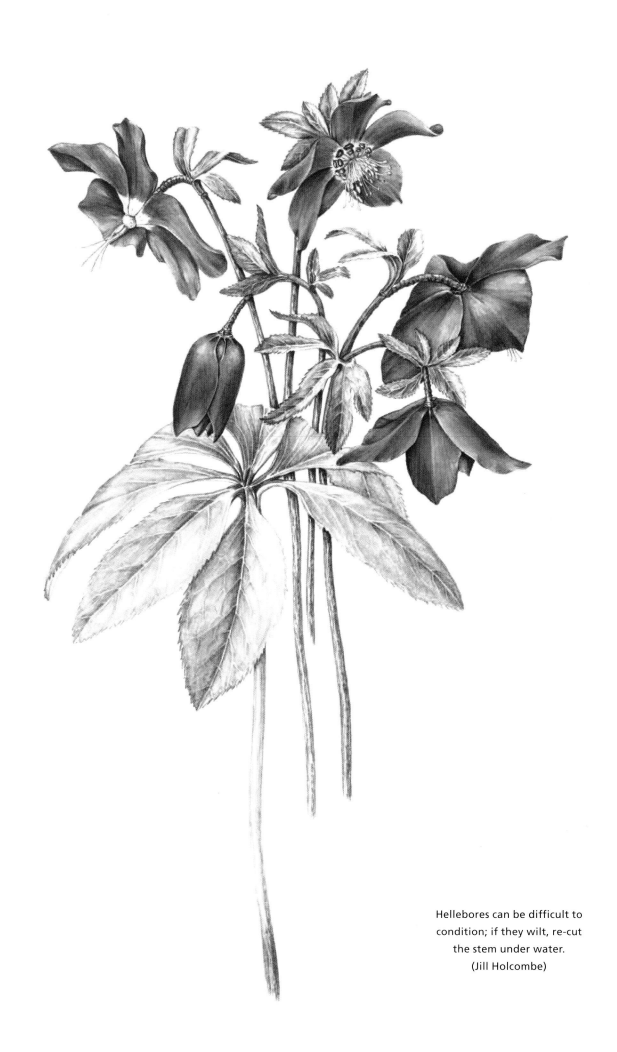

Hellebores can be difficult to
condition; if they wilt, re-cut
the stem under water.
(Jill Holcombe)

PREPARATION OF PLANT MATERIAL

Before you collect a plant make sure that the specimen is typical of its species. Time will be wasted if you start to draw a damaged, deformed or mutant plant. A good field guide or guide to garden plants can be used to check the textbook features against those of your own subject.

Collection of Plants

Choose your plant material carefully; only collect healthy robust specimens for drawing. Cut the flowers just before they are fully open and look to see whether there are other flowers coming into bud, in case your first flower has to be replaced. Select plants that will last in water for a few days, because once they have been removed from their natural habitat some plants and flowers will begin to wilt and droop very quickly.

Ideally collect plants and flowers in the late afternoon or early evening when the sugar content is at its highest. This will allow plenty of time for the plant to take up water, and become conditioned to its new surroundings, in time for a drawing to commence the next morning. Alternatively plants and flowers can be cut early in the morning when they are full of water. Collection around mid-day in summer months should be avoided, as this is the most stressful time for plants and flowers since they will have lost moisture in the heat of the sun. Flowers will start to open up as soon as they are brought into a warm room, so place them somewhere cool and dark until you are ready to start. Whenever possible take a bucket of lukewarm water into the garden so that plant material can be placed into it as each stem is cut.

Transporting Plant Material

Look after your plant specimens and transport them carefully. A man attending one of my classes called at a service station to buy some flowers to draw. He selected a bunch of tulips and pushed them into the saddlebag on the back of his motorbike before continuing his journey. To his dismay, when he arrived at the class all that remained of his bouquet was a fine collection of stalks.

Plants can be transported by placing them inside a blown-up plastic bag. The bag should contain a sprinkling of water, and tied at the open end. Plants and flowers may be transported in this way between your home and art class or painting group. The plastic bag serves the same purpose as the traditional botanist's vasculum, which is a metal collecting box. When used in the field this was lined with wet paper to protect plant material from wilting.

Firm plastic containers are suitable for transporting plant material and for keeping delicate flowers fresh. Lay the flowers on wet tissue in the bottom of the box and place a dry piece of absorbent tissue over the top of them to catch any condensation. Replace the lid and store the box in a cool place, preferably a refrigerator, until required. Needless to say plants and flowers will not stay fresh indefinitely.

Conditioning of Plant Material for Drawing

It is important to condition your plant to extend its remaining life for as long as possible after it has been collected. Problems occur when air locks form in a stem just behind the cut area causing the flower to wilt. To prevent an air lock forming place the stem in a wide topped jar and re-cut the stem of the plant under water. This remedy is usually successful although sometimes tricky to perform.

Without proper conditioning your plant may wilt and die shortly after commencing your work. When this happens you will be forced to abort the drawing and arrange for another specimen to be collected. I have been known to rescue a student's discarded plant from the waste bin and revive it so that

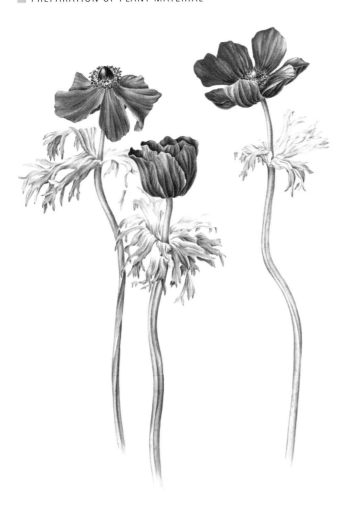

Anemones do not like to be out of water for any period of time. Check water levels regularly so that they do not dry out. (Judith Pumphrey)

Hellebores

Hellebores are notoriously difficult to keep upright. To condition the plants prick the stem all the way up to the top, stopping just behind the flower head, and place the plant in a milk bottle full of water. Alternatively try gently slitting the stem casing from top to bottom; the slit should pierce only the first outside layer of the stem. Then follow the same procedure to condition using a milk bottle. Re-cutting the stem underwater is also successful.

Lupins, Dahlias, Hollyhocks, Delphiniums

Flowers with hollow stems such as lupins, dahlias, hollyhocks and delphiniums can be upturned and their stems filled with water. Tap the upturned stem first to release any air bubbles and pour in the water using a watering can with a fine spout. The end of the stem can be plugged with cotton wool. To ensure that no air bubbles are trapped, pierce the stem with a pin just below the flower head. Collect dahlias when they are half or fully open, as the buds will not develop into flowers once they are cut.

Oriental Poppies and Species of Euphorbia

Flowers such as the oriental poppy (*Papaver orientale*) and species of euphorbia exude a milky sap when the stem is cut. The sap can be a skin irritant and it is advisable to wear protective gloves when handling this type of plant material. To seal the cut stem the end of the stem can be seared with a flame, placed in boiling water for a few seconds or plunged into ice-cold water; this will prevent further seepage of the sap. The plant is able to survive for a limited period using the moisture trapped within the stem.

Gladioli

Gladioli should be secured in an upright position once they are picked. Flowers bought from a florist should be examined carefully to see if the stems are straight. The tip of the flowering spike will turn upright if gladioli have been allowed to fall at an angle in a bucket or vase; this will result in an unnatural bend.

Roses

The best time to collect roses for drawing is when the petals are just beginning to open. The end of the stem should be placed in very hot water for about fifteen minutes; this will avoid an air lock and enable the stem to take up water. Protect the flower

an abandoned drawing can be continued. However, this situation is avoided if a few minutes are spent to ensure the plant material is correctly prepared in advance.

Early spring tree foliage is very difficult to condition and can wilt remarkably quickly after cutting. Cut the stems at a sharp angle and immerse the plant completely in warm water for about half an hour, allowing the leaves to absorb water through their surface tissue. If the foliage is dusty, it can be refreshed by gently swishing it in warm water with a drop of detergent and rinsing it in clean water. After conditioning the stems should be placed in deep water in a cool room, and left overnight if possible. This immersion procedure is particularly suitable for holly (*Ilex aquifolium*) and ivy (*Hedera helix*). Leaves that are grey, woolly, hairy or velvety are not suitable for this treatment, as water becomes trapped by the fine hairs, and grey plants lose their colour. Floating individual dried leaves in warm water can help revive them sufficiently to continue a drawing, but collecting a few fresh leaves is often a better solution.

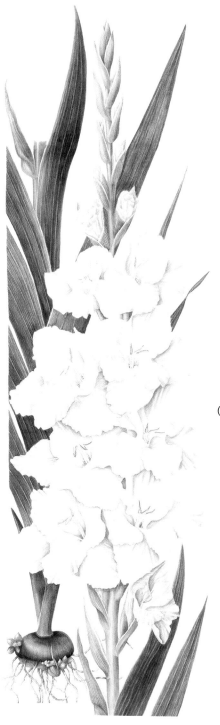

The tip of the flowering spike of gladioli should be straight. *Gladiolus* 'Ivory Tower'. (Isobel Bartholomew)

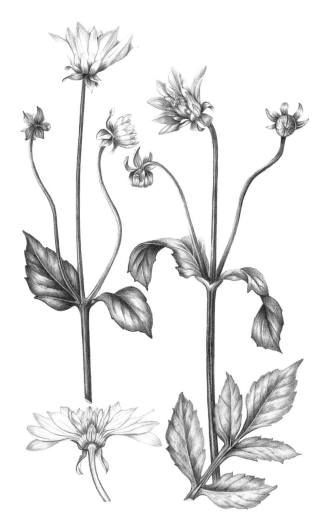

Ensure you have enough material to replace any spent flowers with fresh ones as you progress. Only the half-open flowers of dahlias will open fully when placed in a warm room; tight buds will not develop. (Valerie Oxley)

Lilies

Many florists remove the anthers from the stamens of lilies as soon as they open. This is to prevent the staining pollen from being shed onto clothes, carpets and furniture. Botanical artists prefer flowers with stamens intact and are generally prepared to take the risk of brushing against the flower. Should pollen fall onto clothing place a piece of sticky tape over it, press gently then lift the tape away from the garment. This procedure may need to be repeated several times but is usually successful. Pollen rubbed into a garment may result in a permanent stain.

Bulbous Plants

Flowering stems from bulbous plants should be cut and not pulled. Daffodils bought from a florist may have been pulled

head from the steam by placing newspaper around it. Roses collected in tight bud may not open. Floppy and faded petals may deteriorate fairly quickly and fall from the flower. A wilted rose can be revived by re-cutting the stem and placing it in a vase full of water for at least thirty minutes. The water should cover the stem and leaves but not the flower itself. Roses that are wilted at the neck and bend over at a sharp angle may be more difficult, or even impossible, to revive.

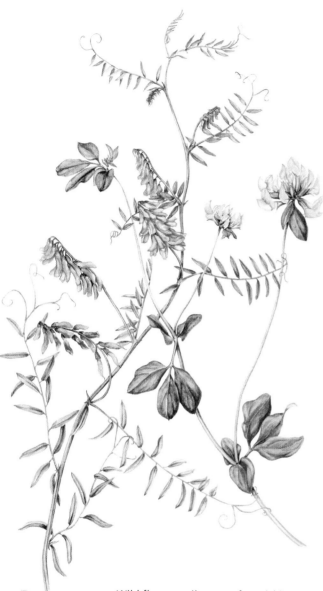

Wild flowers wilt soon after picking.
Only collect what you need and observe the
country code. The intertwining relationship
of the tufted vetch and bird's foot trefoil
has been observed and recorded as they
grow together in the countryside.
(Judith Pumphrey)

Carnations and Pinks

These plants should be cut between the leaf joints or nodes; if a cut is made at a node the plant will be not be able to take up water.

Tulips and Crocuses

Tulips continue to grow after being cut; they turn towards the light and open fully in a warm room. Crocuses will also open fully as soon as they are taken indoors; the petals will turn right back, sometimes quite severely. To prevent these flowers from opening too much, tie cotton thread carefully around the flower heads as soon as they are brought indoors.

Thistles, Mallows, Chrysanthemums

Woody stems may need to have a little more help to take up water. Try slitting the stem from the bottom upwards for about two centimetres, or scrape away the lower 2cm ($^3/_4$in) of bark from thick woody stems before placing them in warm water.

Water Lilies

Melted wax dropped carefully between the petals can stop the flower from closing.

Wild Flowers

Obtain permission from the landowner if you wish to collect wild flowers or draw them in the field. Picking wild flowers could be theft if permission is not sought beforehand from the owner of the land.

Only collect what you need for your illustration, because wild flowers will wilt soon after picking. Use reference material wherever possible such as field notes, sketches and photographs.

Picking flowers interrupts the reproductive cycle and prevents the plant from setting seed. Plants should not be picked from a nature reserve or a site of special scientific interest (SSSI). Every country has its own laws and guidelines for the protection of its wild plants. In the United Kingdom the Wildlife and Countryside Act, 1981 protects our native flora. It is advisable to check the current status of the Act as there have been amendments and changes to lists of protected plants over the years since the Act came into force. It is illegal to pick, dig up or destroy any wild plant that is protected. The legislation also includes the uprooting of wild plants that are not listed without the permission of

from the ground when they were collected by the grower; if this has happened there will be a white area at the base of the stem. Re-cut the stem to remove the white part; water will only be taken up from the green area. It is worth noting that daffodils exude a poisonous sap which can affect other flowers if placed in the same water. A tip from a grower in Spalding, Lincolnshire is to place flowers for drawing in a plant pot filled with damp sand. Simply push an old pencil or biro into the sand to make a hole and place the stem in it.

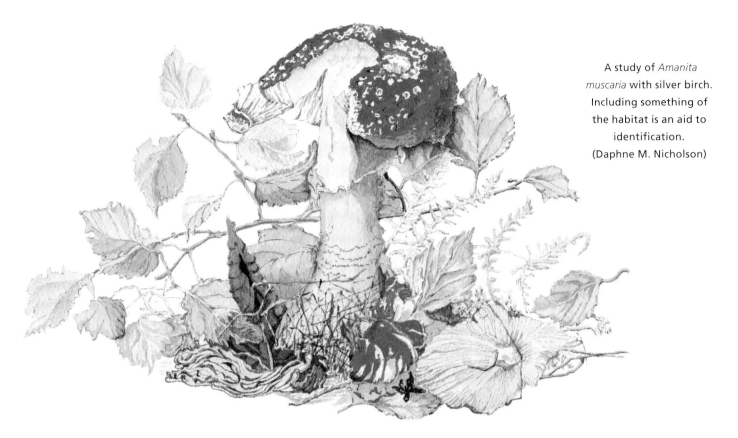

A study of *Amanita muscaria* with silver birch. Including something of the habitat is an aid to identification. (Daphne M. Nicholson)

the owner or occupier of the land. Collecting small pieces of plant material for botanical purposes is usually acceptable except where the plants are listed as endangered in the national Red Data Books or on County Rare Plant Registers. Collect only where plants are plentiful and leave those you cannot identify or that appear unusual.

Keeping Plants Fresh as You Draw

Spraying a fine mist of water will help keep plants fresh, but avoid spraying the flowers, particularly pansies and sweet peas, as the petals may deteriorate and show signs of brown spotting.

Cut flower preservatives, supplied by florists, can be used to prolong the life of plant material. Alternatively the addition of a teaspoon of sugar to the water in the jar or vase may help. Flowers often benefit from filling their container with one part tonic water to two parts water.

Preparation for Drawing: Reminders

1. Ensure you have permission to collect the plant material you require.
2. Collect plant material in the late afternoon, early evening or morning.

3. Using a sharp knife or sharp secateurs to cut the stems of plants.
4. Cut flowers when they are just beginning to open; the warmth of the studio will open them fully.
5. Have a bucket of water with you and place the flowers in it as you cut.
6. Spring flowers, such as bulbous plants, do not open so quickly if placed in cold water.
7. Condition your plant material to prevent wilt.
8. Allow your plant to settle and take up water before starting to draw.

Fungi

Use a basket to collect fungi from the wild. Place bracken fronds between the layers to protect the specimens. Alternatively, paper or greaseproof paper bags can be used. Fungi will sweat in plastic bags. When you return home put the specimens in a rigid plastic container. Put dampened tissue in the bottom of the container, not too wet, and place in a refrigerator or somewhere cool until required for drawing. Fungi will only last a few days depending on the condition and age of the specimen when it was found. Do not collect very mature specimens as they will deteriorate quickly and may even have a maggot infestation.

Always seek the landowner's permission and follow the

country code before collecting fungi to illustrate. Some species will be protected and appear in the national Red Data book or on local registers. Only pick what you need to complete your illustration.

Understanding Your Plant

Plants can move to a limited extent even when cut. They are affected by their environment, light, heat and the time of day. Goatsbeard or Jack-go-to-bed-at-noon (*Tragopogon pratensis*) closes at mid-day; evening primroses (*Oenothera biennis*) start to open up mid-afternoon; the Nottingham catchfly (*Silene nutans*) opens at dusk.

The flowers of the yellow iris (*Iris pseudacorus*) and the yellow day lily (*Hemerocallis lilioasphodelus*) will last only a day, the former starting to curl up neatly during the afternoon until it forms a tight ball. This process can be disconcerting if you start your drawing at lunchtime. There are usually other flowers on the same plant ready to open the next day but too late to continue the drawing of the first.

Sometimes a whole mass of flowers on one plant will shed their petals only to be replaced by a fresh collection of flowers the next day. I have watched cistus doing this in my garden, the petals starting to fall like confetti in the late afternoon on a summer's day. Every day the previous day's flowers are replaced, and this process seems to be repeated day after day for quite some time. These unexpected problems can be avoided if you take the trouble to find out the name of the plant you are about to draw, and something of its habit.

Fruits can be unexpectedly explosive as they dry. One winter I collected a twig of box (*Buxus sempervirens*) to draw. I was particularly attracted to the shape and formation of the fruits. The twig was placed in a jar of water in preparation for drawing the next day. After a little while I heard a 'ping' followed by another 'ping' and another and another. On investigation I discovered the fruits had opened up in the warm atmosphere and the small seeds were shooting out, quite some distance, around the room.

The explosive fruits of bear's breeches (*Acanthus spinosus*) can be particularly alarming. The large seeds, which are like bullets, can shoot a long way from the pods if the plant is allowed to dry in a warm room after collection.

The airborne seeds of the cardoon (*Cynara cardunculus*) and bulrush (*Typha latifolia*) are not so explosive, but they can burst and spread seeds all over your studio. To help prevent this happening spray the whole seed head with a firm-hold hair spray to keep the seeds intact.

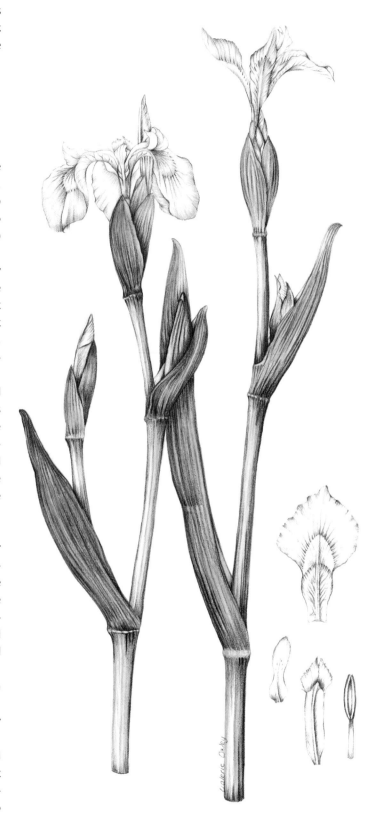

The flowers of the yellow iris *Iris pseudacorus* start to curl up as the day progresses so drawings have to be carefully planned. (Valerie Oxley)

Holding Plant Material in Place for Drawing

There are numerous ways to hold plants in position for drawing. The main consideration is to make sure the plant is secure and will not fall or topple over, and that it has enough moisture to avoid wilting. Care must be taken not to pinch the stem too tightly when setting up the plant as this will restrict the water flow. Remember that plants need moisture to survive and stems must to be able to transport water throughout the living material.

Jam Jar and Masking Tape

Plants can be secured to the inside of a jar or glass vase using masking tape. The jar should contain water, but ensure that the area where the tape is to be fixed is dry.

Florist's Pin Holder

A weighted florist's pin holder placed in a dish of water will hold most stems securely. The pin holder should be fixed to the base of the dish with special florist's adhesive and water added to keep the plant fresh. Continue to check the level of water in the dish as you progress with your drawing so that the base of the stem remains covered.

Helping Hand

A gadget known as a helping hand or a jig is useful for holding woody stems over a jar of water or for grasping a piece of Velcro placed around a florist's vial. The angle of the plant and a florist's vial can be adjusted as long as the angle isn't too low, enabling the water to dribble out.

Florist's Foam

Absorbent green floral foam is excellent for anchoring many plants. Large brick-like blocks can be cut into smaller pieces if required. The piece of foam should be soaked in water for about fifteen minutes. The soaked foam can be attached to a dish using florist's tape wound completely around the foam and the dish. Alternatively weighted pin holders, with a few long pins, can be used to secure the foam.

 Flower stems can be inserted directly into the soaked foam. The foam can be stored in a sealed plastic bag for further use, but eventually it will break up with the continual insertion of

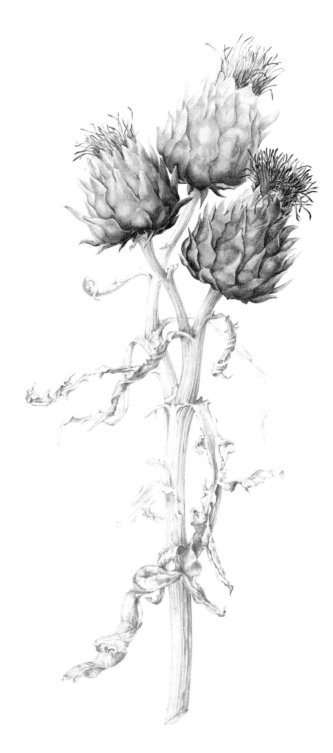

The Cardoon, *Cynara cardunculus* can shed its airborne seeds if picked at a later stage in its development. Spraying with hairspray can help avoid any potential problems.
(Judith Pumphrey)

stems and will need to be replaced. This method is not suitable for very soft stems or for some of the early spring bulbous flowers. Take care not to use brown or coarse floral foam as this has been manufactured for dried material and will not absorb water.

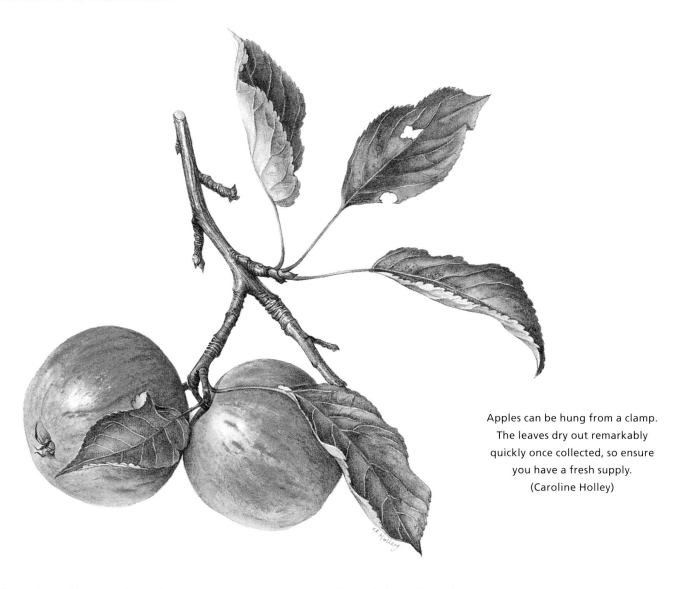

Apples can be hung from a clamp. The leaves dry out remarkably quickly once collected, so ensure you have a fresh supply.
(Caroline Holley)

Laboratory Retort Stand

Trailing or climbing plants may need some support. Laboratory retort stands can be used for climbing plants such as black bryony (*Tamus communis*) and sweet peas. They can also be used for plants that hang downwards such as clematis. Laboratory retort stands are useful where extra support is needed for tall plants such as sunflowers, bear's breeches, foxgloves and cardoons.

Clamps

Strong clamps, which are useful for holding large woody material or fruits, are manufactured by specialist firms for the craft industry. Avoid crushing or pinching stems if you are using a clamp as this could restrict the flow of water through the plant.

Revolving Stand

A homemade wooden revolving stand, or a revolving cake decorating stand, can be turned to show different aspects of the plant without disturbing the plant itself.

Shallow Dish and Damp Tissue

Very small specimens and single leaves can be placed on dampened absorbent paper tissues in a shallow dish or saucer.

Preparation of Roots

Roots should be carefully removed from the ground so that as little damage as possible occurs to the root tips. The soil can be removed from the roots by gently washing them under a run-

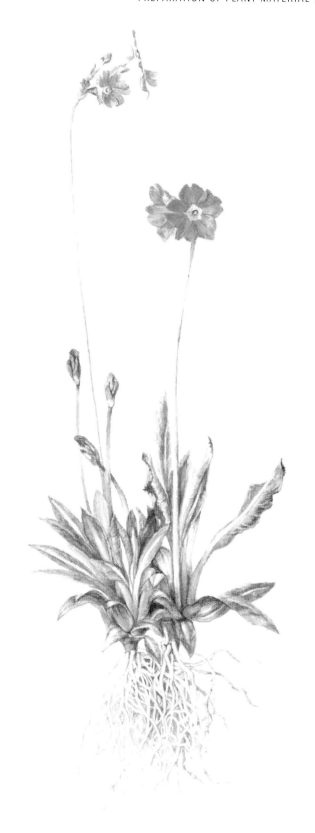

RIGHT: *Primula rosea*; the spaces between the white roots have been shaded to help show the root structure. (Sheila M. Stancill)

ning tap. Most plants can tolerate being out of the ground for a short time, but plants with fibrous roots are particularly difficult to display for drawing as they fall into a close bunch after rinsing in water. A convenient way to solve this problem is to make a card collar with a hole in the middle so the plant can be wedged in the top of the jar and the roots spread out in the water. Drawing is done through the glass of the jar; there will be some distortion, but it is not an impossible task.

A retort stand with a clamp can be used where roots are quite strong and hold their shape. Take care not to handle broken roots because some plants such as monkshood (*Aconitum napellus*) have poisonous roots. It should be noted that as roots dry some slight shrinkage may take place.

Check the diagnostic features to ensure all the parts of the root have been removed from the ground if the root is an important part of the illustration. Sometimes immature roots do not show the expected characteristics because they have not had time to develop.

Positioning Your Plant

Flowers will naturally turn towards the light. Patience will be rewarded if you allow your plants time to adjust and settle into position before commencing a drawing.

Anglepoise lamps should be positioned some distance from the plant as the heat from the lamp could cause the plant to become dry and stressed.

Care of Your Plant Between 'Sittings'

Between 'sittings' it is advisable to move your plant material to a cool place. Unless the specimen is too large, plant material can be placed in a blown-up plastic bag with a little moisture and stored in a refrigerator overnight. Re-cut the stem if the plant shows signs of wilt or stress the next day.

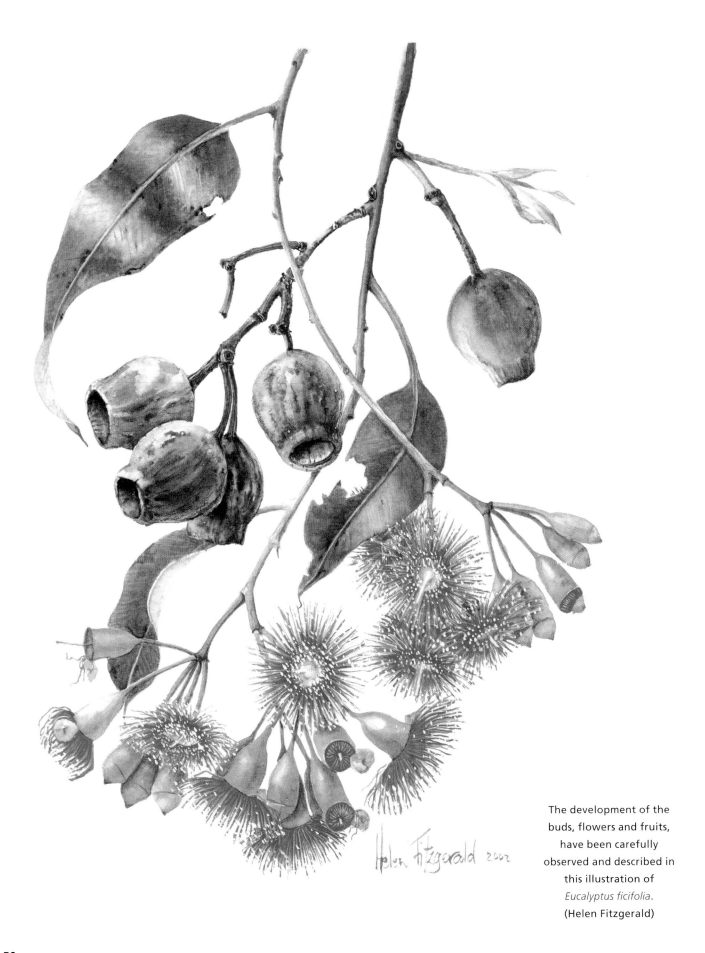

The development of the buds, flowers and fruits, have been carefully observed and described in this illustration of *Eucalyptus ficifolia*. (Helen Fitzgerald)

OBSERVATION TECHNIQUES

Identification

Look before you draw. One of the most important aspects of botanical drawing is the observation and identification of the specimen you have chosen to illustrate. Confirm the identity of your plant by using a guidebook for flowers. Check the textbook features against the actual specimen to ensure the plant is typical of its type.

It would be a useful exercise to make a note of your own observations first before checking with a guidebook. This will help you to look carefully at features on the specimen and will build up knowledge of the plant for the future.

Flowers from a Florist

Flowers bought from a florist may not display the typical textbook features. There could be too many petals or the reproductive parts may be deformed. This is often the result of pressure on growers to provide even larger, sometimes doubled, and bizarre flowers to satisfy market demands. On one occasion I asked class members to bring tulips for a session on plant dissection and identification. I asked the students to observe their own specimens, whilst I talked through the characteristics of the group, the monocotyledons. Expecting that we all had typical specimens, I confidently pointed out that the flowering parts in a tulip are based on the number three. I stated that they would find their flowers were made up of six petals, the perianth segments. They would find three inner perianth segments and three outer perianth segments. Uproar greeted this statement as some flowers had five perianth segments and some had seven, even some of the stigmas had four parts instead of three. It was a salutary lesson, for me as well as for the class; drawings from these flowers would have conveyed incorrect information. Ever since this memorable class, I have provided flowers that I have checked beforehand for the sessions on dissection. The plant growers, in the search for bigger and better flowers, are often forced to mutate floral parts, sometimes using stamens to create more petals. In some cases flowers lose not only their stamens but their characteristic scent and ability to reproduce, thus becoming sterile.

Habitat and Position

Plants in the wild flourish in habitats where conditions meet their requirements for healthy growth. Growing conditions for cultivated plants rely on the knowledge of the individual gardener, and not all plants end up in ideal locations. Plants of the same type may be tall and robust in one garden and small and stunted in another. Differences can be seen between the same type of plants growing in contrasting conditions, sun or shade, damp or dry, acidic or alkaline, and in rich or impoverished soils. Before embarking on a drawing it is worth making the effort to check that your plant shows typical features and has not been affected by its growing position.

Natural Growth Habit

The natural growth habit of the plant should be observed; does it grow upright, hang, trail, scramble or climb? This information could affect the layout of your drawing on the paper, for example whether the format is landscape or portrait.

Stems

The stem of your plant should be considered. Cut the base of the stem straight across to see whether it is round, triangular or square. Feel the surface to see if it is smooth, ridged, hairy or bristly. A magnifying glass will help confirm whether the stem has hairs, prickles or spines and where they are located. Where hairs are present they could lie along the veins or appear densely over the whole surface area. There are a variety of hairs,

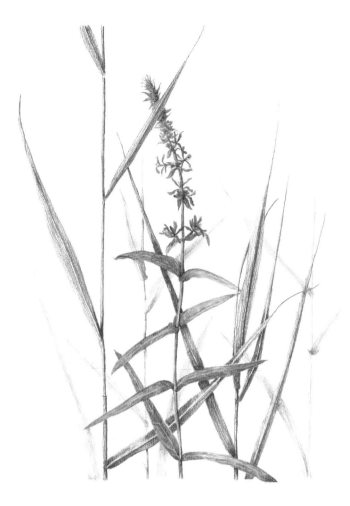

A study of purple loosestrife, *Lythrum salicaria*, growing among purple moorgrass, *Molinia caerulea*, at Woodwalton Fen, Cambridgeshire. Similar plants growing beside lakes, slow rivers and canals often show more vigorous growth.
(Helena Andersson)

including some that are star-like and some that are branched; they all give different surface effects. Sometimes stems vary in thickness along their length, wider at the base and narrowing towards the growing tip. They zigzag slightly to accommodate the emergence of a leaf or another stem. A straight stem is rarely absolutely straight.

Leaves

The position of leaves and their arrangement on the stem should be observed. Sometimes leaves are arranged in opposite pairs, alternately or whorled. The leaves can be simple or compound, tough and thick or fine and thin. Leaf margins can be smooth, serrated, lobed or wavy; there are many variations and all have a name. Leaves also vary in width; the widest part might be at the tip, in the middle or at the bottom of the leaf blade.

Sometimes there are hairs and spines on leaves; these may be located on the topside of the leaf as well as on the underside. Examine the leaf carefully to determine exactly where the hairs are situated as their position could be an important identification feature.

Some plants shed their leaves in the autumn whilst other plants retain them. Plants which retain their leaves often have a waxy tough covering which acts as a protection against the harsh weather in winter. For these plants the process of shedding leaves takes place continuously. Leaves drop when they are old or diseased and are replaced by new growth in the spring.

Veining Patterns

Leaf veins may be parallel along the leaf blade from the apex of the leaf to the base, or they may branch out from the midrib. The veins are usually prominent on the underside. Leaves on different plants have their own particular venation or veining pattern, which should be carefully observed and measurements taken for accuracy.

EXERCISES

Rubbings can be taken of leaves to show up their individual venation. To make a rubbing place tracing paper over the underside of the leaf, rub evenly over the paper with a soft pencil or wax crayon and the pattern of the veining will be revealed.

Another way to see the veining pattern is to place the leaf directly onto a photocopier with the underside of the leaf against the glass. Turn the copier to the lightest setting, and the copy will display the shape of the leaf and its veining pattern.

Flowers

Flowers vary enormously in shape, size and colour. Their position on the plant should be noted, the petals counted and the attachment of any bracts below the flower observed. The flower should be examined carefully both inside and out for characteristic markings and patterns, the presence of hairs and the position of any nectaries. The male and female reproductive parts of the flower should be carefully observed. Take a spare flower apart if necessary to check the floral parts.

Fruits and Seeds

Look for the position of the fruit on the plant. Fruits develop over a period of time, so they can vary in size, colour and texture as they grow. Most plants produce fruits, but some are dioecious

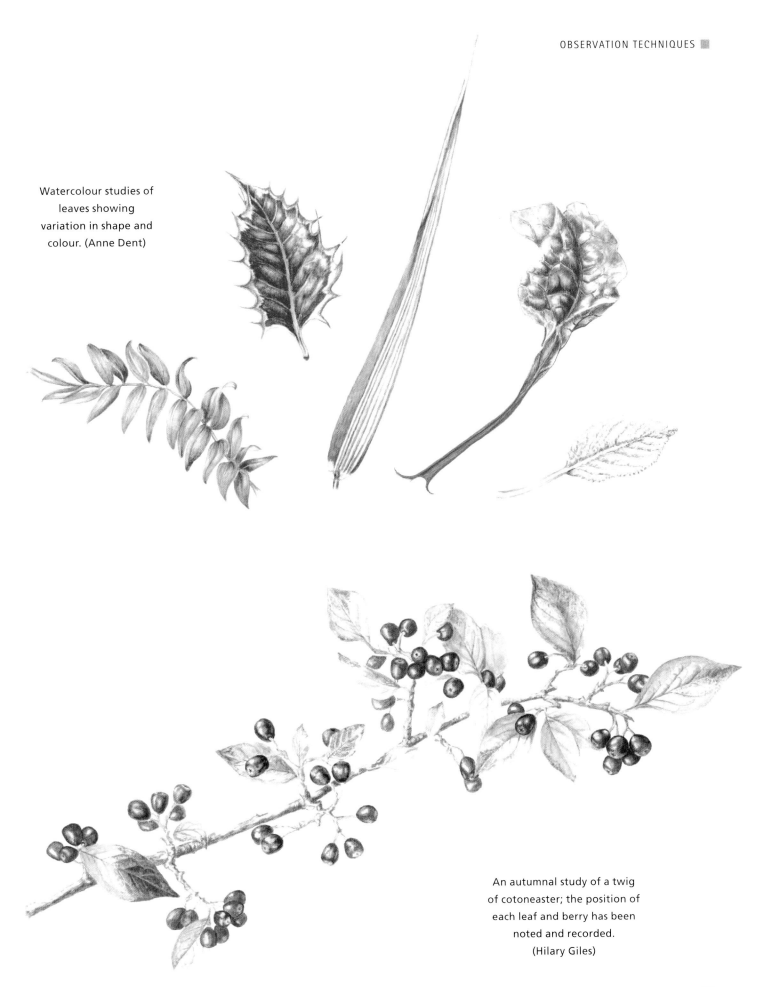

Watercolour studies of leaves showing variation in shape and colour. (Anne Dent)

An autumnal study of a twig of cotoneaster; the position of each leaf and berry has been noted and recorded.
(Hilary Giles)

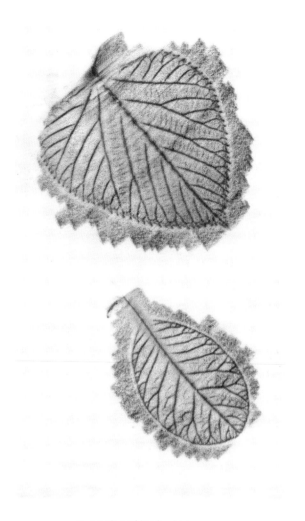

Examples of leaf rubbings.

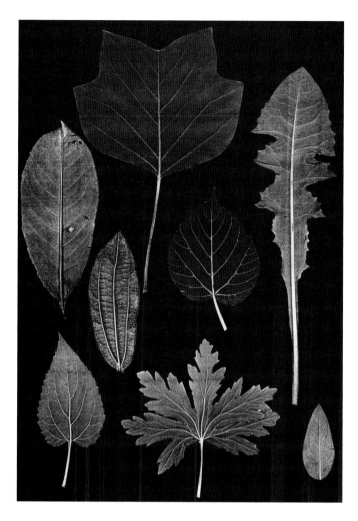

Examples of photocopied leaves.

with male and female flowers on separate plants. In dioecious plants only the female will produce fruits; the holly (*Ilex aquifolium*) and the olive (*Olea europaea*) are examples. No fruits will appear on the male plants. When you are illustrating plants from this group it is important to show examples of both types of flower and the fruit. To complete an illustration of a fruiting plant, consider the inclusion of both a transverse and a longitudinal dissection of the fruit. Seeds are usually shown in a drawing where there is a dissection of the fruit. In some cases the seeds may be shown separately.

Seedlings

Seedlings are very important if the life cycle of the plant is being recorded. A drawing of a seedling can indicate whether a plant is from the monocotyledon or a dicotyledon group. The first two leaves of a dicotyledonous plant are usually very different from subsequent leaves. Seedlings are often neglected in an illustra-

tion, but it is worth growing some seeds yourself or making notes in your sketchbook in the spring for future use. Their inclusion may be important for identification purposes.

Roots

Other parts of the plant to be considered are the roots. Occasionally it is the underground part of the plant which is a distinctive aid to its identification. For example some irises have rhizomes and others grow from bulbs, yet the flowers are similar in formation. For identification purposes the whole life cycle of the plant should be recorded.

Reminders

1. Check you have all the plant material that you require before you start drawing.
2. Observe all the plant material carefully; note the height

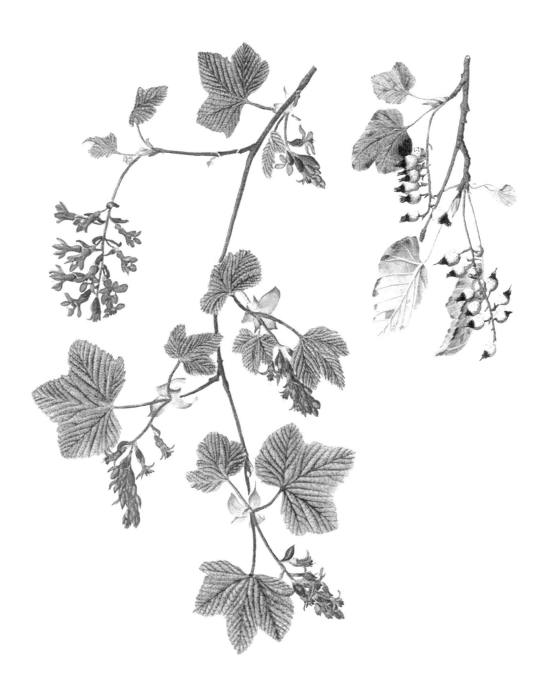

The flowering currant,
Ribes sanguineum, showing
the development of the opening
flower and the distinctive colouration
of the fruit in the autumn.
(Cyril Stocks)

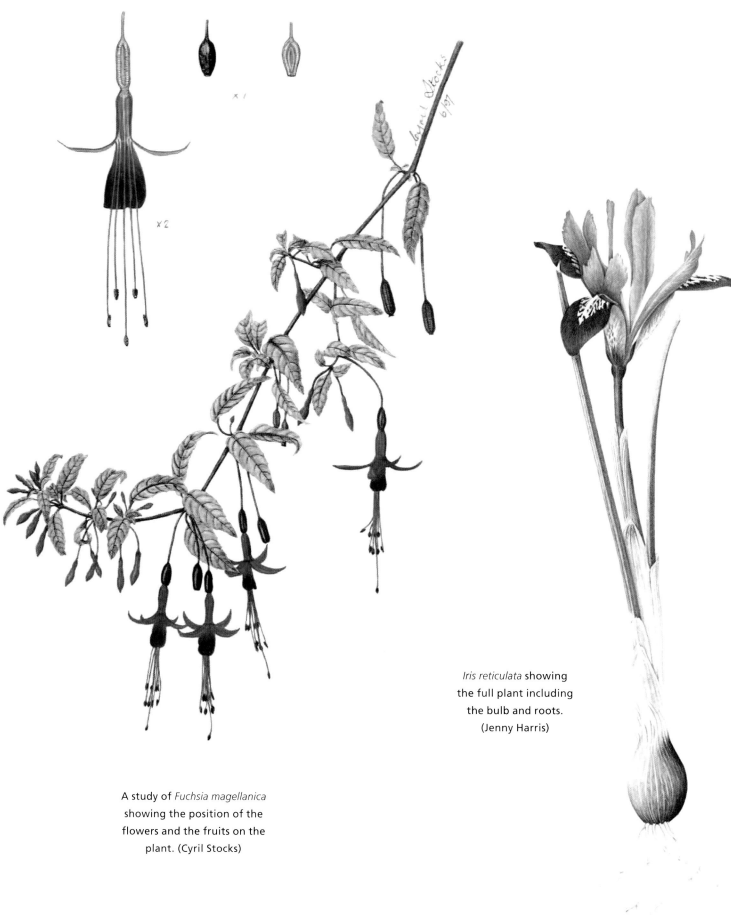

Iris reticulata showing
the full plant including
the bulb and roots.
(Jenny Harris)

A study of *Fuchsia magellanica*
showing the position of the
flowers and the fruits on the
plant. (Cyril Stocks)

of the plant and look at the position of the leaves, buds, flowers and/or fruits.

3. Look at the habit of the plant; does it grow upright scramble or climb?

4. Look closely at the flowers and buds, their position on the plant, shape, size and colour.

5. Look at the stem and feel it; check whether the stem is smooth or ridged, round or square and if there are prickles, spines or thorns present.

6. Look to see if the stem tapers towards the tip and if the shape changes where leaves and flowers emerge.

7. Look at the leaves and note their colour and shape.

8. Look at the leaf margins and note whether they are entire or serrated; carefully observe the pattern of any serrations.

9. Feel the leaf to see whether it is rough or smooth; look to see whether the underside is the same as the topside in texture and colour.

10. Check the leaf attachment to the stem; look at the arrangement of the leaves to see if they are opposite, or alternate.

11. Look at the fruits if any are present; are they mature or just beginning to develop?

12. Close your eyes and gently feel the plant; open your eyes and look at the plant again to check if there is anything you have missed.

13. Make a note of your observations and check the identity of your plant with a plant guidebook.

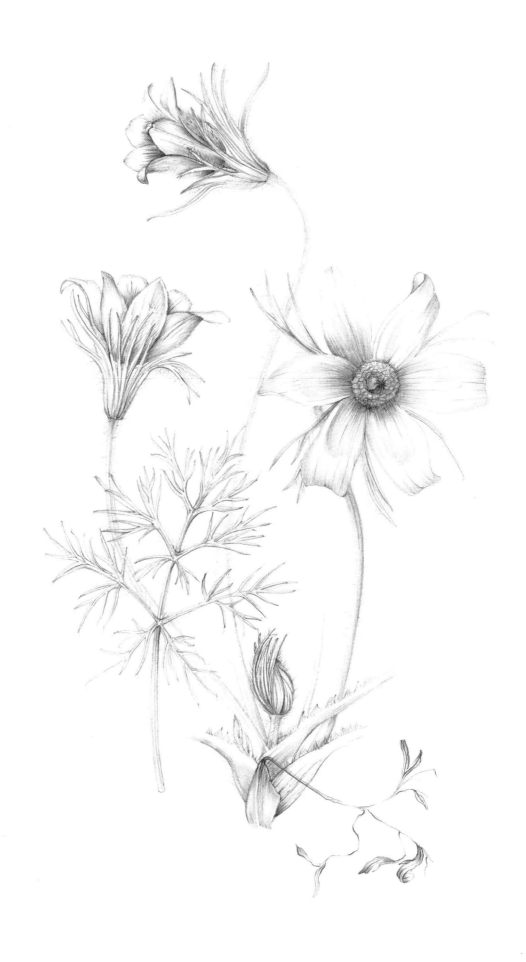

STARTING TO DRAW

Warm Up

Ten minutes spent warming up will be time well spent. Use an HB pencil to fill a sheet of A3 drawing paper with different strokes. As you draw your arm will become more relaxed and the line will become natural and flowing. Taking a pencil for a walk is a good way to practise a flowing line: place the pencil point anywhere on the paper and move it around without lifting the point. Experiment by varying the pressure on the pencil point to make light and dark marks.

Check your posture before you start drawing. Make sure you are sitting comfortably, either with the drawing board resting on your knee and against the table or by using a table easel, which in most cases helps to keep the back straight. Check the feet of the easel fit over the edge of the table if you are using a table easel; this will prevent the easel sliding away from you.

Botanical drawing requires certain skills and refinements of technique that need practising. It is essential to practise a variety of pencil strokes and experiment with different types of mark making on paper before attempting an exacting botanical illustration. Hold the pencil lightly about halfway along the shaft. Tension will be created if you hold the pencil close to the sharpened point. This could result in a heavy dark line on the paper and unwelcome consequences in the form of aches and pains in your wrist and arm as tension travels from your hand.

Preliminary Drawing Exercises

DRAWING A CONTROLLED LINE

To draw a controlled line place two pencil dots on the page, put the pencil point on one dot, look at the second dot, and draw a line to it. Look ahead of the line to the second pencil dot as you draw. Do not be tempted to follow the line with your eyes as you

A tonal study of the pasque flower, *Pulsatilla vulgaris*. (Valerie Oxley)

draw it; always look ahead to your destination or a wobbly line will emerge. Use your whole arm as you draw with the movement coming from the shoulder. Any tension in the arm or hand will be transferred to the line on the page.

The following exercises will help in your preparation to draw your plant with understanding. Collect together several pieces of drawing paper, a sharp HB pencil, a drawing board and a cutting from a plant with leaves and flowers.

QUICK PRELIMINARY SKETCHES

Look at your plant carefully noticing its particular features, such as the height, the position of the leaves and flowers and shape of the stem. After observing your plant make two or three very quick timed outline sketches of it, turning your specimen to a different position for each sketch. Each drawing should last no longer than thirty seconds. Try to record as much information as possible but remember to hold the pencil loosely. The purpose of this exercise is to help with observation of the plant material rather than to compare the quality of the finished studies. These drawings usually appear as quite lively outline sketches and should be completed in the time allowed.

HAND AND EYE CO-ORDINATION

Draw the same specimen, only this time look at your plant and not at the paper. Try not to be tempted to look down and do not worry about the finished image. Start by placing your pencil at the bottom of the page where the base of the stem would be positioned. Continue by looking at the base of the stem of your plant and not at your paper. Imagine you are drawing a line around the silhouette of your plant with your eyes. As your eyes move around the plant let your pencil follow, try not to lift the pencil from the page.

The result on the paper may only be a squiggle of lines at the first attempt, but do not be disheartened; it is not the result on the page but the practice of hand and eye co-ordination that is important.

DRAWING FROM MEMORY

Concentrate and look carefully at your plant, noting the height and the variation in size of the leaves. Check the position of the flowers and look at the shape of the leaves and the veining pattern. Close your eyes and gently feel the plant, feeling the stem and the leaves. Feel the area where the leaves and flowers are attached. Open your eyes and look more carefully at these areas. Look at the relationship in size between the flowers and the leaves. Close your eyes again and gently feel the flowers, feeling the difference in texture between the stem, the flowers and the leaves. Open your eyes and check these areas again. When you think you know your plant put it well out of sight and draw it from memory. Allow yourself ten minutes for this drawing. This exercise will help you to commit visual information to memory. Each time you look at a plant to draw you have to absorb a little bit of information in order to transfer it to the paper.

Drawing a simple leaf.

DRAWING IN DETAIL

Take your time for this drawing and do not hurry. Use the same plant material and draw the plant in outline. Try to record carefully all the details, particularly where leaves and flowers are attached to stems, the margins of leaves and veining structure. Take time to look at the plant and to observe it carefully. Notice the proportions and relationships between different parts of the plant and try to be as accurate as possible. You should now be drawing with understanding.

These exercises are useful as preparations for a longer and more detailed study. They help you to understand your plant and locate areas of difficulty, particularly with leaf attachments, perspective and foreshortening.

accuracy could result in a hesitant and stilted drawing and progress will be slow.

Develop Drawing Skills
Accuracy and Proportion

When you become more proficient and comfortable with the pencil you should aim to draw accurately and in proportion. Botanical subjects are generally drawn life size. Achieving correct proportion may be a problem at first, with leaves and flowers appearing on the page drawn either too large or too small. This often happens in the early stages of drawing and in most cases this will correct itself with practice. Eventually the hand will record more accurately what the eye sees. It is important to build up your confidence until you feel comfortable about having a drawing pencil in your hand. Aim to judge measurements by eye in the first instance and only use the dividers to check your measurements are correct. At a later stage when you have more experience dividers will become an essential tool. In the initial stages, however, too much fiddling about and concern for

Drawing Stems and Veins

To be able to draw stems and veins you will need to acquire the skill to draw a second line parallel to the first and also to be able to draw lines that taper to a point. To practise drawing parallel lines, draw the first line horizontally without taking the pencil from the paper; remember to look ahead to the destination of the line as you draw. For the second line place the pencil point at the required distance below the first line and draw the line. Follow the first line that you drew with your eyes and do not be tempted to look at the line you are actually drawing. Practise until you feel confident and then try adapting this so that the lines gradually merge until they meet. You may find it easier to turn the paper around and draw upright stems in a horizontal position.

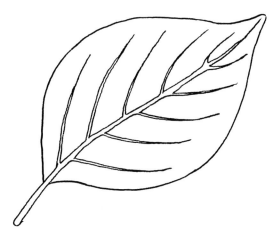

Adding veins.

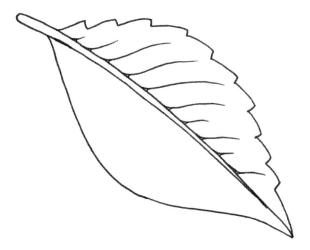

Drawing the serrations on the leaf margin.

GROWTH CURVES AND CROSSING STEMS

Look for the natural growth curve as you draw so that stems do not appear as a row of straight sticks across the paper. When more than one stem appears in a picture, care should be taken that they do not cross each other in the middle of the page or that a number of stems do not cross at the same point. Crossing stems in these situations detracts the eye from moving around the whole design, but it does not mean that crossing stems should not appear anywhere in your composition. Before proceeding to the next stage of the drawing check that all the stems lead somewhere and that leaves and flowers are properly attached.

Drawing Leaves

POSITIONING VEINS

Draw the mid-rib and petiole, or leaf stalk first; then attach the sides of the leaf. Look ahead of the line as you draw so that the lines meet at the tip of the leaf with no overlaps. Draw lightly with a continuous line. Look for serrations on the leaves and draw them in once the outline of the leaf margin is completed. Draw in the secondary veins; look to see where the vein starts on the mid-rib and where it finishes on the leaf margin. Sometimes it is easier to draw in the veins before you add the serrations, as there may be a connection between the two. Some veins do not go directly to the margin of the leaf but curve inwards and appear to loop into the adjacent vein. Look at the width of the veins; they usually taper to a very fine point.

Study the veining structure carefully, take a rubbing or photocopy to help you distinguish the main features. The whole leaf will be a network of veins, but you need only draw in the main veins and those that help describe the character of the leaf. For example, it is important to include more of the veining structure on a primula leaf as this will help describe the puckered effect, whereas less veining can be shown on a lisianthus leaf which has a bland surface.

FORESHORTENING LEAVES

One of the main areas of difficulty lies in the presentation of leaves which come towards to the viewer, or those going away. This is known as foreshortening. The leaves appear shorter than their actual length. Before attempting to draw a foreshortened leaf you should make sure that the leaf is in the correct position. Sometimes a leaf coming head on towards the viewer can look a little awkward and a more pleasing aspect might be gained from turning the plant slightly.

To begin drawing a foreshortened leaf, first establish the midrib, using dividers if necessary. When drawing leaves coming towards you measure the distance from the stem to the tip of the leaf, and mark the spot with a light pencil mark. Measure the width of the leaf at the widest point you can see and record the measurement on the drawing in the same way as before with light pencil marks; these are your reference points. Check the angles between the midrib and the main stem. Once these reference points are established, the leaf should be carefully observed again before drawing in the leaf edges. Draw lightly so that adjustments can be made. It may be helpful to look for the double curved line that looks like a simple flying bird shape in the completed drawing.

Practise a variety of different leaf presentations, leaves coming towards you and leaves going away from you, try different twists and turns until you feel confident. A twist on a leaf can add interest and variety to a drawing and provide information about the veining and texture on the underside

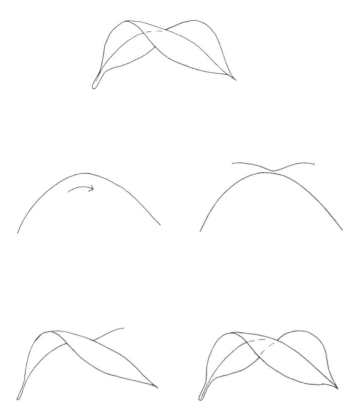

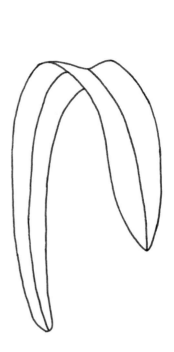

Stages in drawing a foreshortened leaf.

Look for the 'flying bird' shape in the completed drawing of a foreshortened leaf.

of the leaf. Dried and curled autumnal leaves make good subjects for practice.

Take care that the veining does not represent a fish bone. Veins taper and some are only a hair's width. You might consider drawing the veins on the topside of the leaf as a line showing no width and drawing the veins on the underside with two lines to show the width. This will help to show the difference between the top and underside, and avoids the veins on the top side looking too wide and heavy.

Drawing Flowers

Drawings of flowers can be based on geometrical shapes to help establish the basic structure and perspective. Cup-shaped flowers look more natural if drawn from a three-quarter view than fully head on. The outside edge of the flower will change from a circle to an ellipse as it is tilted back and forth.

A plastic cup tilted at various angles can help you understand the perspective and structure of flowers such as tulips, single peonies and buttercups. The amount that can be seen inside the cup will depend on the tilt. Look at the outside edge and notice the change from circle to ellipse.

EXERCISE FOR THE PERSPECTIVE OF CUP-SHAPED FLOWERS

Take a plastic cup and tilt it at various angles, draw the different positions in pencil outline. Take care to keep your head in the same position each time you look at the cup. Notice how much of the inside of the cup is exposed in each position. These observations relate to the drawing of open cup like flowers. It is impossible to see the entire outside and all the inside at the same time. When you have practised drawing the plastic cup, take a cup shaped flower and draw it from different angles, change its position by tilting it slightly backwards and forwards. Notice how the shape changes and how much you can see of the middle of the flower in each position.

Flowers such as lilies and daffodils can be based on the cone shape; again twisting the flower will affect the amount of the inside that can be seen. A full frontal view of the flower can give a dramatic effect but it creates difficulties for the artist in describing the true shape.

Drawing Fruits and Seeds

Fruits such as berries are generally based on the sphere. The position of the stalk should be noted and the hollow in which it

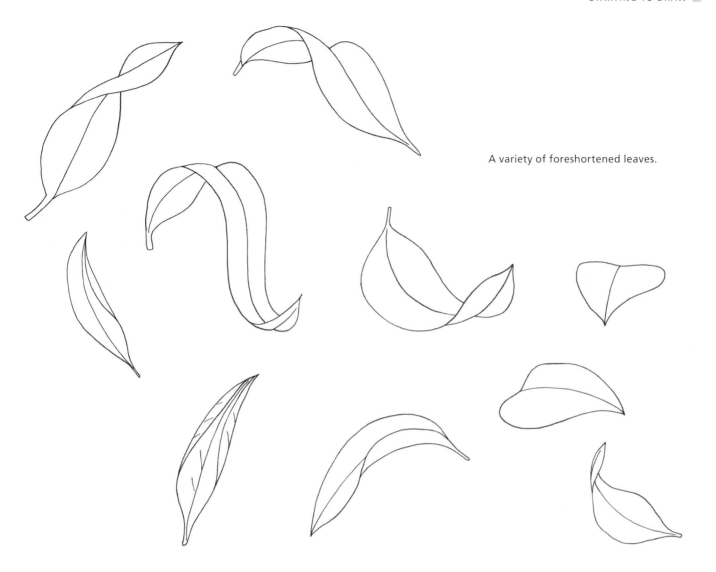

A variety of foreshortened leaves.

sits carefully described. You may not be able to see inside the recess. Some fruits are more oval than round and they are not all exactly the same shape. Take care and look for variation and do not simply repeat the shape without close observation. The fruit could be dissected to show the seeds.

Some fruits have a definite structure; look for the spirals which appear on fir cones and pineapples. The structural pattern can be mapped out before further detail is attempted.

What to Move or Leave Out

When you are confronted with a mass of foliage some of it can be omitted as long as the botanical information is not sacrificed in the process. Some of the petioles, or leaf stalks, showing where leaves were positioned, could be retained if it was felt the botanical information was being compromised.

Drawings of orchids, delphiniums and other flowers which produce many small flowers on a single spike could be another situation where the artist might want to simplify the structure. It is acceptable to omit some of the flowers that show through from the back of the plant so that the structure can be clearly understood.

The artist must decide whether the correct botanical information has been conveyed in the drawing in the best way possible. When leaves and flowers are huddled together they can be repositioned to give a more open design; and leaves lining up with stems can be moved slightly so that the drawing can be clearly understood.

It is difficult to know whether to include insect damage and nibbled bits, as well as leaves that have been on the plant all year and look discoloured and weary. When you are illustrating a plant that retains its base leaves all through the year, such as a primula, it would be unwise to tidy up the plant and remove the older leaves as this would destroy part of the plant's life history. Leaves with autumnal fruits will not appear as fresh as they were in the spring.

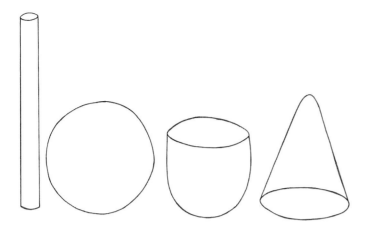

Geometrical shapes can help with the structure and perspective of flowers, some are based on the half sphere.

Look where the stalk appears on a fruit; it often sits in a hollow.

The underlying pattern can be mapped out for fruits that have a spiral structure.

Drawing Techniques

Aerial or Atmospheric Perspective

Aerial or atmospheric perspective is the name given to the loss of contrast, detail and sharp focus as you look into the distance. Aerial perspective can be used effectively to show depth and form in a drawing even with plant material where everything seems to be in the foreground. In botanical drawing, structures that are closer to you will be clearer, bolder, and more distinct than those further away, which will be lighter and less distinct.

Linear Perspective

Linear perspective is based on the principal that objects of a similar size become smaller the further away they are from the viewer. The artist should be aware of the theory and apply the principle where appropriate. For example linear perspective might be considered in a habitat study or a drawing of a large dense plant with many fruits or flowers both in the foreground and background.

Diagrammatic Line Drawing

The use of an even continuous line to describe botanical structures is known as diagrammatic line drawing. Clear outline drawing is often preferred by botanists because detail can be shown accurately and clarity is not blurred. Leaf junctions and veining patterns are examples of structures that can be clearly illustrated in pencil outline. An HB pencil would be a suitable pencil to use for this kind of drawing.

Reminders

1. Detailed and accurate drawing requires practice. Compare it to playing the piano: the more you practise the better you will become.
2. Getting the hand to record what the eye sees can be frustrating in the early stages, but keep trying and do not worry about the results.
3. Do not become technique ridden or your work will become stiff and lifeless. Aim to produce accurate, lively drawings.
4. Ensure you are comfortable before you start a drawing. Go through the warm-up drawings to help you to relax so that you feel confident and can enjoy the drawing process.
5. Draw what you see, not what you think you see; you are recording the truth about the plant. Once you have decided on a suitable position for your plant try to look

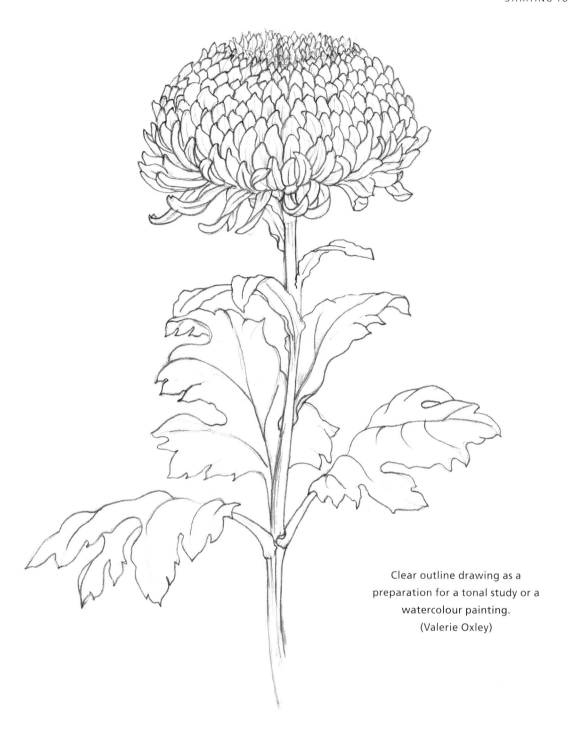

Clear outline drawing as a
preparation for a tonal study or a
watercolour painting.
(Valerie Oxley)

at it from the same viewpoint each time you draw.
A slight movement of your head from left to right,
leaning back or forward in the chair can alter the
perspective of the drawing.

6. Work with living plant material whenever possible.
 The most successful and lively drawings are from the
 actual plant material.

7. Look for life and movement in your plant, the natural
 flow and growth curve, and aim to capture this in
 your drawings.

8. Make sure you have enough time to complete the
 drawing so you will not feel under pressure to take
 shortcuts in order to finish quickly. Set yourself tasks
 that you know you can complete in the time available.

9. Each drawing should be an improvement on the
 one before.

10. To erase a horizontal line, rub vertically as this will
 avoid smudges.

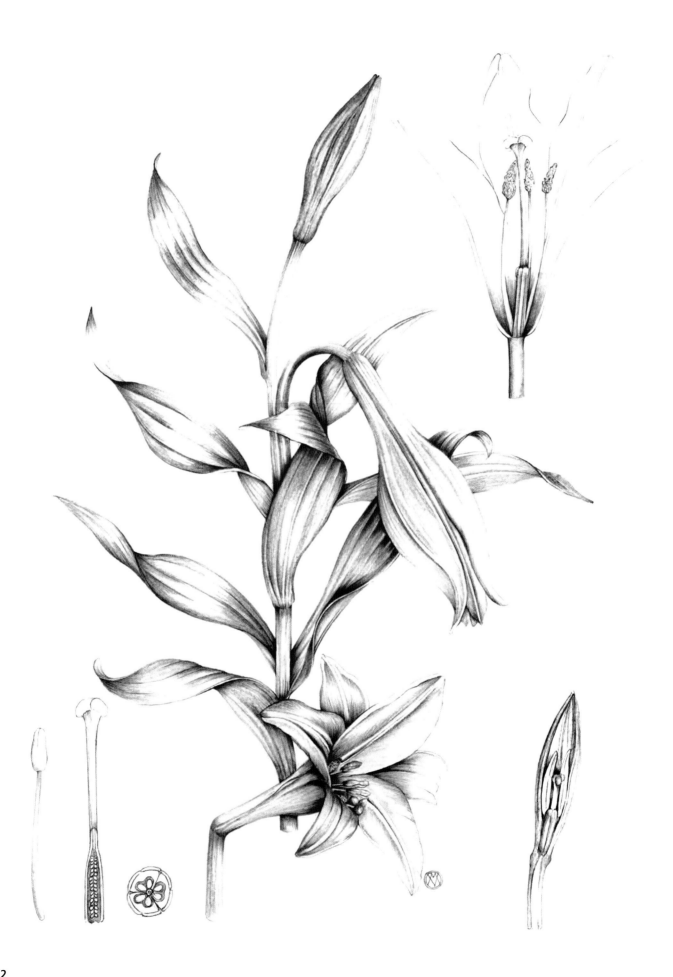

DEVELOPING TONAL STUDIES

Equipment
Papers

All paper has surface texture, even the very smooth hot pressed papers. Your graphite pencil will pick up the texture as it moves across the surface of the paper. This may not be very noticeable if you are drawing a line, but when you cover an area with graphite, white specks will be seen amongst the dark, where the pencil has skimmed over the uneven surface. This effect will be emphasized if you are using heavily textured papers, with pencils from the B range. The harder H pencils fill in the gaps more readily and will create a smoother appearance.

CARTRIDGE OR DRAWING PAPER

Cartridge or drawing paper has a smooth surface and can be used for tonal work in graphite. There are many types of suitable drawing paper including good quality heavyweight papers.

HOT PRESSED WATERCOLOUR PAPER

Hot pressed watercolour paper has a smooth surface and is suitable for tonal drawings in graphite. The colour of the paper may vary from white to cream. The paper is better in quality than the drawing papers and can be used for work that is to be exhibited.

BRISTOL BOARD

Bristol board is a good quality, smooth, shiny white paper. The smooth surface makes it a good support for tonal work in graphite.

Tonal drawing in graphite of *Lilium longiflorum*.
(Valerie Oxley)

NOT WATERCOLOUR PAPER AND ROUGH WATERCOLOUR PAPER

These papers have surface texture which shows up considerably with the use of the softer B range pencils. Although they could help to create surface texture for drawings of citrus fruits they are generally not suitable for fine tonal botanical drawings.

Pencils

The most useful pencils when you are starting tonal work are 2H, HB and 2B. With experience, the range can be extended to include even harder or softer pencils from the full range, which extends from 9H to 9B. Various brands of pencil are available, some are harder, and some generally softer. It is worth experimenting by using pencils from other manufacturers if you are not happy with the brand you are using.

Tonal Techniques
Varying Tone in Line Drawing

By gradually increasing pressure on the pencil tip you can draw a line which will range in tone from light to dark. Light and shade can be shown by using dark and light lines in the appropriate places; this is known as expressive line drawing. Contrasting tone in line is used for drawing very fine stalks. More pressure can be exerted for the shadow side of a stem and less pressure for the light side. This effect would not be so noticeable with the harder pencils.

Observing Tonal Areas

Sometimes people tell me they are unable to identify a range of tones across their plant. Often the problem is that artificial light

Periwinkle from a Dorset
hedgerow. A little dash of
watercolour enlivens a tonal
drawing. (Valerie Oxley)

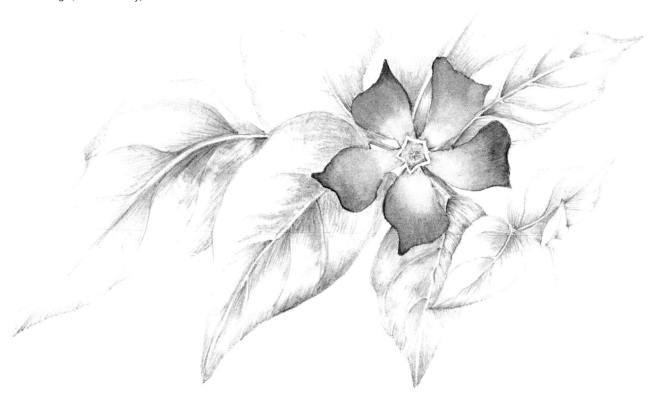

from above is flooding out all the shadows. Eliminate as much overhead light as possible and use a good directional light source to overcome most difficulties. Although natural light is preferred, sufficient and constant light from a natural source can be difficult to achieve, particularly during the winter months. A good alternative is to use a lamp with a daylight simulating bulb. A daylight bulb in an Anglepoise lamp would be suitable placed at an angle of 45 degrees to the far left of the plant. Check that you can see a gradual range of tone from light to dark across your plant before you proceed. A lamp placed too near the plant will show a sharp tonal contrast between light and dark. When sharp contrasts are reproduced on paper they look like a flat pattern of light and dark patches. Once established, the light should be from the same direction throughout each drawing.

To help you to see areas of light and dark on your plant material half close your eyes, or squint; this will help you to define the main tonal areas.

Creating a Three-Dimensional Study
Cylinders, Spheres and Cones

The artist Cezanne stated that one should 'treat nature in terms of the cylinder, the sphere and the cone.'

Shading basic shapes will help you to work out the relevant shading for each part of the plant. Stems are based on the cylinder; rounded fruits such as berries and rounded inflorescences such as hydrangea are based on the sphere. Tubular and trumpet shaped flowers such as the foxglove are based on the cone. The half sphere is used to help describe flowers such as tulips and daisies whose flowers are cup shaped.

Using the Full Tonal Range

The tonal range should be from the lightest highlight to the darkest shadow. The mid tone should be shown, and the two

half tones in-between. Aim to create five tones in your drawings. A tonal range can be created on the paper by using different grades of pencil ranging from light to dark and by increasing the pressure on the pencil. The hard pencils will produce fine light grey smooth shading and the B pencils will produce dark grey textured shading. Shading can be started lightly with HB.

For very fine smooth work some artists prefer to start shading with very hard pencils such as 5H. I am often amazed at how little pressure is required to make a mark on the paper. The lightest shading can be achieved by hardly touching the paper with the pencil, likened to a whisper or a feather touch.

Shading Techniques
Continuous Tone

The side of the pencil tip can be used to create a broad line and different shades of grey. An even grey tone can be achieved by flattening and polishing one side of the pencil tip, first on fine sandpaper and then by rubbing on a piece of scrap paper to create a smooth surface. Start lightly and increase the tone by building up the layers. Eventually the paper will not absorb any more graphite in the darkened areas. If it is overworked the paper will look polished and further graphite will not stick to the surface; it may even tear. It is essential to understand the tonal range of each pencil to avoid overworking with one particular grade.

Hatch Line Shading

In this method you can create varying tones in line by placing repeated lines nearer or further away from each other. Dark tone is achieved by placing the lines close together, and light tone is achieved by placing them further apart. Generally hatch lines follow the shape of the subject. Fine hatching lines can be achieved by a flick of the pencil on the paper; this forms a tapered pencil mark, thick to thin and dark to light. In botanical work the hatching lines should be carefully placed; done too hurriedly it creates a sketchy effect. When lines are placed together so they touch continuous tone is created. The area of continuous tone can be extended by moving gradually outwards from the edge; if the pressure on the tip of the pencil is lessened as you move outwards a tonal range from light to dark will be achieved.

Cross Hatching

Darker areas of tone can be established by crossing lines with

Tonal sketch of a lemon on a NOT surface paper. The textured surface of the paper has helped describe the surface texture of the fruit. (Linda Ambler)

other lines on an angle; this is known as cross hatching. In general, this is a sketching technique used for darkening an area of tone quickly. It can be used for botanical drawing if it is executed carefully. Cross hatching can be used where an area of solid or dark tone is required. The effect can be enhanced by the spacing and the strength of line. Cross hatching that is too open will create a pattern which could convey misleading botanical information.

Elliptical Shading

Elliptical shading is created by an elliptical movement of the hand, which originates from the shoulder. Large or small ellipses can be drawn on the paper in pencil using this method of shading. The tip or the side of the pencil can be used. Variation in tone is achieved by moving across the same tonal area to lay down more graphite in the darker areas. It is advisable to alter the size of the ellipses as you work to avoid dark tonal ridges as the tonal area is enlarged. Start with light pressure on the pencil and build up the layers of graphite gradually.

Dust Work

Dust work is a medical illustration technique where graphite dust is applied to the paper with a dry brush. The dust is

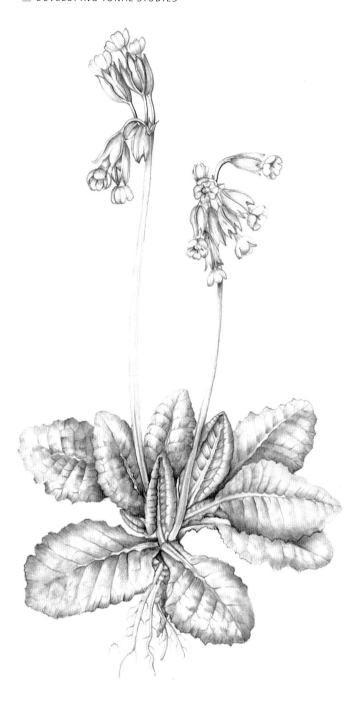

Cowslip, *Primula veris*. A stronger line has been used on the shadow side of some individual flower stalks and on the edges of leaves to pick out detail and form in this tonal sketch.
(Valerie Oxley)

produced by rubbing the side of the point of an HB pencil onto fine sandpaper. The dust can be picked up using a dry brush or tortillion. When the graphite dust is applied to the paper a mid tone is established; this can be softened with a putty rubber or strengthened with more pencil work. The final effect is a smooth continuous tone.

Stipple Shading

Stipple shading is the name given to shading with dots placed near together or further apart to give a tonal range. It is associated principally with the use of a technical pen for black and white work and is used only occasionally in pencil shading to create a special effect.

Solid Tone

Depth can be emphasized by using areas of solid tone. This can be used with great effect to sharpen up a drawing. Pencils from the B range give the sharpest contrasts. Solid tone can be applied to shadow areas around leaf joints and underneath flower heads. It can also be applied to areas where leaves twist and overlay each other.

Blending and Smudging

Stumps, tortillions, cotton buds, card, matchsticks and fingers can be used over shaded work to smudge and smooth the surface. The tones merge together as the surface is rubbed and disturbed. Care should be taken to ensure that the surface is not blended too vigorously; otherwise the tonal range will be lost in the process. Although fingers can be used as a blending tool this is not usually considered a suitable method for botanical studies. Grease from your finger can be transferred onto the paper surface, and the marks from fingers are too wide to be effective for fine botanical structures. A more refined technique is required to blend small and precise tonal areas.

Creating Effects with Coarse Sandpaper

Coarse sandpaper placed under thin drawing paper will create a textured effect when a soft B pencil is rubbed over the top. This technique can only be used with the thinner papers. It is not a technique that is used widely, but it might be useful to indicate texture on leaves for quick reference sketches.

Creating Effects with an Indenter

An indenting tool such as a fine knitting needle or parchment craft embosser can be used to indent marks in the paper. This technique can be useful to help describe structures such as hairs on a stem. When the pencil is rubbed over the top of the indentations in the paper they remain white.

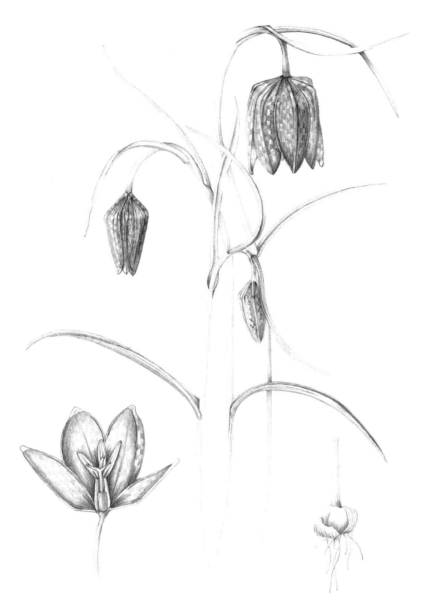

Snake's head fritillary, *Fritillaria meleagris*. Directional lighting helps to create shape and form; detail is lost in the highlights and in the shadows, but is more evident in the mid-tone areas. (Valerie Oxley)

Highlights and Shadows

Gradation of Light

Texture, true colour and pattern are more evident in the half-tone area. These details are lost in highlights and in the deepest shadow area.

Highlights

The highlight is the lightest and brightest area that can be seen on your plant. The intensity of the highlight can be affected by the surface on which the light falls. Colour and texture are affected by the intensity of a highlight. Some plant surfaces are highly reflective; examples are holly and camellia leaves. The outer surfaces of some fruits show more than one highlight. When all the highlights on a highly reflective surface such as a

fruit are reproduced exactly as they are seen, the effect might be a number of spots across the fruit. Sometimes reflected shapes of studio lights and the light from windows appear on the surface of the fruit. Where they look unnatural you may have to make a decision about which highlights are to be retained and which can be obliterated. Some highlights on the shadow side of the fruit can be included: in pencil drawing they can be shaded lightly as they usually retain a little colour of the fruit; these areas are usually referred to as low lights.

Reflected Light

Reflected light is the light which bounces back onto the far shadow side of the plant or fruit. This light area can be created by a secondary light source or from a reflective surface placed behind the plant such as a white board or alcove. It can be seen

77

A detailed tonal study of an oak leaf showing subtle changes in light and shade. (Lionel Booker)

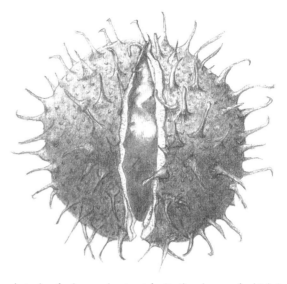

Tonal study of a horse chestnut fruit, the shape of which is based on the sphere. (Anita Page)

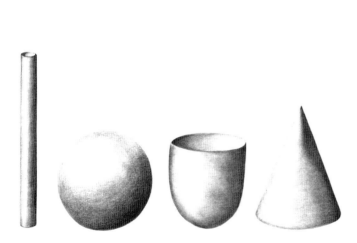

Shading geometrical shapes will help you to understand how the effect of light can be used to create three-dimensional studies. (Karen Colthorpe)

Drawings of acorns and empty acorn cups. Notice how the shading has been used to describe the concave shapes of the empty cups. (Lionel Booker)

as a light area on the far edge of the shadow side of the plant or fruit. Reflective light can be difficult to describe without a contrasting background as the far edge will have no definite boundary. The best way to achieve the desired effect is to ensure the reflected light is slightly lighter than the deepest shadow but darker than the mid tone seen between the lightest and darkest areas. It is a useful device to help describe berries in a cluster or individual grapes in a bunch.

Cast Shadows

Cast shadows can help define structures and create depth in a drawing. Generally, cast shadows are not shown beyond the subject in botanical work. Sometimes fruit are shown with a cast shadow at the base, which helps to fix their position and to show that the fruit curves upwards.

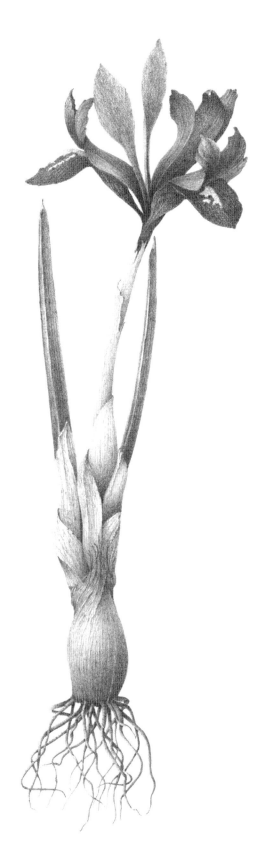

A range of tones has been used for this drawing of pussy willow to show the contrast in texture between the hard bud case and soft stamens. (Valerie Oxley)

Study of *Iris reticulata* in continuous tone.
(Lionel Booker)

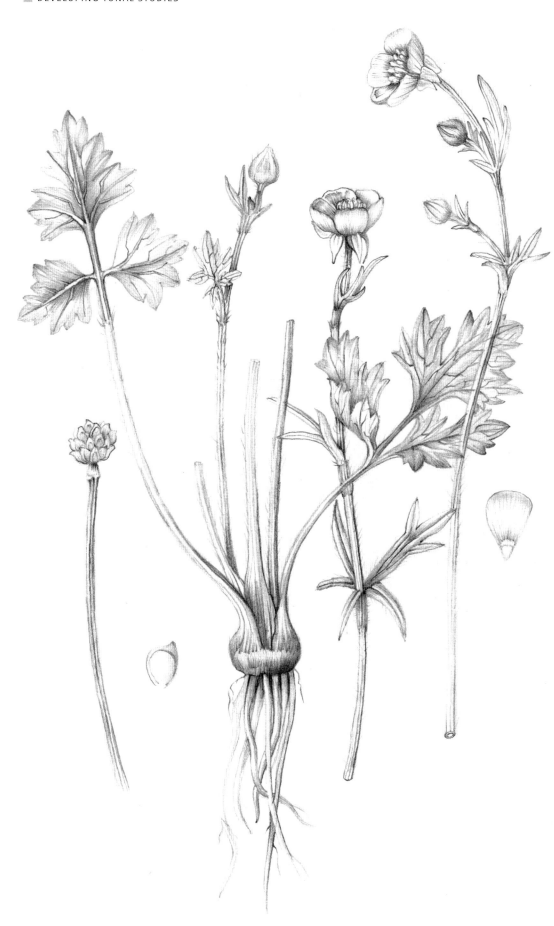

Tonal drawing of the bulbous buttercup *Ranunculus bulbosus*. The flowers are based on the half sphere or cup shape. Varying the pressure on a line can help describe the effect of light. (Valerie Oxley)

Wood shavings provide excellent material for studying the effects of light. (Linda Ambler)

Self Shadows and Overlaps

Very often the shadows projected by thorns and stiff hairs can be shown on the stem of a plant, which helps to create realism. Shadows cast by overlapping leaves or crossing stems or roots can create depth and give a realistic effect to the drawing.

Shadows in Concave Areas

Concave structures are inwardly curved and can be found in botanical subjects such as the half fruit of a peach or plum with the stone removed. Some orchid leaves show dimples, and depressions can appear on fungi where a piece has been nibbled away by a visiting slug. To create the illusion of a depression check you have a good single light source. The light will fall into the far side of the depression and is reflected back to the viewer. The main shadow appears just below the near inside edge, the edge above the depression is lighter.

Lost and Found Edges

The initial outline should not appear as a strong edge around a tonal study. The outline should merge with the tone adjacent to it to create a smooth transition of tone. Occasionally a small area of the edge can be emphasized to great effect and serves to pick out a twist or a turn.

Reminders

1. Pencil shading is not an essential addition to an outline drawing and it can blur clarity. Clear outline drawing may be preferable for studies where it is important to describe botanical structures in detail.

Tonal study of a variegated acer branch. Tonal adjustments have to be made to describe colour, pattern and the effect of light on the leaf. Highlights can be lifted with the aid of a putty eraser if required. (Karen Colthorpe)

2. Each pencil has its own range of tone from dark to light depending on the pressure used.
3. Pencil shading can give a drawing shape and form and creates a realistic three-dimensional illusion on the two-dimensional paper.
4. Light should appear to come from one direction only. In botanical drawing it is generally accepted as coming from the top left.
5. Indicate the shadows or darkest tonal areas lightly at first using a mid tone HB pencil. A range of tones over the whole drawing can be built up gradually.
6. In each shaded area there should be at least three tones: light, mid tone and dark. To render form effectively aim to extend the tonal range to five tones: light, half light, mid tone, half dark and dark.

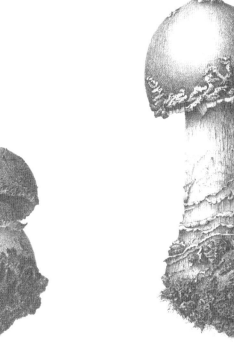
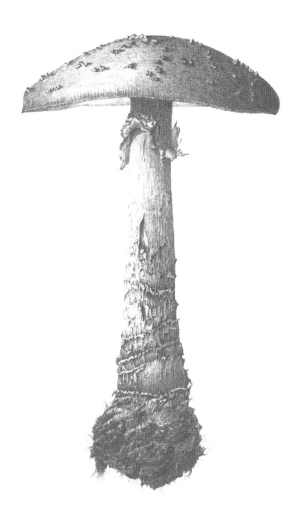

Three studies of a developing *Amanita muscaria* fungus, showing a range of pencil techniques. Working from light areas on the left to dark areas on the right describes the three-dimensional aspect of the fungus. Self shadows across the stem under the cap help to position the stipe and selective shading has been used to pick out the texture. Notice how the split in the stem of the mature specimen is portrayed to create a hollow area. (Lionel Booker)

7. The white of the paper should be used for your lightest tone. To lighten a tonal area dab the area gently with a putty eraser.
8. To create the illusion of shine, use darker tones near highlights.
9. Colour, texture, and surface patterning overlap with tone and can be used to help describe shape and form. True colour, texture and surface patterning are shown in the half-tone areas, they disappear in the highlights and are darkened in the shadows.
10. Reflected light bounces back onto the subject from the space around and is shown on the far edge of the self-shadow. It can be effective where stems cross and fruit is shown in a cluster.
11. Look for darkened areas underneath flower heads where they are joined to stems.
12. Look for cast shadows where stems and leaves overlap.
13 Work on an illustration from top to bottom and from left to right to avoid smudging the work as you progress.
14. Cover your work as you proceed to avoid smudging and to protect your paper from grease which could be transferred from your hand.

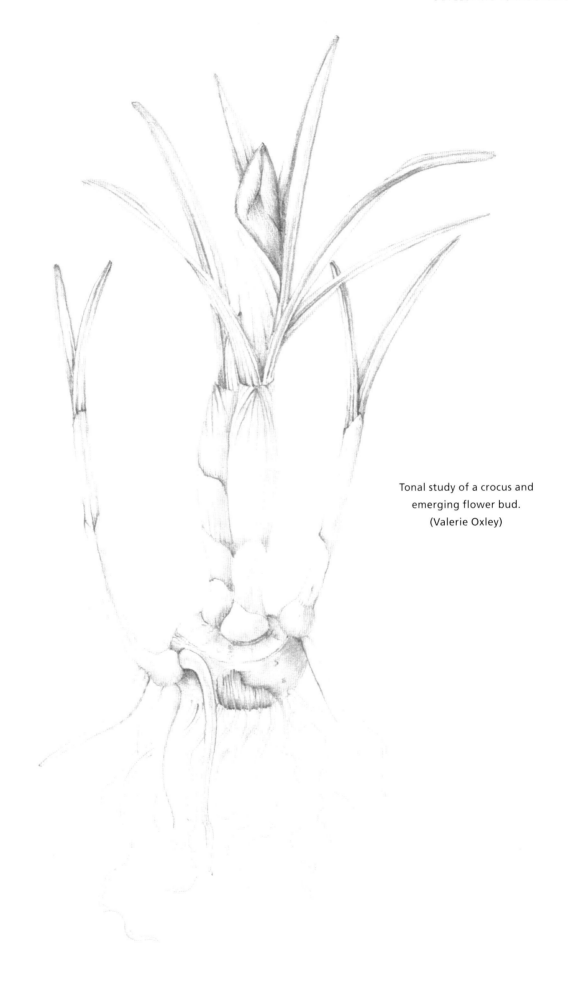

Tonal study of a crocus and
emerging flower bud.
(Valerie Oxley)

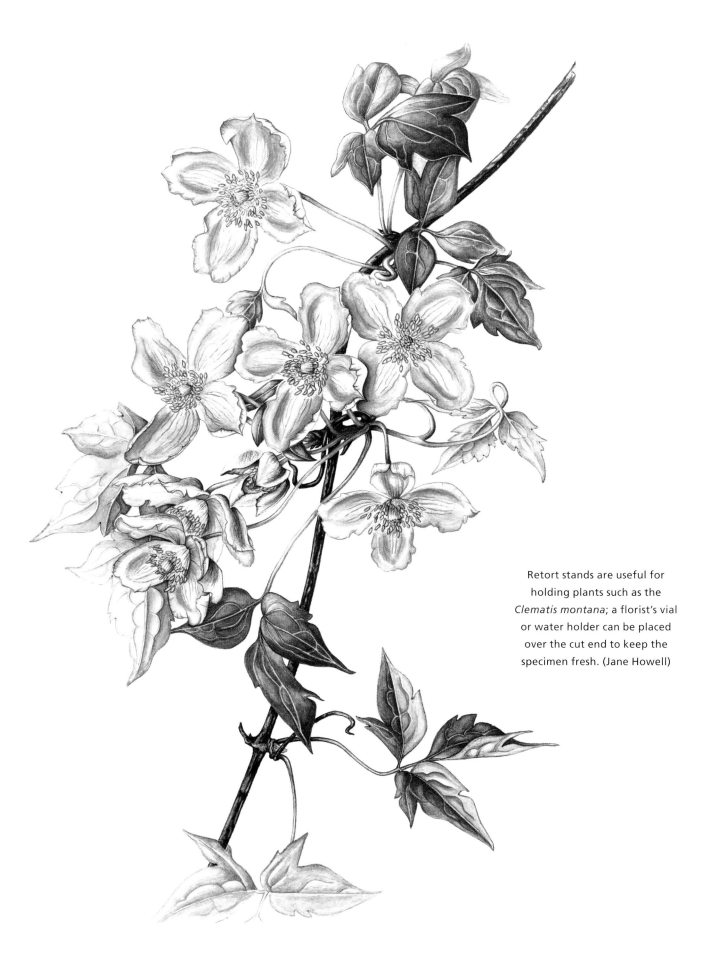

Retort stands are useful for holding plants such as the *Clematis montana*; a florist's vial or water holder can be placed over the cut end to keep the specimen fresh. (Jane Howell)

PREPARING TO PAINT

Selecting Paper

Watercolour Papers

The paper to which watercolour paints adhere is known as a support. Watercolour papers can vary in colour from bright white to cream. They are made from cellulose fibres, normally derived from the cotton plant, or from wood pulp; occasionally a mixture of the two raw materials is used. The term rag is often used to describe good quality paper; this term refers back to the time when papers were made of the remnants from the cotton industry. Experiment with different papers, including hand made papers, to find one that suits you. Do not be persuaded that there is only one type of paper that has to be used for botanical work; some of the most exciting work has been executed on papers which would be considered unsuitable by many botanical artists. Handle watercolour paper carefully, as grease can be transferred from your fingers. Careless handling could cause the paper to buckle and crease.

Size of Paper

Choose an appropriate piece of paper to suit the size of the specimen you are going to illustrate. Try not to cramp your illustration by selecting a piece of paper which is only just the right size. Remember that your drawing needs breathing space around it, and some extra space should be allowed for a margin.

Watercolour papers are sold in single sheets under the following names and sizes:

Double Elephant	66cm (27 in) x 102cm (40 in)
Imperial	56cm (22 in) x 76cm (30 in)
Royal	51cm (20 in) x 64cm (25 in)

Weights of Paper

Paper is supplied in different weights. The weights are usually based on imperial size paper. The weight is given in pounds per ream; a ream refers to 480 sheets of hand-made paper or 500 sheets of machine-made paper.

The following weights are the most popular; metric equivalents are included:

90lb	190gsm
140lb	300gsm
200lb	425gsm
300lb	638gsm

The higher the weight of the paper the thicker it will be. Some artists prefer to make further preparation of the painting surface by stretching all paper, whatever the weight, but generally most botanical artists only stretch paper below 140lb.

Paper Surface

HOT PRESSED PAPER (HP)

This paper has the most desirable surface for watercolour painting; it has a smooth surface on both sides and is excellent for detailed work. The paper will have been pressed between

A range of different watercolour papers, which are available in single sheets as well as in blocks or pads. (Winsor & Newton)

A twig of *Chimonanthus praecox*, wintersweet, with horse chestnut and hazel. This study is painted on a smooth hot pressed paper. (Judith Pumphrey)

hot plates or flattened by some other treatment to make it very smooth on both sides. 300gsm (140lb) is a suitable weight for most botanical studies.

NOT SURFACE PAPER

NOT means not hot pressed and refers to paper with a slight texture. Sometimes it is referred to as paper that has had no other treatment. It is also referred to as cold pressed, or simply CP. This paper can be used for botanical subjects. Some botanical artists prefer this type of paper as paint can be moved around and lifted from the surface. 140lb (300gsm) would also be a suitable weight for botanical subjects.

ROUGH SURFACE PAPER

This is a heavily textured paper suitable for painting landscapes. It is difficult to portray fine detail on this paper.

It should be noted that the texture of the surface of the paper in each category varies slightly between the different manufacturers. Fabriano, Arches, Saunders Waterford, Winsor & Newton and Daler Rowney all supply a range of papers.

Archival Quality Paper

Check that your paper is acid free. Also ensure that it is wood free and does not contain lignin, which is part of the cell wall of

a plant. Lignin will chemically degrade the paper if it is not removed during manufacture, making it turn yellow after a period of time. Pure wood pulp is used in the manufacture of some papers and is acceptable.

Sizing of Paper

Paper which is not sized is called waterleaf and is like blotting paper; it is not suitable for watercolour paintings. Sizing gives the paper some added strength and resistance to water so that the pigments sit and dry on the surface and the colours look more intense. Watercolour papers have internal sizing, which is incorporated during manufacture at the pulp stage. Even if the surface is disturbed the paper will have the same absorbency throughout the fibres; this prevents the paper from soaking up the watercolour paint. Some papers also have surface sizing with a gelatine coating; this helps to give the paper added strength. Papers which are surface sized with gelatine are more resistant to the application of masking fluid. This makes the masking fluid easier to remove and prevents surface damage.

Watermarks

During the manufacture of the paper a watermark is added to the felt or working side. To check the watermarks hold your paper to the light. When you can read the watermark it is generally assumed that you are looking at the correct side on which to work. For future reference, before dividing a single sheet into halves or quarters, ensure there is an identifying mark in pencil in each corner of the working side.

Different Formats of Paper

SINGLE SHEET

These are usually sold in Imperial size 22in x 30in (56cm x 76cm approx.). They can be divided up into the size required. Some mail order firms will cut the paper prior to sending it out, but many art shops are reluctant to offer this service in case the customer decides not to go ahead with the purchase once it is divided. When buying large single sheets it is advisable to take a large portfolio or carrying case so the paper can be transported easily. Rolling the paper can cause wrinkles and should be avoided.

BLOCK

Watercolour paper can be supplied in a block in which all the sheets are glued together to form a pad. The drawing or painting is removed from the block by inserting a rounded palette

From left to right, hot pressed, NOT and rough surface papers.
(Winsor & Newton)

knife in the gap where there is no glue. The gap will have been left by the manufacturer for this purpose. Keep the knife flat, and move it round all four sides of the paper until the sheet is free. The advantage of a block is that the paper is kept taut and there is a firm pad base or block to work on. A disadvantage is that a light box cannot be used to transfer a drawing. The traditional tracing paper method would have to be used to transfer drawings for a watercolour painting.

PAD OF PAPER

Watercolour paper is available in a pad with one edge glued to keep the sheets together. Paper can be removed easily and fixed to a drawing board with masking tape.

SPIRAL PAD

Watercolour spiral pads are convenient; the paper can be used on the pad or removed and attached to a drawing board. The pad will open flat and remains flat when the pages are turned.

Stretching Paper

Lighter weight papers, less than 300gsm (140lb), will benefit from stretching. Without stretching, some papers will buckle when watercolour paint is applied. The reason the paper might buckle is that as you apply watercolour paint the fibres swell and stretch; on drying they settle down unevenly, and a cockled or buckled surface is the result. Painting in watercolours on a buckled surface may produce puddles and watermarks.

Some artists stretch all paper to avoid any chance of buckling. The stretching process hardly alters the actual size of the paper; the fibres rearrange themselves throughout the paper, and once dry further disturbance with a damp brush is negligible. It is advisable to go through the procedure well in advance of starting a painting so that the surface can dry thoroughly.

Hot pressed paper has been used for this bouquet of early summer flowers. (Suzanne Osborn)

2. Submerge your watercolour paper in the bowl for about 20–30 seconds. Heavier papers need a slightly longer time for immersion. Hold the paper by its edges and try not to finger the area where you are going to paint.

3. Lift the paper from the water holding it by the top corners and at a slight angle to allow the surplus water to run off.

4. Place the paper on the drawing board allowing the bottom edge to make contact with the board first; this will hold the paper in place and will allow you to pull the rest of the sheet into position as it is laid down.

5. Gently dab the paper dry with the sponge or clean cloth to remove any excess water; a clean tea towel is ideal for this purpose. Do not rub dry as this will spoil the surface of the paper.

6. Ensure the gummed strips are folded firmly along their length before dampening the gummed side lightly with the sponge. Apply the dampened strips in turn around the paper. Each strip should have half its width on the paper and half on the drawing board using the line of the fold as a guide. Make sure that all the edges of the gummed strip lie flat; any lifting at this stage may cause a buckle in the paper as it dries.

7. Leave flat on the table to dry, this may take a few hours. A hair dryer may be of assistance at this stage. Move it back and forth across the paper, otherwise drying will be uneven and the paper could pull away from the gummed strips and tear.

8. The paper must remain under tension until the painting is completed.

9. Finally cut the watercolour paper free with a rounded palette knife or craft knife.

Unfortunately a light box cannot be used with paper treated in this way; transfer of drawings will have to be made using a commercial trace-down paper or by using ordinary tracing paper.

How to stretch paper

To stretch your paper you will need a strong board that will not warp when wet, access to a sink or washing-up bowl, scissors, a roll of gummed paper tape and a natural sponge. The sink or bowl should have enough water in it to cover the paper.

1. Cut your watercolour paper so that it is smaller than the board onto which it is to be fixed. Cut four gummed brown paper strips to fit around your paper, allow about 5cm (2in) extra at each end. Fold the brown paper strips lengthwise with the gummed side inwards.

Transferring Drawings

Drawings are transferred so that there is as little disturbance as possible to the surface of the watercolour paper. Any erasing will affect the surface of the watercolour paper, making it look furry when seen through a magnifying glass. Clarity will be lost if watercolours are painted onto a disturbed surface. Any corrections and rubbing out can be done on the drawing paper before the image is transferred.

Indicating a Margin

Check the size of the watercolour paper before transferring an image. Remember to include a margin of about 2cm ($^3/_4$in). This should be drawn lightly with a ruler around the edge of the watercolour paper before the design is transferred. The margin serves as a boundary to the artwork, and it can be used to write

A study of alliums which have been individually drawn, traced off and rearranged. The design has been transferred onto hot pressed watercolour paper and completed in coloured pencil.
(Margaret Wightman)

down notes about the plant and for colour matching. The margin also allows for extra space beyond the boundary for the artwork to be mounted.

Outline Drawing as Preparation for Transfer

Prepare a clear outline of your plant on drawing paper, using a sharp HB pencil. The drawing should show botanical structures accurately including the veins on the leaves. Layout paper or tracing paper can be used as an alternative support for the

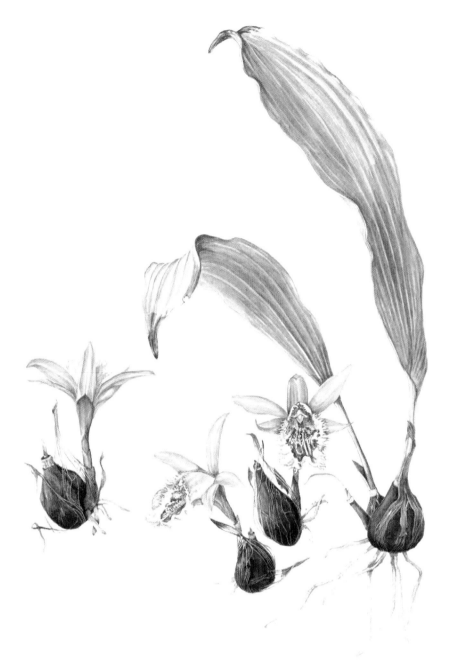

Completed study of *Pleione* Eiger 'Pinchbeck Diamond' on hot pressed paper. To help compose a final design, separate drawings can be made of the flowers and leaves, which are then cut out and redesigned using a light-box. (Judyth Pickles)

initial outline drawing. These papers are more transparent and make the process of transferring the drawing easier. It can reduce the number of stages in the traditional tracing paper transfer method. Only light pressure should be placed on the tip of the pencil when transferring a drawing onto watercolour paper. Pressing into the paper will push the graphite into a groove and make it difficult to remove at a later stage.

Tracing Paper Method of Transferring a Drawing

This is the time-honoured way of transferring a drawing. Place a piece of good quality tracing paper over your initial drawing.

Greaseproof paper or baking parchment is not suitable as the surface is too motley and the lines of the original drawing will not show through it clearly. Fix the papers with masking tape at the corners so that they will not slip during the transfer. Use an HB pencil to trace the lines of the initial drawing onto the tracing paper. Remove the tracing paper and turn it over. Place the tracing paper on a piece of spare paper for support. Go over the same lines on the tracing paper again very carefully; this puts graphite onto the back of the original lines ready for transfer onto the final drawing paper. This stage should not be omitted as otherwise the drawing will be reversed.

Turn your transfer paper to the top side and place it on top of your watercolour paper, checking the position of the image against the drawn boundary. Fix in place using masking tape

and trace the image for the third time. Stop to check the image is being transferred correctly by carefully lifting the edge of the tracing paper. (Drawing directly onto tracing paper in the first place will eliminate the first stage of the processes and will save time.)

Light-Box Method of Transferring a Drawing

Light boxes, which are used commercially for photographic and design work, are very useful for the easy transfer of outline drawings. The original drawing is placed face up on the top of the box. The watercolour paper for the finished study is placed on top, right side uppermost and the light switched on. The image should be seen clearly through the top layer. Care should be taken to see that the image shows through in the correct position on the top paper. Ensure that it is straight and check the distance from the image to the boundary on all four sides. When you are satisfied with the position of the drawing carefully tape the corners of the drawing to the light-box with masking tape. Use an HB pencil lightly to trace off the image.

Remove the original drawing from the light-box and go over the lines of the final version again with a pencil or with a black pen if it does not show clearly with the light switched on. Switch the light off occasionally to check all the lines are transferred as you progress. Dissections and complicated flower parts can be drawn separately and traced into position using this method.

Using a Window to Transfer an Image

The same effect as using a light box can be achieved by fixing your paper to a window and using natural daylight to throw the image forward, or even using an upturned stool with a sheet of glass on top and an Anglepoise lamp underneath.

Carbon Paper Method of Transferring a Drawing

Another effective method of transferring a drawing is to use tracing paper as a type of carbon paper. Cover one side of the tracing paper evenly with graphite from an HB pencil and rub smooth; this can be done with a tissue. Place the watercolour paper for the final study face upwards on the drawing board, and put the tracing paper with the graphite side down on top. Place the initial drawing face upwards on top of the other two sheets. Check it is in the correct position and tape the corners onto the drawing board. Carefully go over the lines of the original drawing and check by lifting an edge that it is being transferred. To avoid any unnecessary smudging try not to rub your hand across the drawing as you progress.

Using Commercial Transfer Paper

Commercially produced transfer paper called Tracedown or Transtrace can be used to transfer a drawing. Slide the transfer paper, carbon side down, between the drawing paper and the watercolour paper as described above and go over the drawn outlines using an HB pencil.

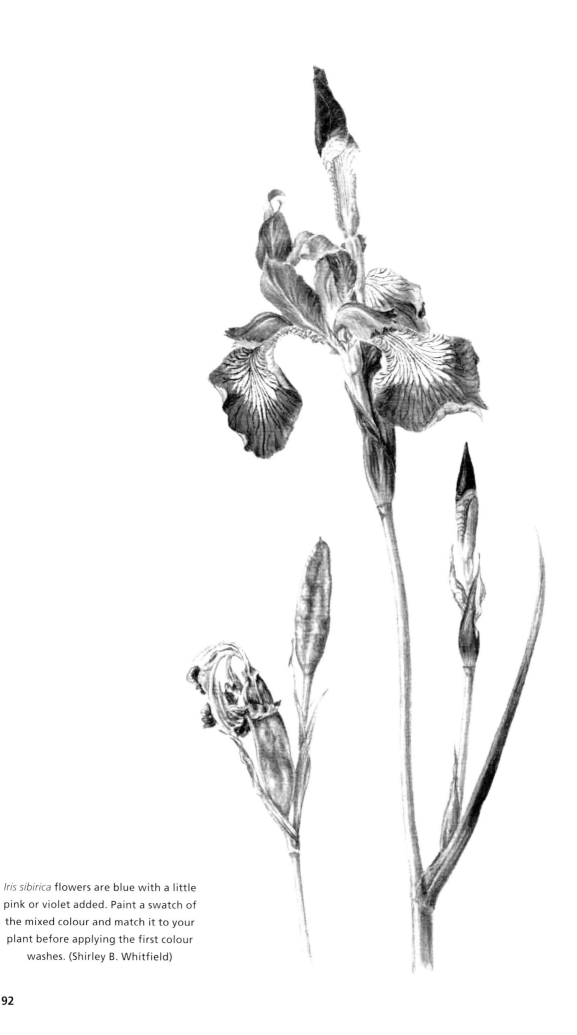

Iris sibirica flowers are blue with a little pink or violet added. Paint a swatch of the mixed colour and match it to your plant before applying the first colour washes. (Shirley B. Whitfield)

COLOUR AND WATERCOLOUR PAINTS

Body Colour and Gouache

During the sixteenth century body colour, or opaque water-colour, was particularly popular with illuminators and miniaturists. Early botanical illustrators learnt many of their techniques from the miniaturists and painted with body colour, which is similar to opaque watercolour, known today as gouache. The early colours were made from ground pigments to which white was added to increase the density; gums were used to help the paint adhere to the support. This combination gave the paint body and greater covering ability. The colours were often fugitive and were prone to fading, but this was not a problem as much of the work was on manuscripts that were not exposed to light.

It is uncertain when the term gouache came into use to describe body colour. It has been suggested that the word comes from the Italian word *guazzo*, which refers to the mixing together of water, pigment and gum. High levels of pigment and gum are still used in its manufacture today. It is particularly popular with designers and illustrators, but it does not have the translucency of fine watercolour. Some of the brighter gouache colours have lower permanence and therefore should only be used when permanence is not a priority. Many of the newer colours are permanent. Gouache used too thickly may crack. Because of the greater covering possibilities of gouache, light colours can be painted over darker ones and it is possible to paint over mistakes.

Fine Watercolours

In early paintings it had been the practice to add transparent layers of watercolour pigments to the finished painting like a glaze; these were derived from organic raw materials. It was the development of these transparent layers that has given us the watercolour medium in use today.

During the seventeenth century colour traders appeared, known as colourmen, who traded in the preparation and supply of pigments for artists. This trade probably arose due to the increase in world trade and availability of raw materials for manufacturing pigments. The more established artists continued to prepare their own pigments but by the nineteenth century the colourmen were well founded and there were several firms in London. Books were published outlining details of their products. The advance of chemical science throughout the nineteenth century produced a greater range of pigments and also cheaper alternatives to existing expensive natural colours.

Traditional watercolour paint, which is widely used today, was refined and developed through the partnership of the artist Henry Newton with the chemist William Winsor. They increased their range of colours in association with George Field, the author of a standard work on colour for the artist. Winsor & Newton developed the first moist watercolour paints by adding glycerine to the watercolours already in production. The glycerine enabled the existing watercolours to become more soluble in water and led to the development of watercolours in tubes.

Today there are two grades of watercolour paints: artists'

Pigment and gum arabic, two of the raw materials for the manufacture of watercolour paints. (Winsor & Newton)

A colour wheel showing the three primary colours, which are red, yellow and blue, and the secondary mixes, which are orange, violet and green. (Valerie Oxley)

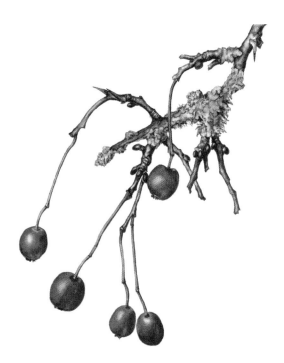

The red of the hawthorn berries contrasts with the green lichen, its opposite colour on the colour wheel. (Judith Pumphrey)

quality and student quality. Artists' quality generally contains a higher quantity of pigment and a more diverse choice of pigments providing a greater variety of wash characteristics. Most of the pigments are transparent. The white of the paper shows through the thin layers of paint to give highlights or a translucent glow. This is known as 'pure' watercolour painting. The student colours have lower pigment strength and a shorter colour range, using some alternative and cheaper pigments in their production to lower the costs for artists.

The Colour Wheel

Isaac Newton (1642–1727) the English physicist produced the first colour wheel. Through his studies he discovered that when white light passes through a prism it becomes divided into seven spectrum colours. He connected each colour with the notes of a musical scale, to show a connection between light and sound. He also demonstrated that the two ends of the colour spectrum joined together showed the natural progression of colours. Newton set the colours on a circular wheel; this is the basis of all colour wheels today. It was the German artist Jakob Christof Le Blon (c. 1670–1741) who recognized that all other colours could be mixed from the three primary colours, red, yellow and blue. He also discovered that the three primary colours mixed together as paint produced black, whereas the primary colours

of light produced white. This became known as additive colour in primary light colours and subtractive colour in primary pigment colours.

Pigments

Today there are a vast number of chemicals and raw materials available for the colourmen to develop into artists' watercolours. These materials are processed into in a range of pigments which can be painted onto paper.

A pigment consists of minute particles of solid material. The particles are dispersed through a binding medium by the colourmen. The particles are evenly spaced and bound so that when painted the colour will stick to the paper. The pigments come in different shapes and sizes and they are insoluble. Larger particles allow the artist to lift a colour from the paper to create a highlight. Fine particle colours penetrate the paper's surface causing them to stain the paper, making them difficult to remove.

Dyes are colours that are soluble in water and form a solution in which the colouring material cannot be separated from the water. When this solution is painted onto paper the tiny molecules of colour penetrate the paper's surface causing it to stain the paper, and it is difficult to remove.

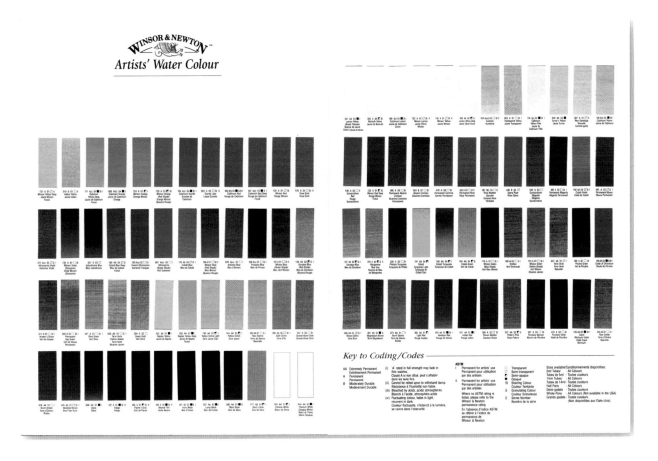

A manufacturer's hand-painted colour chart is a useful guide
when you are matching colours. (Winsor & Newton)

Beginning to Use Colours

It is essential to know your own watercolours and their mixing
possibilities to avoid disaster in your painting at a later stage. A
large range of new colours in a box can be daunting. Begin with
a few colours and attempt to understand their qualities before
extending your range.

Colours can be bought in tubes, pans or half pans. Half pans
are suitable for the botanical artist as only small amounts of paint
are used at a time. Care should be taken that colours do not
become contaminated with other colours or dusty. Colours can
be bought individually; only purchase additional colours that
are recommended or as you require them. When you are using
tube paints you may find a little clear gum when you remove the
cap from the tube; this will have been added by the manu-
facturer to protect the paint. Squeeze out the gum and wipe
the top of the tube with a paper towel. Mix your colours using
a white palette with recesses, or use a white saucer or white
plate with sloping sides. To mix true colours the mixing palette
should be white. A coloured palette will affect your perception
of the colour.

Create a Colour Wheel

To understand colour and colour mixing it is advisable to make
your own colour wheel. If possible use artists' watercolours and
good quality hot pressed watercolour paper. Use sufficient paint
to create strong colours; a thin watery colour wheel will be
of little use for mixing and matching purposes. The colour wheel
will be a useful reference when you are mixing colours to match
those on your specimen.

It is generally understood that the three painting primary
colours are red, yellow and blue; they are called primary colours
because they cannot be created by mixing, only by manufacture.

By using combinations of the three primary colours we are
able to create secondary colours. Mix any two of the primary
colours together to create the secondary colours, which are
orange, (red and yellow) violet (blue and red) and green (blue
and yellow).

By mixing equal amounts of a primary colour with a secondary
colour we get the tertiary colours, there are six of these in the
colour wheel: red/orange, yellow/orange, blue/violet, red/vio-
let, blue/green and yellow/green.

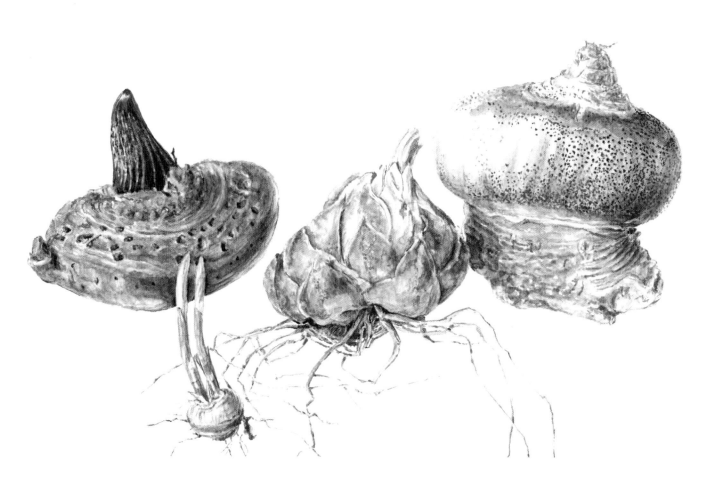

A transparent wash has been added to the bulb in the centre of this study of bulbs and corms. The wash creates a glow and the bulb becomes the focus of the design. (Suzanne Osborn)

Opposite or Complementary Colours

Complementary colours are the ones that lie opposite each other on the colour wheel. Green is the complementary of red, orange is the complementary of blue and violet is the complementary of yellow. A little of the complementary colour added to its opposite colour will have a neutralizing effect making it appear dull. If more of the complementary colour is added a range of greys and browns will be created.

Create Colour Lines

To discover all the hidden colours between any two individual colours you can create a colour line by gradually adding one colour to the other and recording the result. These records can be repeated with different blues, reds and yellows from your box. They can provide a useful record for matching watercolour paint to plant material. Always label your colour lines so that you can remember which colours you have used. I keep swatches of colour lines for reference when I am colour matching. Store your colour lines covered when not in use to reduce the risk of fading if any of the colours used are fugitive. A colour on your colour line that exactly matches your flower or leaf is worth noting by writing its name on the edge of the colour swatch for future reference.

Winsor & Newton produce an excellent hand-painted colour chart which can be used with their watercolour paints. Each colour is graded from light to dark. Product information is available to indicate opaqueness, transparency, and the degree of permanence.

The best time to match colours is in the morning, using north light. Ideally colours should be matched when the eye is not fatigued. It is tempting to continue painting when natural light levels are low, but it is difficult to see true colour unless a lamp is used with a daylight simulating bulb.

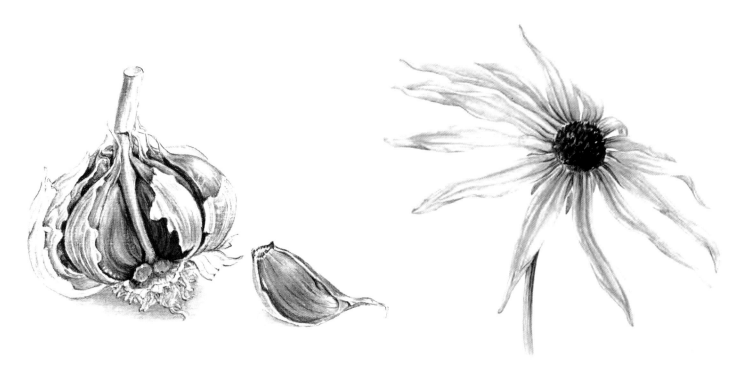

Subtle shadows have been used in this study of a garlic to create an illusion of whiteness. Opaque white paint can be used for veins, hairs and spines if necessary.
(Shirley B. Whitfield)

A little violet into yellow can give a satisfactory shadow colour.
(Judith Pumphrey)

Warm and Cool Colours

A range of colours can be mixed from the three painting primaries. Pure colour cannot be reproduced in watercolour form, so each primary colour will have a slight bias towards another colour. This means each colour has a bias or colour temperature, which is either warmer (e.g. redder) or cooler (e.g. bluer). By extending the three colours to six and using two blues, two reds and two yellows chosen for their warm and cool qualities, we can extend the range of secondary and tertiary colours to give a useful range of colours for the artist. Many artists have their favourite colours for basic mixing, and manufacturers often supply a list based on their own watercolours.

A basic list of six colours could be:

warm colours	French ultramarine
	cadmium red
	cadmium yellow
cool colours	cerulean blue
	permanent rose
	cadmium lemon

It should be noted there is no manufacturers' standard across the industry, so cerulean blue for example may vary depending on the individual maker.

Hue is another name for a colour such as red, yellow, green, etc.

Value refers to the lightness or darkness of a colour in relation to black and white. Yellow has a light value whereas blue has a dark value.

Tint

To lighten a colour in traditional English watercolour painting, white is not added to the pigment as this would make the colour opaque. To lighten a colour, gradually add clean water to the mix to dilute it until the correct strength is achieved. These lightened colours are known as tints. Always test the colour on paper; simply looking at the puddle of colour in the palette is not a satisfactory way to judge the correct strength. The colour will usually paint out lighter than the puddle of paint you can see in the palette.

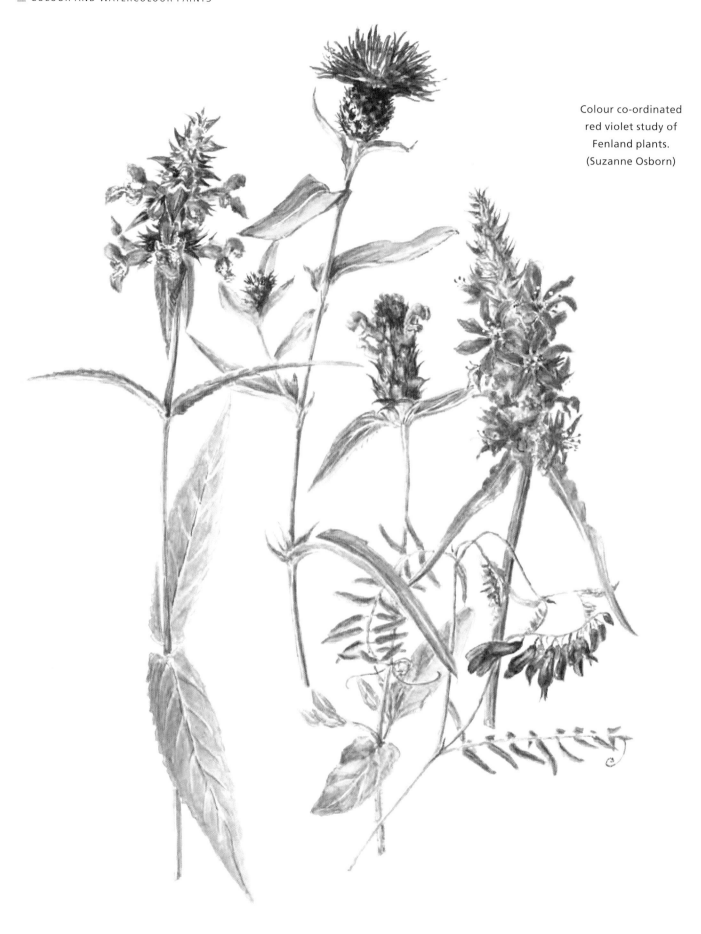

Colour co-ordinated
red violet study of
Fenland plants.
(Suzanne Osborn)

Transparency

The degree to which light passes through a colour is known as transparency. Thin layers of watercolour paint will be reflected by the white of the paper on which they are painted. When one colour is painted over another the colour beneath should show through.

Opaqueness

Not all watercolour is transparent; if colours contain white they will be opaque. Gouache, which is manufactured opaque watercolour, can be diluted to make the colours more transparent, but they will look dull and are generally chalkier in appearance than artists' watercolours.

Producing Individual Hues

BLACK

A mixture of the three primary colours will produce black; mix the red and blue first then add a little yellow. This mixture can be watered down to create a range of neutral colours in dilution. A mixed black is preferable to a black straight from a tube or a pan as it is a livelier colour and not so intense. French ultramarine and burnt sienna mixed together will create a lively black.

WHITE

Opaque or gouache white can be a useful addition to your palette and can be used to paint spines on a cactus, hairs or minute veins. Try using process white or designer's gouache white for greater covering power. When you are using white from the watercolour ranges use Chinese white or titanium white. Do not use white to lighten colours; water is used for this purpose in pure watercolour studies.

GREENS

One of the most difficult mixing problems in botanical illustration is to find the right green to match the greens found in nature. Rarely do the manufactured colours match the natural greens of the foliage around us, and even when we think we have a good match it usually has to be adapted by adding a little more yellow or blue to truly reflect the greens we find throughout the natural world.

Understanding the colour is helpful; there is really no substitute for making your own charts and recording your mixing experiments carefully. By creating the mixes yourself you begin

Blue violet study of a *Dendrobium* hybrid. (Peter Gravett)

to appreciate how subtle changes in the colour are affected by the amount of pigment added to each mix. Make yourself a greens chart. Mix together the blues and yellows in your palette using equal proportions. Mix each blue with all the yellows and make a record on your chart. This will give you a quick reference for the greens available to you from your own palette. Leave extra spaces on your chart for more colours to be added. Gradually create colour lines of all the yellow and blue mixes. After a while you will be able to see a whole range of greens that you can mix yourself. A blue/yellow colour line that matches the range of greens in your plant can be used for all the different greens throughout the plant. The fresh foliage will be at the yellow-green end and the older foliage at the blue-green end.

Try mixing the darker blues, including indigo, for darker greens. Payne's grey gives interesting green-grey colours when mixed with lemon yellow. Ready-made greens such as oxide of chromium, viridian and perylene green can give an interesting range of greens with the addition of blue or yellow.

Green is opposite red on the colour wheel. The addition of a little red or reddish brown will tone down and darken a green to make a useful shadow colour.

SILVER GREY AND GREY-GREEN AND BLUE-GREEN

Davy's grey is a soft slate grey straight from the palette. Mixing cerulean blue with burnt umber will give a silver grey colour, or try using Payne's grey and lemon yellow. French ultramarine and

Naples yellow will also create a grey mix. Grey is basically a combination of the three primaries in the correct proportions. To create a blue-grey try mixing French ultramarine with permanent alizarin crimson before adding a dash of cadmium yellow.

YELLOWS

Yellows usually paint out very clearly. To shadow a yellow on a daffodil, freesia or crocus try using Davy's grey, which is a soft slate grey, or add a little blue violet to the yellow mix. Adding too much will make the colour look muddy. Alternatively underpaint the shadows with a slightly darkened yellow first. Two yellows can be mixed together if you are unable to match the yellow of your flower from your palette. Yellow painted over a pencil line will enhance the line so it is advisable to dab away as much graphite as possible before you start painting. Alternatively paint just inside the pencil line and rub it out once the paint is thoroughly dry.

PINKS AND VIOLETS

This is another colour range that can cause a few problems. Some of the manufactured pigments in this range are fugitive and should be used with care if the completed work is to be exhibited. A bright sugar pink known as opera is available from Holbein paints; it is quite unnatural on its own but combines well with a range of blues to give clear and bright colours in the violet range. Winsor & Newton have a similar colour called opera rose. Both these colours are considered fugitive, but there are few paints which can reproduce the colours of geraniums, campanulas and other flowers with their bright red and blue violet petals.

REDS

To match the red of your flower hold a swatch of the nearest red from your palette close to the flower and decide whether you need to modify it in any way. To capture brilliance you may need to place another flower head behind the first, placing the second in shadow so the first is visibly thrust forward.

BLUES

Blue colours are generally reliable and they have an interesting history. Genuine ultramarine was originally made from the precious stone lapis lazuli, which was very expensive. In 1826 an alternative and cheaper synthetic colour was discovered by J.B. Guimet, a Frenchman after whom the colour is now named: French ultramarine. This is a very good colour to use in basic mixes.

Indigo blue has a colourful history. The Dutch East India

Company and the English East India Company imported large amounts during the sixteenth century; trade continued until synthetic indigo was discovered at the end of the nineteenth century when the demand for natural indigo decreased and the market collapsed. This colour can be mixed in the palette using French ultramarine and burnt sienna; a little added to a green mix will help to darken it. Cerulean blue mixed with different yellows gives a range of fresh greens, but it can be gummy and sometimes a streaky effect is created when it is painted onto paper. For some flowers you can mix two blues together. For example, try French ultramarine and cerulean blue for cornflowers.

Permanence of Watercolour

There is more product information from the paint manufacturers today than in the past, and the lightfast ratings of watercolours are usually stated. Colours that fade are known as fugitive. Colours that do not fade are known as lightfast. You can do your own lightfast test by painting your watercolours on watercolour paper, noting the date, then covering half and placing them on an inside window ledge for a few months. Check at regular intervals, keeping a record of the dates.

Reminders

1. Some watercolours are fugitive and fade in time. The degree of permanence is indicated on colour charts produced by well-known makers.
2. Large particle colours sit on the paper surface and can be easily lifted from the paper. Fine particle colours penetrate the paper's surface causing them to stain the paper, making them more difficult to remove.
3. Diluting the paint will create a range of tints; as more water is added to the paint mix the paler the colour will become.
4. To darken a colour and to create a shadow colour add a little of its opposite on the colour wheel.
5. Watercolour dries lighter in tone than when first applied and still wet.
6. Keep your water jar replenished with clean water. Water even slightly tinted is a colour in its own right and will affect colour mixes.
7. To retain purity in your mixes use distilled water to blend colours together.

OPPOSITE: A striking study of *Rhododendron simsii* 'Benishimai'. (Yoko M. Kakuta)

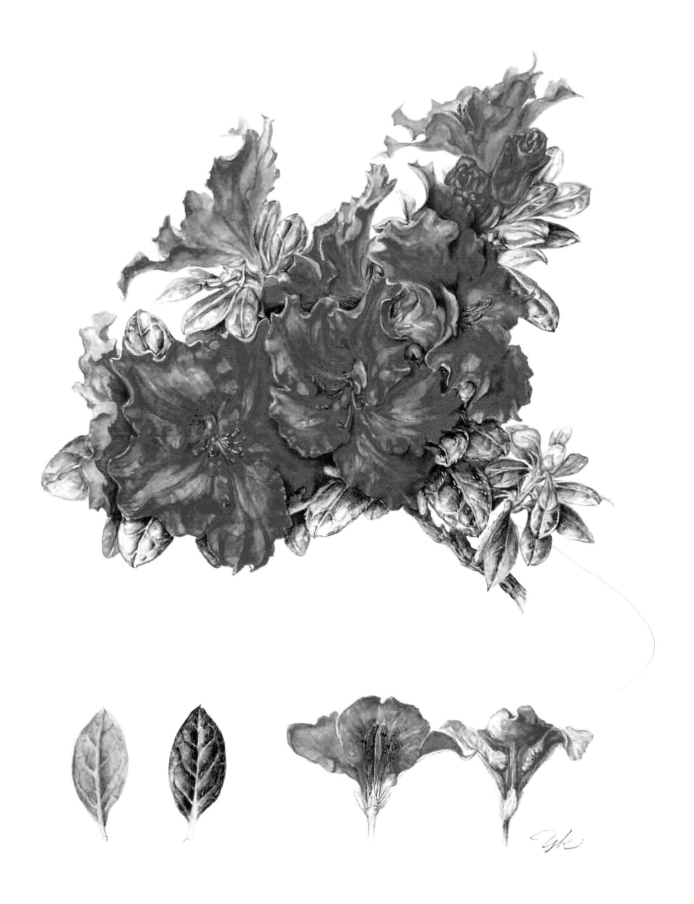

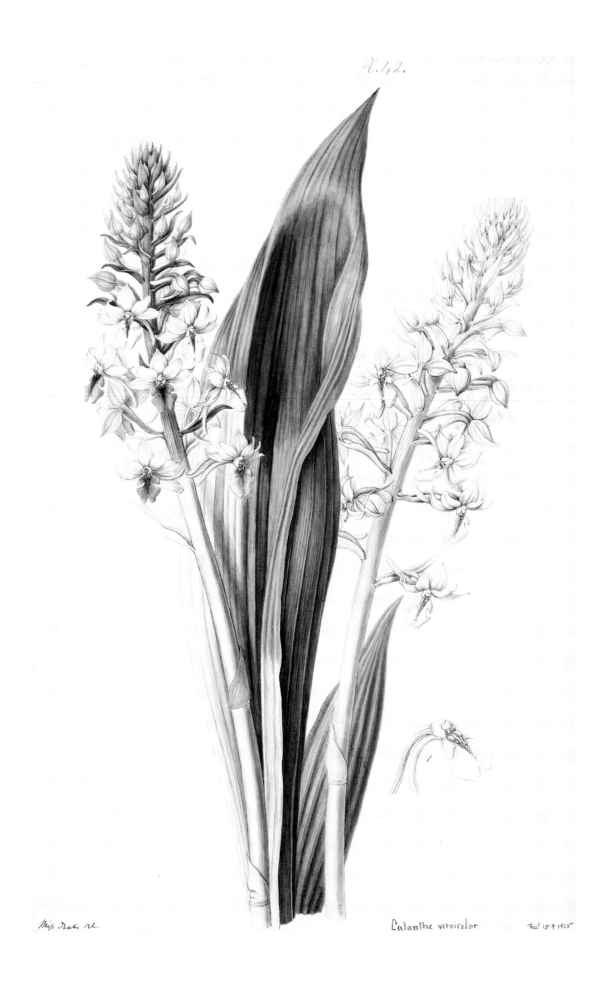

Pl. 1, 2.

Calanthe versicolor

WATERCOLOUR PAINTING TECHNIQUES

To create a successful picture you need to find a method of working and an approach with which you feel comfortable. Botanical illustration is an exacting art, but care should be taken not to become technique ridden, otherwise the painting becomes stiff and stilted, and the character and life of the plant is lost. There is the danger of repeating a formula which simply becomes a repetition of the same technique. Every leaf will appear as same as the one before, and the plant will appear lifeless. Continual observation of the plant must not be disregarded. Aim for the true representation of a vibrant living plant.

Making it Look Alive

Paramount in an illustration is your ability to capture the life of the plant. Careful observation is required to note how the light plays around the whole plant including between the leaves and flowers. The effect of light shining on your plant will help to create a three-dimensional illustration. Shading everything on the right without looking at the actual specimen will make the final illustration look unreal. Sometimes veins on a leaf disappear in light or shadow, and flowers at the back of an inflorescence are not seen in such detail as those at the front. Shadows on stems depend on the angle of the plant and positioning of the leaves. The shadow should not be determinedly stuck on the furthest edge away from the light. It is the artist's response to the living plant that draws the viewer in to look at the picture again and again.

Looking and responding is essential, but progress cannot be made until some of the basic painting techniques have been mastered. You should work on building up knowledge of colours

A drawing by Sarah Anne Drake, a nineteenth century artist working for John Lindley. The effect of under-painting in grey to establish light and dark areas, shape and form is clearly shown.
(© Royal Botanic Gardens, Kew)

and colour mixing. You will need to know how to mix the correct amount of paint and understand the effect of watercolour paint on watercolour paper. It is very important to gain experience in the handling of watercolours before attempting to paint a plant portrait. Once confidence with watercolours is acquired you need to develop a successful method of applying them to the paper. Experiment with different approaches until a method is found with which you feel comfortable.

Selecting Your Technique

We are all individuals, and there is not one method of painting that suits everyone. To follow a strict formula that guarantees success may sacrifice individuality, stifle natural flair and suppress the imagination. You should always be in control of your own work, which should be fresh and exciting.

In the 1960s, when I was training as a teacher, the emphasis was on young people learning by discovery; the classroom was an exciting place but to be successful the teacher had to be highly motivated and organized. It was believed that if the teacher prepared the right environment the children would learn; the old methods of rote learning were disregarded and a challenging new era began. In practice the ideals turned out to be disastrous for some children. Today progress is carefully monitored and more structured programmes of learning have been implemented, but imagination and individuality are often the causalities of this approach. It is a careful balancing act to be able to give enough instruction without dominating and managing the outcome and stifling creativity. Strictly following the rules can lead to everyone producing similar work. As adults we should learn from the experience of others, develop our own individual approach and keep an open mind.

Outlined below are some of the watercolour techniques that are required to be able to illustrate a plant. Practise them, evaluate them and decide for yourself which would be the most useful for you. Be prepared for some failures and learn from your

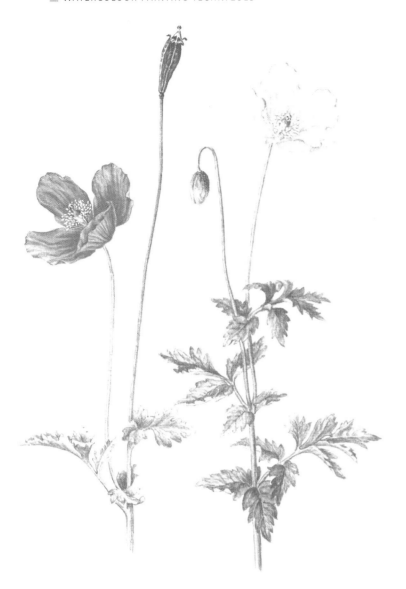

Yellow flowers are difficult to describe as the shadows can look dingy if they are too dark. This illustration of Welsh poppies is fresh and lively and the technique does not appear laboured. (Shirley B. Whitfield)

A personal response to a single rose hip, which appears to dance on the page. (Gael Sellwood)

mistakes. A method that is successful for one artist may be a disaster area for another. Take your time, experiment, and keep all your efforts for future reference and comparison.

Loading a Brush with Paint

Brushes made from natural hair hold more paint than synthetic brushes. The scales on the natural hairs trap and hold moisture. Sable brushes, although expensive, are more desirable than those made with a synthetic material; more paint is held within the belly of the brush and it does not need to be continually replenished. You should use a brush size appropriate to the area

to be covered. A discernable edge could appear where the new brush-load of paint begins if you run out of paint before the area is completed. Large leaves may require a larger size brush, a 6 or a 7. Always ensure the tip of the brush retains its point; a sable brush is no good if the point has been worn down.

To pick up the paint from your palette lay a moistened brush in the puddle of paint; the paint will soak into the brush. Lift the brush from the puddle of paint and hold upright for a moment with the hairs pointing downwards. Should the paint drip from the end there is too much on the brush. Sometimes the point of the brush swells but does not drip; in this case there could be an excess of paint which you might not be able to control. Drag the tip of the brush over the edge of the recess in the palette to

release any excess paint into the original puddle. Test the brush on a piece of spare paper or in the margin of your artwork. It is not advisable to drag the brush over the edge of the water pot as this not only wastes some of the paint but may leave a residue on the edge of the pot that could be picked up inadvertently at a later stage. Always test the colour and tone before progressing with your artwork.

A Watercolour Wash

A wash is a mixture of watercolour paint and water which is applied to dry paper. The paper can be dampened to allow the paint to flow more evenly across the surface; this avoids the brush being dragged across the surface creating uneven painted areas with white patches. Your drawing board and paper should be held at a slight angle when applying watercolour paint so that it flows downwards and does not sit in a puddle on the surface of the paper. Avoid too much moisture; if the paint collects in a puddle or blob in the bottom corner of the area you are painting, apply a clean dry brush to the excess paint so that it can be soaked up and removed.

APPLYING A WASH

The first washes need to be kept very light indeed. Match the colour you require and transfer some of the mixed paint to another well in the palette and dilute with water. Knowing how much paint to mix up is a concern for all artists and on the whole it does become easier with practice; it is not unusual for people to mix too little paint and then struggle to recreate the colour and tone required. Mix more paint than you think will be required if you are a beginner. Do not worry about wasting paint; if the paint dries in the palette at the end of the day it can be resurrected later by adding a little water.

The tone you use for your first washes should be much lighter than the final colour. There will be a few layers of paint to build up in the light and dark areas before it begins to look like your specimen. The palette does not need to be washed clean if the painting is still in progress; a covering of cling film over the palette will stop any dust collecting until the next painting session.

LAYING DOWN A FLAT WASH

A flat wash is a basic technique which is very useful for establishing the first light washes over each part of the plant. These first washes lightly block in each positive area and help to avoid a possible catastrophe later when a space between leaves might be painted rather than the leaf itself.

To practise the technique, load the brush with paint. Test the amount of moisture on the brush and check the tone before

The spring foliage of a tree peony captured in pencil and paint.
(Valerie Oxley)

Examples of the gradual layering of flat washes to create depth, and various applications of the graded wash technique. These are two essential watercolour techniques that require practice.
(Karen Colthorpe)

Blending colours from dark to light helps to model shape and form as in this study of autumn fruits. The contrast between dark and light emphasizes the rounded shapes. (Suzanne Osborn)

An apple painted using the dry brush technique to model shape and form. (Lionel Booker)

proceeding. Continue with the side of the brush to the paper but slightly lifted at the ferrule end. Cross the paper for a short distance of about 5cm (2in) with the brush; move slightly downwards at the far edge and return the stroke, slightly overlapping the proceeding brush stoke. Move backwards and forwards in this fashion until the area is covered with a flat even wash. Alternatively pull the brushstrokes downwards and overlap from side to side. When you are painting a leaf with serrations it should be possible to accommodate these as you approach each edge; the brush may need to be lifted slightly in order to fill in the serrations with the point of the brush. Ensure that the whole of the first layer is dry before proceeding with a second application. The under layer may lift from the surface of the paper if it is still damp; drying times can vary according to the warmth of the room and movement of air.

EXERCISE: USING THE FLAT WASH TECHNIQUE

Select a cutting with a flower and a number of leaves. Mix a sufficient amount of a single colour to reproduce the plant on the watercolour paper. Paint a picture of your cutting on the paper without drawing it first. Start at the top of the plant and work down to the bottom. Try to keep the watercolour flowing as you work. The finished study will be a silhouette in paint of your original plant specimen. This exercise will help you to familiarize yourself with the brush and control of watercolour paint.

LAYING DOWN A GRADED WASH

A graded wash is a useful technique to master as you can move between areas of dark and light without spending time building up flat washes and waiting for them to dry. It can be used to model shape and form where appropriate. There are various ways to apply a graded wash; you will find some more successful than others. Practise each of the following methods and decide for yourself which is the most effective.

1. Load the brush with paint and move backwards and forwards across the area as with the flat wash. When you want the tone to lighten dip the point of the brush into clean water. Remove a small amount of moisture by touching the brush on a paper towel or tissue. Continue with the painting, picking up the edge of the previous brush stroke as you progress. Dip the point of the brush in clean water as you proceed to increase the tonal gradation as you move across the paper. This is a useful technique when modelling larger stems such as those of the lily. Turning the paper so that the stem lies horizontally across the page will make the technique easier because the moisture flow along the stem is downwards. It is possible to add a little paint to the

lighter side of the stem by turning the paper around so the darker side appears at the bottom. To deepen the tone a second or third graded wash can be applied once the first is dry. When the paper is too dry dampen it again in the area where you are working. The paper should only be damp, not shining with water or glistening.

2. Another method is to mix a range of tones and start with the darkest. Instead of picking up clear water to lighten the colour the next lightest tone in the palette is used. The tonal range is more gradual using this method and avoids the possibility of a sudden change in tone. To practise this technique, mix the paint to the colour required as in the first method and transfer some to another well in the mixing palette. Dilute the paint in the second well and repeat this procedure by diluting paint from the second well to create a third one. You should have three wells of the same paint but varying tones of lightness. Start with the darkest tone and pick up a lighter tone of the same colour as you proceed. This could help to create an even gradation from dark to light tones. The amount of moisture has to be controlled, and it may be advisable to touch the brush on absorbent tissue to remove excess paint as you move from one tone to another.

3. A method that can be employed for small areas is to let the paint run out of the brush naturally. Dampen the paper first, then proceed with the backwards and forwards painting until the strength of the paint in the brush diminishes naturally and the tone lightens. When you are using a large brush it may be necessary to simply touch the tip of the brush on a tissue to remove excess paint as you work; this should be sufficient to lighten the tone.

Dry Brush Work

Dry brush is a misleading term, as it requires the use of a moistened brush on dry or slightly dampened paper. Tiny brush strokes of a light tone are employed. They should be placed next to each other and painted in the direction of the shape of the plant. When the painting is dry, modifying washes or glazes can be overlaid to give a more even effect or heighten colour as required.

Dry brush work was adapted from the miniaturists. It was an early method of applying paint by botanical illustrators when they worked with body colour, which is similar to today's gouache. It can be a painstaking technique for larger plants, and application may take several hours. However, for those artists

A cutting of honesty showing a wide range of tones to describe and understand the shape and form of the plant. Notice the delicate shading on the translucent silicula. These remain on the stem once the seeds have been dispersed.
(Margaret Wightman)

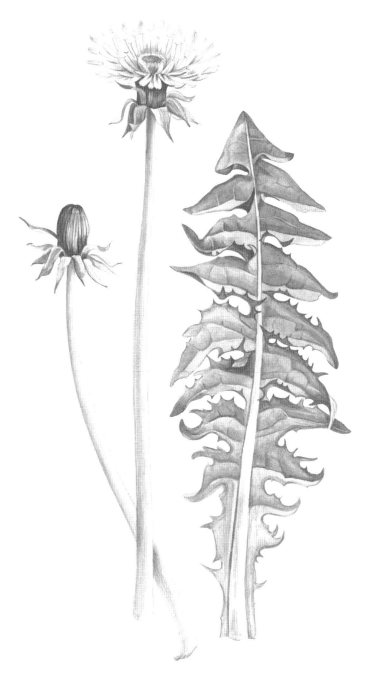

Tonal study of a dandelion in watercolour with light falling from the right. (Jacqueline Dawson)

Wet on Wet

Wet on wet refers to painting with a wet brush on wet paper. This technique can be used to merge colours without creating unwanted hard edges; it can be used for a rose petal where one colour merges into the next. The two colours are dropped carefully into the moistened area and allowed to merge on the surface of the paper. The paper can be turned around to help the flow of paint and allow the colours to spread evenly. Highlights can be created by leaving areas of white paper unpainted. Edges will merge naturally into the unpainted area so that no hard edges appear. The amount of moisture on the paper or brush is critical. When the paper is too wet the paint runs into a corner. When it is too dry it does not flow evenly and the effect of merging colours is lost.

The success of the technique will depend on the type of paper used. When the paper is too absorbent and dries out too quickly it is difficult to obtain a satisfactory result. Do not be tempted to touch up the area before it is dry as the intrusion of the brush will ruin the effect.

Lifting Off

Paint can be removed from dampened paper to reveal the white paper underneath. It can be lifted out with a paintbrush, rag, tissue or cotton bud. This technique can be used to create the highlights on shiny leaves or berries, or to make corrections.

Modifying Wash or Glaze

A modifying wash or glaze can be added to the illustration once the original paint has dried. A thin layer of transparent watercolour paint, in a modifying colour can be applied swiftly over the painting, allowing the underlying colours to shine through. This will enhance or blend colours. When a second layer is required, allow the first to dry thoroughly before proceeding.

Under Painting

Tonal under painting is another technique. The form of the plant is painted first in a shadow mix using a neutral blue-black colour. Alternatively the shadow colour of a particular leaf, stem or flower can be used for the under painting. The tones should be graded from light to dark. The lightest tone in the painting should be left as white paper. Some white paper should be left in each area, otherwise the finished painting will look too dark and dull. The technique requires practice to be successful, particularly with the grading out of the shadow colour. When it is

with patience and who prefer to be in control throughout the whole process of the painting stunning results can be obtained. It is possible to apply dry brush work at any stage in the painting. It can be used from the beginning or it can be employed after the first layers have been applied or at the end of a painting to help model form and to put in the finishing touches.

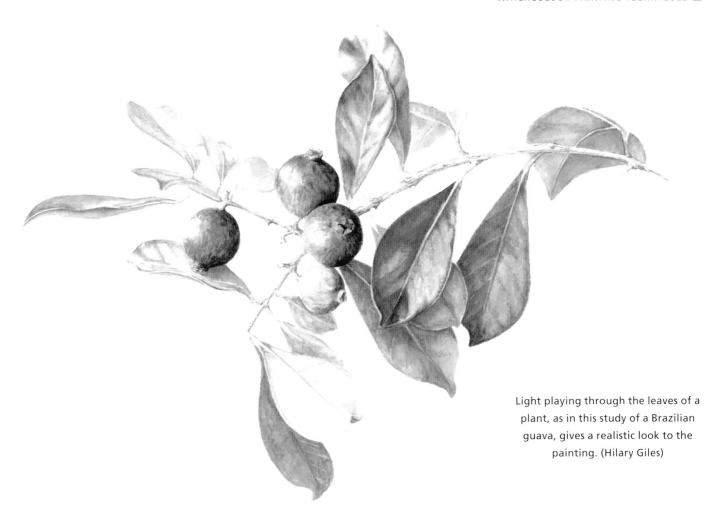

Light playing through the leaves of a plant, as in this study of a Brazilian guava, gives a realistic look to the painting. (Hilary Giles)

too dark the shadow colour remains dominant in the finished painting. When it is too light it is covered completely by the paint during the first application of colour and the effect is lost. It is a straightforward technique and is particularly suitable for people who like a structured approach.

EXERCISE: CREATE A MONOCHROME STUDY

Select a plant cutting with leaves and a flower and draw it in pencil outline. Mix sufficient neutral blue-black colour and use this it to paint a monochrome study of the plant on watercolour paper. Use different tones to create shape and form. Start at the top and continue to the base of the plant. The finished study should show the shape and form of the plant, but not its true colours. This exercise can help you to model the plant on the page to practise the under painting technique.

Aerial Perspective in Painting

In painting, aerial or atmospheric perspective is the term given to the way the atmosphere makes distant objects appear less distinct and more bluish than they would be if nearby. Leonardo da Vinci called this 'the perspective of disappearance and the perspective of colour'. When you look across a landscape into the distance you will notice that the further away your eye rests the lighter and more bluish grey the landscape becomes. When you turn to look at objects close to where you are standing, you will notice that they are clearer, brighter and more distinct with more detail and colour. Should you gradually lift your eyes from the foreground you will notice that as your eye travels across the landscape the change is gradual. Contrast and colour diminish as we look into the distance.

The effect of aerial perspective can be shown in a botanical painting by using less intense or bluish colours for parts of the plant which are in the background. Areas that are more distant from the viewer can be painted with less detail and colour.

Painting a Botanical Study

All botanical paintings should be preceded by a careful outline drawing of the plant in pencil on drawing paper. This is transferred onto watercolour paper.

When you are working indoors it is essential to have your plant

Iris danfordiae, a welcome sign of spring. Dissections in pencil can be added to watercolour studies. (Valerie Oxley)

specimen lit from a single light source. This will enable you to see the light and dark areas, the highlights and the shadows. When natural light is not available you can use an Anglepoise lamp with a daylight simulating bulb to illuminate your plant. The transition between light and dark areas should be gradual.

It is important to have a spare piece of paper, similar to the one you are working on, to test colours, to check the amount of moisture on the brush and to practise various effects as you proceed. You should aim to work from left to right and from top to bottom of the artwork so that you do not smudge the paint.

When flowers are included they should be tackled early in the painting in case they alter; buds can open and petals fall off at the most inconvenient moments.

Commence with the lightest colour you can see on each part of your specimen. Test the colour is correct by painting a sample on the same type of watercolour paper. Let the colour dry and hold it against the plant. When the colour matches transfer some of it into a separate well of your palette and dilute with water. Check you have enough of the diluted colour to paint all the areas requiring that colour. The diluted colour should be transparent when applied to the paper and light enough for the white paper to shine through. Colour that is too heavy and strong will block the transparent effect, and the painting will become dense and dull. Using too much paint is one of the main problems people encounter when starting to paint. Watercolour painting requires patience. Resist the desire to achieve the final colour too quickly.

Use a brush to suit the size of the area to be covered. Dampen each area before you start to add colour; this will help the paint to flow over the paper more easily. Aim to work just inside the pencil lines and only attempt one area at a time. Do not paint adjacent areas before the first area is dry; moisture will seep from one area to another and create a frilly water mark. The colour will run to the bottom edge of the area and gather in a puddle if the paper is too wet.

Add the diluted paint swiftly and evenly, slightly overlapping each brush stroke and keeping the paint moving until the area has been completed. Sometimes a small blob of paint is pushed along ahead of the brush. Lift the brush swiftly when you have finished painting the area to remove the excess paint. Alternatively dry your brush on a tissue and put the point into the blob of paint to soak it up. Do not leave the brush in this position for long otherwise it will start to soak up too much paint leaving a light area in the corner. Excess moisture could run back into the painted area, pushing back the pigment and causing a watermark if is not dealt with it immediately.

The first layers should be very light in tone. Once you have started with the wash do not be tempted to return to the beginning of the area to spread the paint more evenly or to fill in a gap. Continue with the painting until the area is completed. Going back to try and spread out the paint may remove it from the middle of the area and push it to the edges. This will leave a hard line of colour around the outside of the area. This effect can also occur if there is too much moisture on the brush, when the water will push the pigment to the edge.

Ensure the paper is dry before the next application of watercolour. The first layers will not be disturbed if the previous layer is absolutely dry before continuing.

When applying the second layer use the same mix as for the first wash. The second wash should not cover the first wash completely. It is not the same procedure as painting a room with an

under coat completely covered by a top coat. Wait until each layer is dry and continue to build up the layers by pulling back into the shadow areas like a series of steps; the paint will build up in the shadow areas with each application. This will give a gradual tonal range from light to dark across the area which is being painted. Use a second brush slightly dampened to merge the edges as you proceed. Highlights can be left white or painted with pale blue to indicate the reflection of the sky. Under painting with pale blue works particularly well when you are painting shiny leaves.

Continue to build up the layers to show a gradation of light to dark across the whole plant. Small brush strokes can be used to further model each part of the plant using the dry brush technique.

Check your plant, looking for areas where there might be an interchange or reflection of colour. Hints of colour from the flower may be seen on the stem or leaves.

The final colour can be adjusted once all the paint is dry by applying a modifying wash. This involves the application of a flat wash of diluted paint over whichever part of the painting requires it. A contrasting colour can be used to help lift the underlying colour. For example, green gold, or transparent yellow might be considered for leaves, and opera rose for lifting the vibrancy of violet coloured flowers. A wash of clear water can be applied to the painted areas once they are dry to help blend the brush-stokes.

Bring each part of the plant together gradually. Try not to complete one part before moving onto the next because this often results in some areas being overworked. Finally check your painting, tidy up edges and sharpen up the detail. Leave your work to dry and do something else before looking at it again

with fresh eyes to see if there are any parts that might benefit from a little more attention.

Reminders

1. Draw your plant on drawing paper and correct as necessary.
2. Check the composition and transfer the drawing to watercolour paper.
3. Check the transferred drawing before proceeding with the watercolour washes.
4. Look for the lightest colour in each area and paint each separately using a flat wash of diluted watercolour. Do not paint adjacent areas at the same time; wait until the first is dry before proceeding.
5. Indicate shape and form by building up the colour gradually by working from light to dark. Strengthen the colour in the shadows on the stems and leaves using the graded wash technique.
6. Build up the shape of the plant using the dry brush technique in areas of shadow.
7. Heighten and modify the colour as you progress, using modifying washes to blend brushwork and enhance the overall colour. Check the underlying paint is completely dry before you proceed.
8. Look for the reflection and interchange of colour between the flower and other parts of the plant.
9. Enhance detail selectively to strengthen shadows and emphasize form.
10. Name the plant and sign your work.

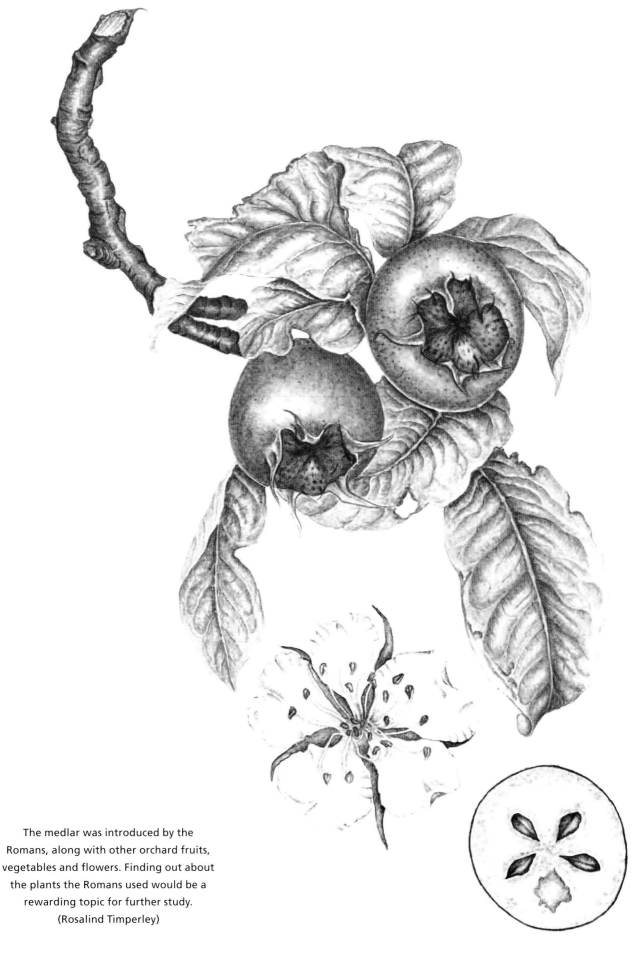

The medlar was introduced by the Romans, along with other orchard fruits, vegetables and flowers. Finding out about the plants the Romans used would be a rewarding topic for further study.
(Rosalind Timperley)

WHAT DO I PAINT?

There are many interesting plants to illustrate; they can be described individually or presented together in a variety of ways. Outlined below are a number of ideas to help and inspire you to pursue interesting projects of your own.

Scientific or Academic Illustration

You may wish to illustrate a plant in a scientific manner. All aspects of growth could be shown, from the germination of the seed through to the flowering of the plant and development of the fruit. Scientific drawings of this kind are usually executed in pen and ink. However, for your own interest you could use a variety of media such as pencil, coloured pencil, pen and wash or watercolours.

Stella Ross-Craig was well known for her scientific drawings. She was an excellent draughtswoman and in the late 1940s was commissioned to illustrate the entire British flora. Many of the plants were drawn from dried specimens lodged in the herbarium at the Royal Botanic Gardens, Kew. The drawings were published in thirty-one parts and took several years to complete. They were started in 1948 and finished in 1973. Although there is a reference key there is no additional text; the clarity of the drawings gives all the information that is required.

Today many scientific drawings are reproduced in journals. *Curtis's Botanical Magazine*, the journal of the Royal Botanic Gardens, Kew, publishes black and white drawings of dissections of plants alongside watercolour illustrations of their habit. The commissioned artists are asked to follow guidelines so that each illustration is executed in a similar style throughout the journal.

Plants in their Natural Environment

Illustrating plants in their habitat rather than individually makes an interesting study. The theme could be used to illustrate plants in their environment, such as plants of the salt marshes, sand dunes, fens and moors and even waste land in urban areas.

In the late 1960s, the artist Barbara Nicholson was approached by Oxford University Press to produce illustrations of flowerless plants. These were for a publication written by Frank Brightman. The work heralded a new departure for botanical illustration; instead of depicting a number of individual illustrations the plants were grouped together using an ecological approach. Once the book was published Barbara and Frank continued to develop their work together. In 1970, after Frank became the Educational Officer at the Natural History Museum they put forward an idea to the Director to produce ecological wall charts showing plants in their natural habitat.

The first charts were published in 1972 and showed not only the plants and their habitat but also seasonal changes. Spring flowering plants were shown on the left, summer flowering plants in the middle, and plants that flower in the autumn on the right. The charts were successful not only with the educational institutions; they were also popular with the general public. The Natural History Museum considered developing the wall charts to include American plant communities, and in 1977 Barbara was invited to visit the Hunt Institute for Botanical Documentation in America. Sadly the idea did not materialize. Barbara's health was failing, and she did not make the journey; she died the following year in 1978.

Following Barbara's innovative ideas studies of plants in their habitat through the seasons would make an interesting and absorbing study. One could start in the winter, the dormant period, progress through the spring and summer and complete the cycle in the autumn with falling leaves and the development of fruits and seeds. Notes could be kept to show the dates when the studies were drawn. The illustrations would become a useful botanical record. A larger study could be undertaken by a group of people over a longer period of time, and the remit could be expanded to show annual changes. It would be of great value to compare the flowering of plants with seasonal changes as we struggle to understand the affects of global warming.

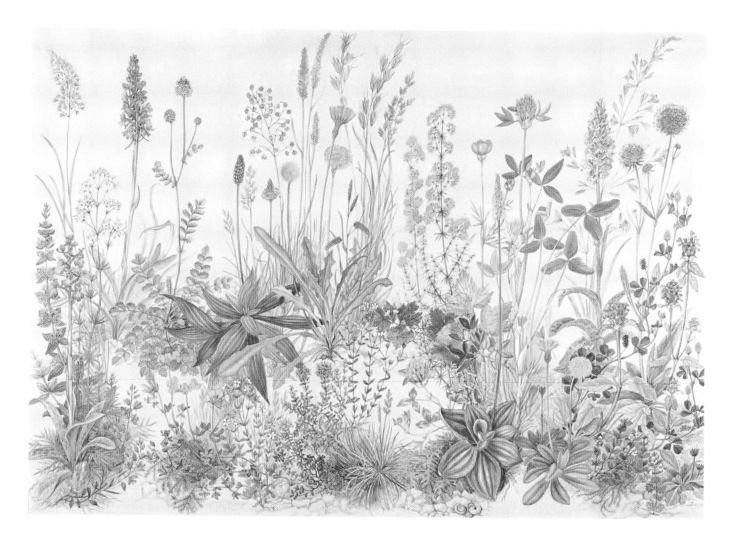

For Natural History Groups or Wildlife Reserves

Joining your local natural history society and offering your services as a botanical illustrator would not only win you friends but open up another interesting avenue to pursue. Payment may not be forthcoming but the lessons learned would be enough reward. Drawing is a very good way to get to know and understand unfamiliar plants.

Occasionally illustrators are commissioned to produce story boards which show plants and trees in a particular woodland or area of natural beauty. The boards are provided for public education and interest. The rarest plants in the area are usually omitted, to discourage people who may wish to seek them out and uproot them.

Plants Found by Past Plant Collectors

Plant introductions, and in particular the plants brought in by the plant hunters, make absorbing studies for drawing and

In a letter to the Hunt Institute in 1977, Barbara Nicholson wrote, 'This is the picture I did on my own and took to the Museum to "sell" them the idea of doing charts like this.' This is a picture of flowers of the Chalk Downs.
(Courtesy of Hunt Institute for Botanical Documentation, Carnegie Melon University, Pittsburgh USA and with kind permission of Mrs Jane Coper)

research. There are wonderful accounts of the travels of explorers, such as George Forrest, Ernest 'Chinese' Wilson and Frank Kingdom Ward amongst others. The plants they introduced are usually well documented. You could make enquiries to see if plants are still growing in some of the botanical and large private gardens whose previous owners may have sponsored an expedition. With permission you may be allowed to draw some of the offspring of the original introductions or even the original plants if they are still surviving.

Medicinal Plants and Early Herbals

The early herbals are publications where some of the first drawings of plants can be found. The drawings were intended to help people identify plants that had medicinal properties. Very often the drawings in these early herbals are distorted and a far cry from the original plant. Instead of making new drawings directly from a plant, the artists simply copied an existing study. The copy of the first study was repeatedly copied, and over a period of time the drawings of the plants became unrecognizable against the living specimen.

Plants are still used in research for medicinal purposes to continue our fight against human disease and infections. Using early herbals for inspiration you could study plants that are currently used in medicine. The study could take you on an imaginary journey around the world and through the ages. You could explore the origins of herbal folk medicine and compare the cures to those used today. It would be interesting to study how plants are used medicinally in other countries such as in Africa, China and India. Many medicinal plants are poisonous, and care should be taken if you intend to handle them. Wear gloves if

Barbara Nicholson's earlier paintings were of plant communities in the south of England that were within easy reach of her home in Dorset. This is a copy of the Heathland wall-chart.
(With kind permission of Mrs Jane Coper and the Natural History Museum, London)

there is a problem with fine hairs that may be an irritant or sap that could cause blisters on the skin. With increasing awareness of health and safety, nurserymen are now labelling plants that are toxic and could be harmful if eaten or a danger to children.

Study of Plant Defences

Plants need to protect themselves in a variety of ways, so we should not be surprised if some of their defence mechanisms harm us or are dangerous to human life. Plants are remarkable in the way they defend themselves; they often live in aggressive

Cowslip in pen and ink. Clear outline drawings to illustrate articles are welcomed by botanical and natural history societies. (Cate Beck)

Sorby Record

A Journal of Natural History for the Sheffield Area

No. 37 2001

Cover of the Sorby Record, Sheffield, 2001. (Cate Beck)

environments and harsh climates. A study of plant defences would be another interesting avenue to explore.

Culinary Plants

Culinary plants offer another route into themed illustrations. Some of the most attractive illustrations I have seen were on the menu of a smart restaurant in the Midlands, where beautiful illustrations of culinary herbs adorned the cover and written text.

Following the culinary theme, vegetables are fun to illustrate and generally easy to obtain. A difficulty can arise when trying to obtain a specimen of the whole plant, unless you have an allotment or live near a farm shop. Vegetables from supermarkets are usually cleaned up for sale, with surplus roots and leaves removed. You could have a wide choice of material throughout the year if you grow your own produce.

Allotments are used for growing a variety of interesting plants. In ethnic communities, vegetables are grown that cannot be obtained in local supermarkets. Recently I visited a shop in

Sheffield that had been recommended as a source for unusual vegetables which would add interest to a course I was tutoring. I marvelled at the array of unfamiliar produce from all over the world, but I had no idea how the items would be used in the kitchen. The shopkeeper scrutinized my basket when I arrived at the checkout and enquired what I was going to make with the contents. He laughed out loud when I told him they were going to be drawn and painted, and wagging his finger said 'Ah, but they would make a good curry'.

Fungi

Fungi are interesting to illustrate; they are usually shown with their habitat for identification purposes. The collection of fungi for drawing has created many amusing moments. On one

OPPOSITE: A botanical study of St John's wort, *Hypericum perforatum*, a plant which has medicinal properties and is used in homeopathy. (Yoko M. Kakuta)

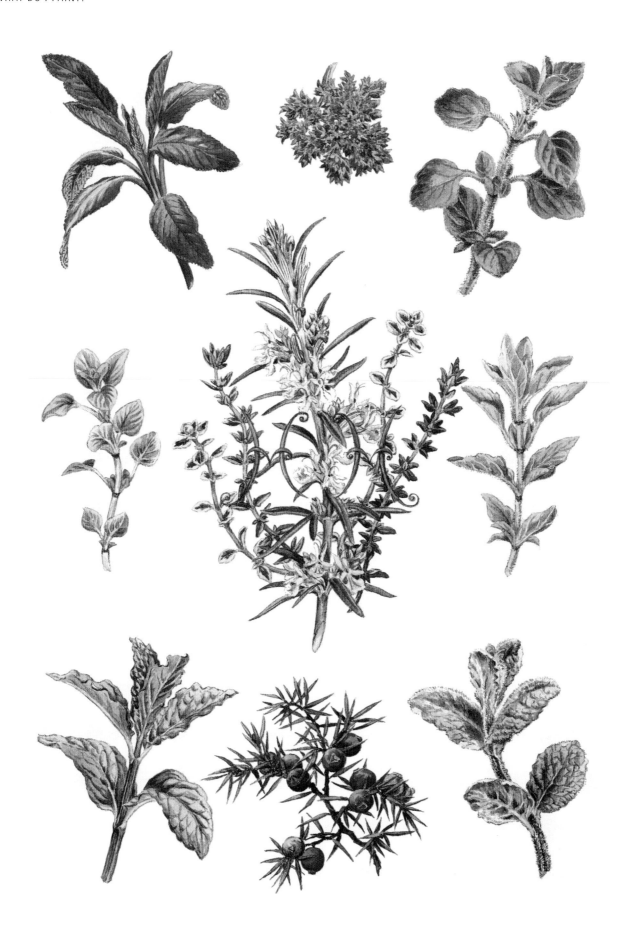

Dennis and Sylvia Sutton grow their own produce on an allotment. Seasonal fruits, such as the raspberry, make interesting subjects to draw and paint.
(Sylvia Sutton)

occasion when I was tutoring a class on illustrating fungi there was a course for European country park rangers taking place at the same college. One of the participants from Poland popped his head around the door to see what we were doing with our collection. When he saw a number good edible species, stuck on nails on wooden blocks waiting to be being drawn, he was aghast; 'but they will be no good for eating now!' he exclaimed. He simply couldn't come to terms with the fact that we were more interested in the drawings than our stomachs on this particular occasion.

When hunting for fungi, people tend to wander off with heads bowed despite warnings and soon become detached from the main group. A whistle seems to be the answer to the problem. On one occasion in particular it worked, but not before a walker, intrigued with the whistles, asked if I was training guiders for the Girl Guide movement.

When gathering fungi in an area where the 'magic mush-

OPPOSITE: Imaginative use of paintings of culinary plants displayed on a menu at Hambledon Hall, Rutland.
(Benjamin Perkins)

room' *Psilocybe semilanceata* is known to appear, gatherers should take care, as possession of a number of magic mushrooms, however innocent, is an offence under the illegal drugs act, and it is no excuse to say you are going to draw them. On one foray I noticed a member of the group being harangued by a passer-by. My student, flustered and confused, excused herself from her aggressor and hastily came to find me. She told me that the passer by had accosted her saying 'I'm surprised that someone of your age is collecting magic mushrooms, you should be ashamed of yourself'. Thankfully there were no magic mushrooms in her basket, but they might have been innocently gathered.

Plants Used for Dyeing

Illustrating dye plants opens up yet another area for research and study. It is an ancient craft going back to early civilizations when people had to rely entirely on natural resources to obtain the colours they required. The history of indigo (*Indigofera tinctoria*) alone makes compelling reading. Specialist books on

Meadow waxcap, *Hygrocybe pratensis*, an edible species that grows on upland grassland in the north of England. (Sheila Thompson)

the subject can be consulted to discover the range of plants which can be grown and harvested. The plants are often large and straggly, making the planting area untidy, but the rewards outweigh a little inconvenience. With permission, plants can be collected from the countryside. These could include elderberry *Sambucus nigra*, blackberry *Rubus fruticosus*, ivy *Hedera helix*, weld *Reseda luteola* and lady's bedstraw *Galium veru*. Cultivated plants include mahonia *Mahonia japonica*, wallflowers *Erysimum cheiri*, and madder *Rubia tinctoria*. Occasionally people have experimented with painting a plant with the dye from the same variety, such as painting a beetroot with dye made from the root. The only problem is that the dye might be unreliable and the colour could fade unless a mordant or fixative for the colour is used.

Plants the Romans Used

Some dye plants may have been introduced or used by the Romans. Alkanet *Anchusa tinctoria* and woad *Isatis tinctoria* were grown in Roman times and referred to in the literature of that period. The Romans used a variety of plants for culinary, medicinal and decorative purposes. They planted orchards and vineyards and it is likely they experimented with growing Mediterranean plants. A study of the plants used by the Romans could lead you into the history of the time. It could include a visit to the Roman garden at Fishbourne Roman Palace near Chichester, West Sussex.

Aromatic Plants

Another area where illustration can be linked by a theme or interest is aromatic plants and plants used in aromatherapy. It is not possible to reproduce the scent of the plant on paper. Investigation into why a plant is scented may send you off down another botanical route to discover the mechanisms involved in the pollination of plants and the attraction of insects. A little sideways step and you may consider adding the pollinator to your drawings.

The dark flowers of the
hollyhock, *Alcea rosea*,
produce a rich source
of mauve and maroon
in the dye pot.
(Suzanne Osborn)

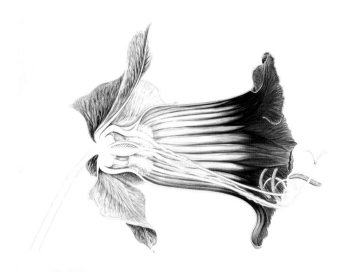

Cobaea scandens, a half flower executed by
Arthur Harry Church in 1909.
(© Natural History Museum, London)

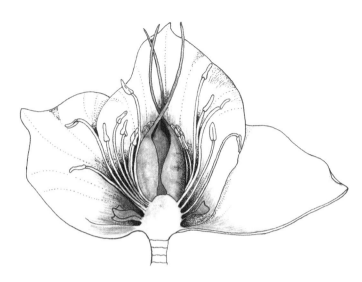

Helleborus hybridus, a half flower in the manner of
Arthur Harry Church. Pen and ink with watercolour.
(Susan Thorp)

Half Flowers and the Work of Arthur Harry Church

Arthur Harry Church (1865–1937) was a botanist who was also an artist and an enthusiastic and caring teacher. He produced a set of coloured drawings of half flowers, many of which are now in the collection at the Natural History Museum. The drawings, executed mainly in watercolour on board, show longitudinal sections of flowers, or half flowers. They were designed to illustrate the pollination mechanisms of plants. It is possible to follow in Church's footsteps with the aid of a scalpel to cut the flower in half longitudinally and a hand lens to look at the structures in detail. Church enlarged some of his drawings ten times so that the structures were clear. He intended his books of floral mechanisms to be published and sold to students studying botany at the turn of the last century. However, the project was costly, many of the illustrations were coloured and only the first volume *Types of Floral Mechanism* was published by the Clarendon Press in 1908.

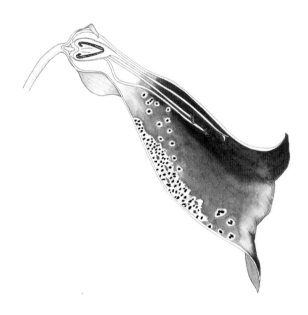

Digitalis purpurea, a half flower that shows the floral
mechanism in detail. (Gael Sellwood)

Plants Grown by Florists' Societies

To return to looking at individual plants one could study the flowers that were grown by members of the florists' societies that sprang into existence in England during the eighteenth and beginning of the nineteenth century. People began growing flowers to a set of rules and regulations and exhibited the results. The flowers that were grown include the tulip, carnation, auricula and anemone. The flowers were often exhibited in hostelries; and in the case of the auricula a copper kettle would

be hung outside to advertise the event. The kettle was later awarded to the winning exhibitor. The show would be followed by a feast, and this tradition still exists amongst some societies.

Many florists' societies continue to exist, including the Wakefield and North of England Tulip Society, where single flowers are still exhibited in brown glass beer bottles standing in rows on trestle tables. Broken tulips are some of the most highly regarded and they have a fascinating history. They accorded great value in Holland in the early 1630s. Growers did not understand how plants which the first season produced a single

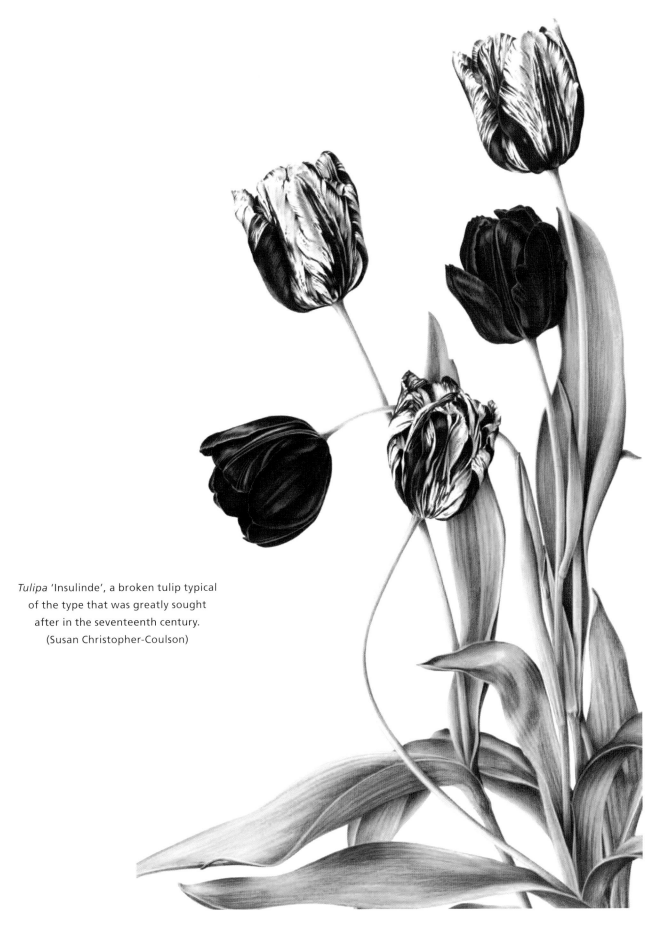

Tulipa 'Insulinde', a broken tulip typical of the type that was greatly sought after in the seventeenth century. (Susan Christopher-Coulson)

Sweet granadilla, the fruit of the
Passion flower, an ideal subject for work in
coloured pencil. (Jill Holcombe)

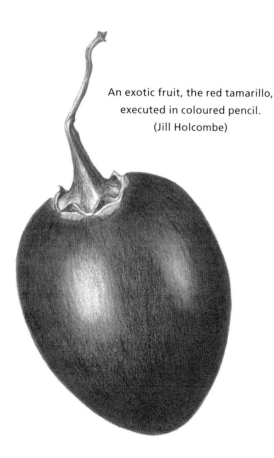

An exotic fruit, the red tamarillo,
executed in coloured pencil.
(Jill Holcombe)

colour could break into stripes and blotches during the following season. The broken tulips became thought of as exotic and were highly prized, resulting in fortunes being won and lost by the sale of bulbs. The phenomenon became known as Tulipomania, and thousands of pounds were exchanged for single bulb. We now know that the breaking of the colours in the tulip flower was caused by a virus.

Plants in Botanical Gardens

For the armchair travellers there is always the possibility of visiting a botanical garden where permission can be sought to draw and paint in a glasshouse in relative comfort. But there may also be difficulties: I once sat in the fern house at the Edinburgh Botanic Garden and was frequently sprayed with hissing mist from pipes crisscrossing the roof, making my dry brush work turn into a wet on wet technique.

Subjects worthy of study are endless; one can examine climbing plants and look at the way they cling, scramble, twine and climb. Plants that tolerate shade can be studied, as well as plants of a particular colour or family. White flowers make an intriguing study and are a challenge to illustrate. You should never be at a loss to find something of interest, whether it is an individual plant or a group of plants; once you start to think about it more ideas will spring to mind.

Shakespeare's Flowers

An attractive subject to explore and one with a literary background would be to study Shakespeare's flowers. There are many flowers mentioned in plays like *The Winter's Tale*, *Hamlet* and *A Midsummer Night's Dream*, and for those people who are skilled in calligraphy the addition of a quotation makes a delightful piece of artwork. Portraits of the flowers could be grouped into garlands and wreaths and enhanced by a quotation.

Silver Leaved Plants

Projects that can challenge the artist include painting silver leaved plants. The gardener Mrs Desmond Underwood was well known for her interest in silver foliaged plants, known in the trade as silvers. She started to grow drought-resistant plants in a particularly difficult area of her garden and discovered by trail and error how to cultivate and keep the plants. She was a pioneer in this area as there was little available information about their cultivation. In 1971 Mrs Underwood published a book called *Grey and Silver Plants*, which is still considered a standard book on the subject today. In the preface to the book

'The fairest flowers o' the season' (*The Winter's Tale*)
(Susan Staniforth)

Mrs Underwood explains how she was inspired by Marjorie Blamey's paintings, which she thought beautifully illustrated the difference between the felt, silk and velvet surface of the leaves. Mrs Underwood developed a nursery in Colchester, which was famous for its silver collection. She was awarded the Royal Horticultural Society's Veitch Gold Memorial Medal for her services to horticulture.

Keeping a Traveller's Sketchbook

Travellers can study plants from different areas of the world or climate zones, for instance plants from the Alps, the Mediterranean, China, Japan, the American prairies or the Rocky Mountains. You may be interested in tropical plants or even have the opportunity to accompany an expedition to study plants in a particular area of the world, but do not forget to take your insect repellent and sunhat. While on a botanical illustration study tour in Sri Lanka I saw wayside stalls piled high with exotic fruits and vegetables of every colour and description in every village we passed through. There is no end to the variety of subjects if you are a traveller; the only restriction may be the time allowed to execute an illustration to your satisfaction.

Eryngium giganteum, known as Miss Willmott's ghost, is a challenge to the botanical artist. A range of greys can be used to portray this attractive plant.
(Judith Pumphrey)

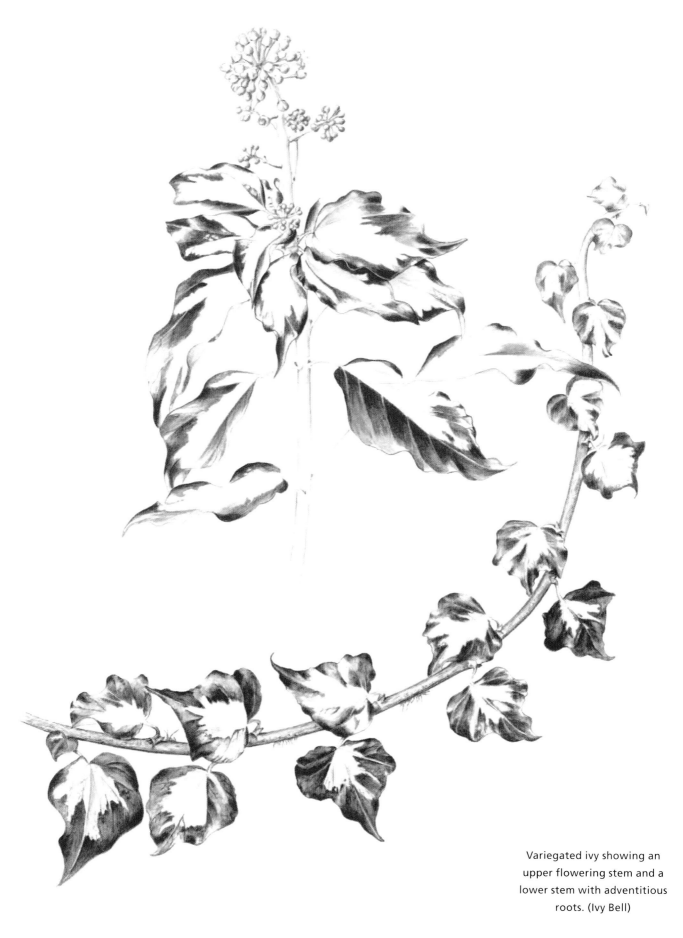

Variegated ivy showing an upper flowering stem and a lower stem with adventitious roots. (Ivy Bell)

HOW DO I PAINT?

This chapter shows in more detail ways in which the parts of a plant can be described using watercolour paint.

Leaves

Observe the leaves carefully, noting where the highlights and shadows fall. Look at the left hand side of a simple leaf to see if any shadows fall between the secondary veins. Look for regular patterns of light areas leading into dark areas. Check whether the patterns of light and dark are the same around the veins on the right hand side of the leaf. Look carefully: sometimes the shadow is on the top side of the vein on one side of the leaf and falls on the underside of the vein on the other.

Look to see whether there are graded shadows, from light to dark across each side of the whole leaf. Occasionally, the whole of one side of a simple leaf catches the light whilst the other side is in shadow. Half close your eyes to see clearly the areas of light and shade. Make reference notes of your observations on a preliminary sketch. Remember that the fall of light will affect each leaf on your plant differently.

Notice any changes in colour between the young leaves and the older leaves on your plant. Check the colour of the undersides of your leaves. The colour on the underside may be a lighter version of the colour on the top side, or it could be a different colour completely.

Before starting to paint check the leaf margins and ensure serrations are correctly described. Check the width of the veins on the top side of the leaves; they are usually quite fine. Any exaggeration in width will make the top side look like an underside, where the veins are usually more prominent. The drawn pencil line should be quite light; if it is too strong remove some of the graphite with a putty eraser.

Start by mixing the colour for your leaf. Paint a sample on a piece of paper of the same type as your painting. Allow the sample to dry before holding it against the leaf to check the colour is correct. The colour will need modifying as you work around the plant; some leaves will be lighter and some darker. Young leaves are usually yellow green and older leaves are usually blue green. When you are satisfied that your colour is correct, move some of the original mix to another recess in your palette and dilute with water. The tone should be very light for the application of the first washes.

Start with the lightest tone you can see on each leaf; in many cases this might be the colour of the veins. Apply the paint with overlapping brush strokes to create a flat wash. Wait until each layer is dry before painting the next one; gradually move back into the shadow area as you progress. This will build up a gradation of tone from light into dark over the whole leaf. Build up the colour gradually; the edges of the painted areas can be blended as you progress using a second slightly moist brush. On completion, the colour can be enhanced or modified as required by applying a thin wash of an appropriate colour over the whole leaf, such as transparent yellow, green gold or cobalt blue.

Thickness of Leaves

All leaves have thickness; on leathery leaves this can be shown by painting the nearest edge slightly darker. When the leaf is twisted or curled, light can be seen reflected from the edge.

Leaf Margins

The paint should not spill over the pencil line. To avoid messy edges apply the paint to just inside the pencil line. Alternatively to create a clear sharp edge to your leaf, paint a line around the margin just inside the pencil line in the colour of the leaf and use this as your boundary.

Painting a Number of Leaves on a Plant

When you are working on a whole plant proceed carefully; bring all the leaves up to completion gradually. It is not advisable to finish a leaf completely and then move to another as this may

Cyclamen leaves often have a serrated leaf margin. Observational studies of this kind provide useful reference material. (Jill Holcombe)

lead to the first leaves being over-worked. Try to be aware of how the light affects the whole plant; the leaves on the left-hand side will be generally lighter in tone than those on the shadow side.

Variegated Leaves

Variegation or patterns on leaves is usually caused by differing amounts of the green pigment, chlorophyll. It can be a sign of mutation or a virus, or it can be a characteristic of the plant which will be reproduced in the next generation.

A variegated leaf can be painted using the wet on wet method to blend the different greens. This method is particularly useful where yellow merges into green. Some modelling to show shape and form can be applied once the first wet on wet wash has dried, and veins can be added. The pattern or variegation will be lighter in tone where the leaf turns towards the light and darker where shadows fall.

Pattern and Blotches on Leaves

Blotches on leaves such as those on lungwort *Pulmonaria longifolia* can be created by lifting the paint from the surface of the leaf with a dampened brush before the paint has dried. Check the colour of the lightened area; it could be a silver grey or a paler tone of the overall leaf colour. A little staining colour could be left behind which may give the desired effect. Masking

fluid can be used for blocking out light areas, but it will leave a hard edge when removed from the paper. The colour can be lifted from dry paper using a slightly wetter brush and tissues for mopping up the loosened paint.

Shiny or Glossy Leaves

Look carefully at the highlights on shiny or glossy leaves, such as holly or camellias. They could reflect blue, white or a very pale tone of the leaf colour. To create a bright highlight, there should be sharp contrast between dark and light areas. The edges of the highlight, between the contrasting dark and light areas, should be blended using a slightly moistened brush; otherwise the contrast will be too sudden and harsh.

The following method is successful for painting highlights but requires practice. Use two brushes; fill one with clean water and the other with watercolour paint to match the colour of your leaf. Apply the brush with clean water to the area where the highlight appears. The clean water should be applied evenly over the whole area inside the pencil lines so that the paper is moist but not too wet. Should water collect at the edges of the area then too much moisture has been applied.

Apply the colour with the second brush all around the highlighted area. Do not paint where the highlight is to appear. Work swiftly and evenly so that the paint blends into the edge of the area of the highlight. Leave to dry and complete any further detail using the dry brush method, which entails using small brush strokes with watercolour.

Alternatively paint the leaf a very pale blue first; then apply the dark green as above, avoiding the highlighted area. A little careful blending can take place between the green and blue areas with a second dampened brush.

Another method is to lift the highlights from the paper after the paint has been applied by using a dampened brush, cotton bud or tissue. When the paint is dry some dry brush modelling may be needed; fine veins can be added to the highlighted area.

The use of masking fluid to block out a highlight leaves a hard edge. Painting a highlight with white gouache tends to look unnatural.

Silver and Grey Leaves

Many silver and grey leaves are covered in tiny white hairs which reflect the light, giving a silvery appearance. The leaves on silver leaved plants are distinguished as downy, waxy or variegated. Nurserymen call all these plants 'Silvers'. The type of hairs is important, as some hairs are branched and give a downy or woolly appearance as in the mullein plant.

Raised silvery areas between veins, which look like silver

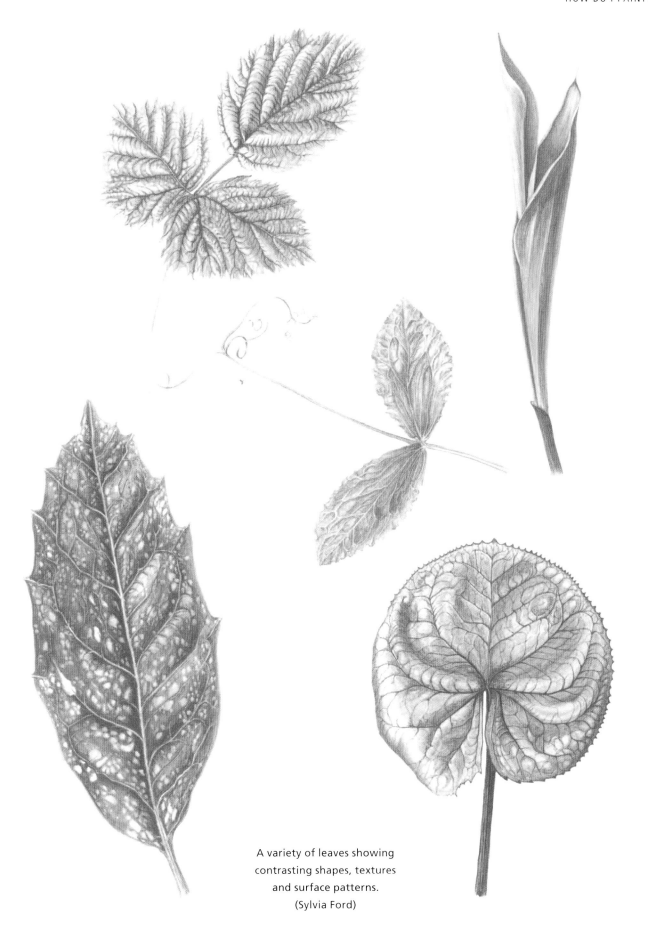

A variety of leaves showing
contrasting shapes, textures
and surface patterns.
(Sylvia Ford)

129

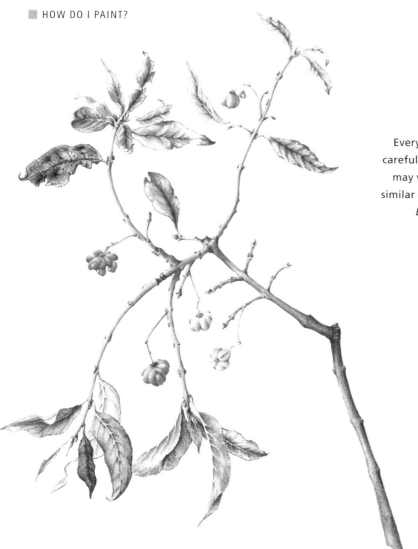

Every individual leaf should be carefully observed. Colour and size may vary but they should show similar characteristics. Spindle-tree, *Euonymus europaeus*. (Alison Watts)

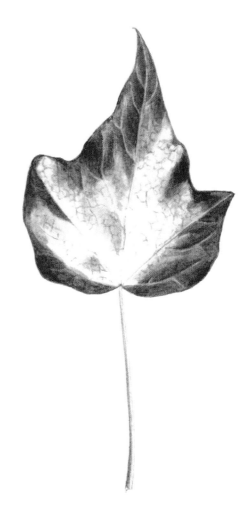

blisters, are formed by a pattern of air pockets lying under the surface of the leaf.

Look at the range of colours and decide whether the grey colour you are observing is blue grey or green grey. It is worth noting the colour of the fleshy parts of the plant underneath the hairs as this will shine through to add to the illusion.

Shadows on the leaf can be established by under-painting with a blue grey colour before the addition of the hairs. Where the surface of the leaf is furry, as in lamb's ears *Stachys byzantina*, apply the paint using small brush strokes in different directions to give a furry effect. Varying the colour and tone of the brushstrokes will help make the leaf look more realistic. The brush strokes need to spill over the edge of the leaf to suggest the texture. For a smooth silky leaf the brush strokes need to lie in the same direction.

Veins

Leaves are covered in a network of veins. They branch out from the mid rib and decrease in size like the branches of a tree. The

A variegated ivy leaf showing traces of the veining pattern appearing in the light areas. (Ivy Bell)

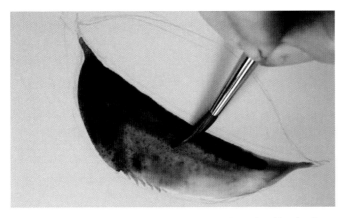

1. Dark green shadow is added to the initial wash of leaf colour with blue highlight. The serrated edge is started.

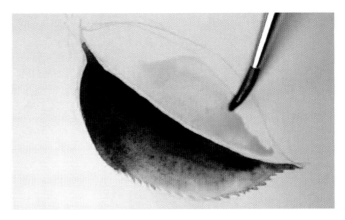

2. Cerulean blue reflection is started on the far side.

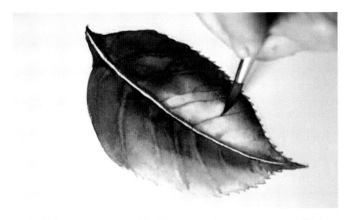

3. Veins are suggested in the green damp area and pulled through the light area.

4. Dark line suggests shadows either side of veins. The main vein is painted in when both sides are dry. The leaf was completed with a final wash of aureolin over the green areas to adjust the colour. (Helen Fitzgerald)

Some of the steps in painting a camellia leaf.

sides of the veins are usually parallel until they reach the edge of the leaf where they taper. Not all veins can be seen easily, and it would be too confusing to show all the veins in a leaf. Sometimes, where too many veins are shown the overall structure of the venation is lost. One should only show the veins that help give the leaf its character, shape and form. As a guide to help you decide how many of the smaller veins to include, place the leaf at arm's length and ascertain how many of the smaller veins can be seen at that distance. Veins on long leaves seem to disappear and reappear as light falls along the leaf. A tonal sketch will help you understand where the light falls and whether the veining looks convincing.

The lightest colour on the leaf is usually the colour of the veins. Unless the veins are a strikingly different colour to the leaf, the whole leaf can be under-painted in the lightest tone of the vein colour; this is usually a yellow green. Paint around the veins as

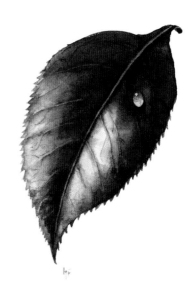

The completed camellia leaf. (Helen Fitzgerald)

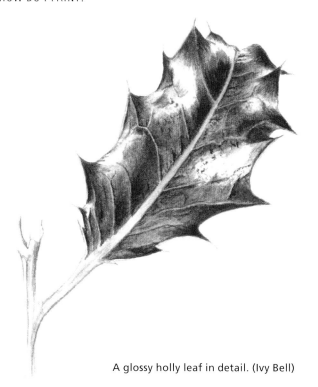

A glossy holly leaf in detail. (Ivy Bell)

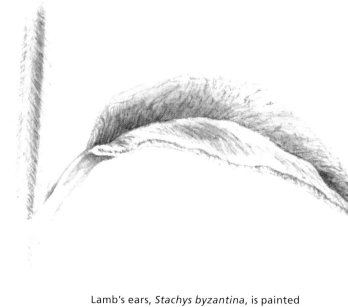

Lamb's ears, *Stachys byzantina*, is painted with small brush strokes to create the soft surface texture. (Jill Holcombe)

the layers of paint are built up on the leaf. To help make a vein on the under-side of the leaf appear more prominent paint a thin dark line against the vein on its shadow side.

Small veins can be lifted out by using the tip of a clean brush with a good point. The brush, which should be damp, is drawn along the line of the vein then lifted swiftly to help give a taper to the end. Wash the brush or dab it on a cotton cloth to remove excess moisture. Repeat the process until sufficient paint has been removed.

Veins can be added once the blade of the leaf has been painted by mixing a little white gouache and painting in the vein where required. When dry, wash over the leaf with yellow green or a light tone of the leaf colour. This will help blend the vein into the overall colour of the leaf.

Masking fluid can be used to mask out the wider main and secondary veins, but care should be taken to ensure the masking fluid is applied with a mapping or lining pen so that the vein is not too wide.

Flowers
Creases, Dips and Folds in Petals

Creases and folds should be carefully observed and understood. Look at the crease or fold in the petal and decide whether it will add useful information to the finished drawing. Compare with other flowers on the same plant and decide whether it is a natural formation, as in the cistus, or the result of a petal being crushed or folded accidentally. A sharp fold in a petal is not usually a natural formation and if portrayed with a hard edge will tend to make the structure look flattened or artificial. However a dip in a petal may be part of the character of the flower, as in the blossom of the hawthorn. A dip in a petal is like the inside of a cup with light falling more on one side than the other.

A quick tonal sketch of the structure will help you make a decision as to whether the structure can be portrayed effectively. This can be followed by an accurate drawing to describe the structure. Look at the margin of the petal to see whether the shape changes to accommodate a fold or crease. Using a single light source from the left, carefully observe where the shadows and highlights are falling. Look to see whether the edges of the shadows are sharp or soft. There is usually a sharp edge leading into a soft edge on a crease. Small graded washes are usually a successful way to portray a crease or fold.

Flower Centres

The centres of flowers can look a horrible muddle if they are not drawn correctly. Often the problem is that people do not understand what they are looking at and try to portray the structures as a series of blobs. Observation is important, and a hand magnifier, lens or microscope is useful aid to seeing exactly what is present in the throat of the flower. Look up the diagnostic features of the plant using a good plant guide and check the structures you might expect to see. Note the position, length, shape

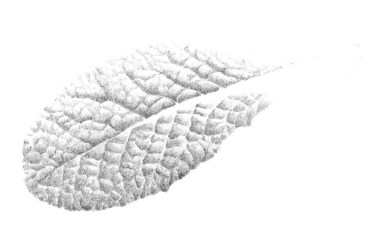

A carefully observed primula leaf showing how light creates little cushions on the surface between the veins to give a puckered effect. (Lionel Booker)

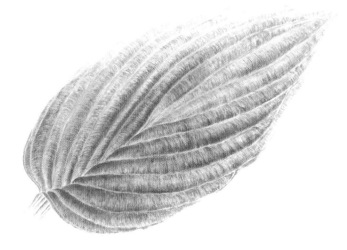

Light falling between the long veins helps describe the character of this hosta leaf. (Tim Peat)

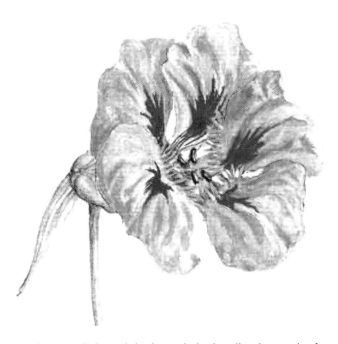

Observing light and shade can help describe the petals of nasturtiums. (Shirley B. Whitfield)

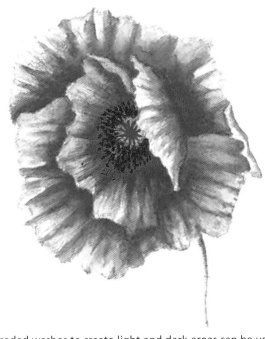

Small graded washes to create light and dark areas can be used to describe folds or creases. (Linda Ambler)

and colour of the stigma and style and the position, shape, colour and number of stamens.

Enlarge the structure on a spare piece of paper to understand how it all fits together. When you feel you know what you are seeing, very carefully draw in the parts on your plant life-size. Do not assume that all pollen is yellow, as it can appear in a variety of colours on different plants. Note that the anthers change

once they open to reveal the pollen. The best time to paint a flower is just before the anthers have dehisced or opened.

Where there are many stamens they can be difficult to portray, particularly if the filaments or stalks are white or pale coloured. The way to cope with this problem is to paint in the background between the stamens with a fine brush, then carefully pick out the shadow on the filament of the stamen with a blue grey

133

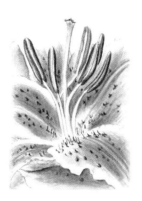 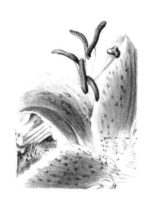 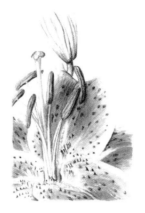 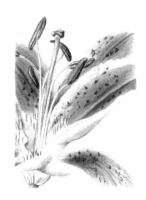

Observe the centre of the flower carefully. (Ivy Bell)

The white filaments of the stamens stand out against the green colour
in the middle of the white amaryllis. (Isobel Bartholomew)

colour slightly stronger than the background colour. An alternative method, where there are many stamens, is to paint in the shadow as a thin line immediately beyond the filament.

The stamens and light coloured structures can be covered with masking fluid prior to painting the background. Test a small area of the paper first to make sure that the masking agent will lift cleanly from the paper when dry. It is easier to paint in the background using this method. When the mask is lifted the filaments are revealed as white areas of paper. Only a little detail in the form of shadows on the filament will be required to complete the structure.

When all else fails, try outlining the filaments using a blue-grey or green colour with a very fine brush.

An illustration of the roots of *Epidendrum phoeniceum* (detail) by Sarah Anne Drake (1803–1857), stopped at an imaginary line. Note the shading between the roots, darker at the centre than the edges.

(© Royal Botanic Gardens, Kew)

The roots of the auricula have been shown more distinctly in the foreground than those in the background. The remaining pieces of detritus help to pick out some of the root structure near the base of the plant. (Sheila Thompson)

Roots

Remove the plant and its roots gently from the pot or from the ground. Carefully wash the roots under a tap or in a bowl to remove soil particles. Place the plant and its roots in a large glass jar or vase filled with water so that the roots spread out and their shape and structure can be seen easily. A collar made of cardboard with a hole in it can be made to fit over the top of the jar, to hold the plant in place. This is suitable for the display of fibrous roots which tend to cling together when wet. There will be some magnification when you look through the glass of the jar.

Examine the roots carefully and observe their length and shape. Look to see whether the roots are branching, how thick they are and if they taper. Examine the point where each root emerges from the plant, and look to see if there are any parts above ground. Observe and note any changes in colour. Epiphytic roots of orchids can be shown as cut off at an imaginary line drawn across the page.

Draw in the main roots first and then fill in other roots including those at the back. Some discretion can be used if the roots

Subtle shadows help to
model the shape and form
of white flowers.
(Caroline Holley)

are a confusing mass. Roots at the back can be shaded completely, whereas roots at the front can be modelled to show a three-dimensional aspect. When describing roots in colour they can be painted using similar shadow colours as white flowers. At the centre of a mass of roots the spaces between individual roots can be filled in with a dark colour; this will help throw the roots forward and give the impression of mass. Shadows shown where there are overlaps will help give a three-dimensional feel to the whole root structure.

Texture, Light and Other Difficulties
White Flowers

Painting white flowers on a white background may seem a difficult task, but with practice the results can be quite striking. Placing the white flower against green leaves is a time-honoured way of creating a background. This method should only be used where the leaves naturally frame the flower.

Painting in a soft coloured background using the graded wash technique around the inflorescence will throw the flower forward. The paper around the petal should be damp but not running with moisture. Apply clean water with a moist brush around the outside edge of the petal. Add small amounts of colour near to the outside edge of the petal and allow it to spread into the water away from the flower so that it blends naturally and fades away. Avoid a hard edge by dampening the paper beyond the graded wash area.

Problems can occur when the colour is brushed into a dry area of the paper, as this will result in a hard edge when the paint dries. Only use diluted colour so that it fades away easily. When the colour is too strong the soft background effect is lost.

Where a white flower is to be painted without the help of convenient leaves and coloured backgrounds, the shape and form of the flower is depicted by painting in the shadows. White is rarely pure white and most white flowers do have a hint of colour; this can be observed by holding your flower against a sheet of pure white paper.

White flowers reflect other colours. For example the yellow glow from stamens, the green reflection of leaves and hints of mauve and pink are often seen in the whitest areas. An Anglepoise lamp can be used to direct light to create shadows, which usually appear at the base of the flower and on the overlap between petals. Veining on petals can throw up subtle shadows. A pencil line can remain to show the margin of a petal. Alternatively margins can be outlined with the point of a brush and a neutral blue-grey.

The artist has to take care not to eliminate the white highlights.

A blue-violet mix applied in varying tones will describe bloom on a plum. (Jill Holcombe)

These often show up on turned down petals. Shadow colours should not be brushed over the whole petal unless deliberately shading it into the background to emphasize depth. When shadows are deepened selectively the flower is brought to life.

Paint shadows with less intensity than they appear on the flower. Davy's grey is useful when painting white flowers; an additional range of neutral greys can be mixed by combining blues and browns such as burnt sienna and French ultramarine. Experiment with neutral colours by combining complimentary colours, blue and orange, red and green, and yellow and violet.

White gouache paints are effective for painting white flowers on tinted papers.

Bloom on Berries and Flowers

The fine powdery surface which can be seen on some fruit such as sloes, plums and figs is known as bloom. It is formed by many varieties of wild yeast. The yeasts, like other similar organisms, multiply by using sugars and nutrients in fruit. The surface can look blotchy where the bloom has been removed.

Bloom can be shown by using a bluish black colour which can be found by mixing French ultramarine and burnt sienna. Occasionally a very subtle highlight can be seen on the fruit as well as bloom but this may be difficult to recreate. Bloom on sloes can be painted by using the blue-black mix suggested above and removing some of the paint immediately with an almost dry brush. The remaining stain on the paper should be the correct colour to describe the bloom on the fruit. Take care to retain a darker side to the fruit to help explain and model its rounded shape.

137

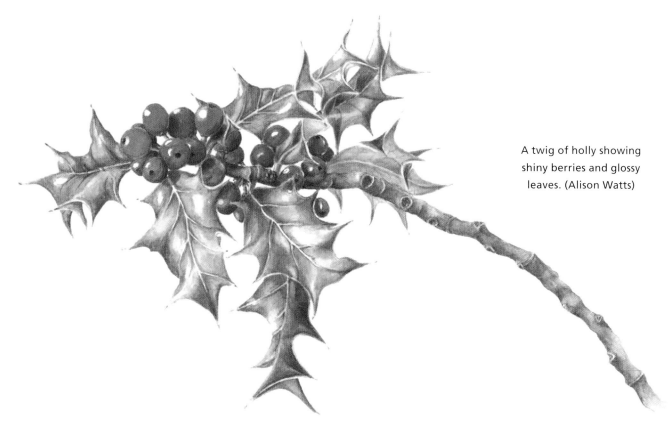

A twig of holly showing shiny berries and glossy leaves. (Alison Watts)

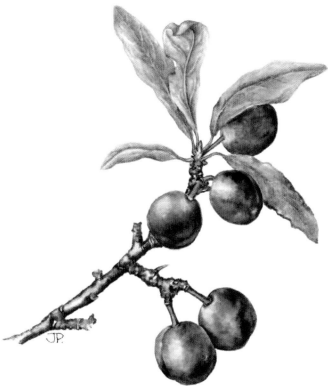

Highlights and bloom on sloes can be described using the wet in wet technique. (Judith Pumphrey)

Bloom can be added after the fruit has been painted by applying a mix of gouache white combined with cobalt turquoise. The correct colour and consistency of the paint is important and may take a little fiddling to perfect. Practise on a separate piece of paper until you are happy that the effect does look like bloom and not mould.

Bloom can be observed on the following flowers and fruits:

bird of paradise *Strelitzia reginae*
Solomon's seal berries *Polygonatum multiflorum*
bilberry *Vaccinium myrtillus*
blackthorn or sloe *Prunus spinosa*
dewberry *Rubus caesius*
mahonia berries *Mahonia aquifolium*
fig *Ficus carica*
passion fruit *Passiflora edulis*
black grapes *Vitis vinifera*
damson *Prunus insititia*
plum *Prunus domestica*

Farina

Farina is the powdery substance like flour found on the surface of leaves, stems or floral parts of some plants. To create the effect

Reflected light helps to show the shape of the cherries.
(Sheila Thompson)

of farina apply the colour of the flower, leaf or stem using the stippling technique. The paint should be applied directly onto the white paper using less paint where there are highlights. The white of the paper will create the powdery effect. Alternatively gouache white can be stippled onto the leaves, stem or flower with a very dry brush just before the painting is completed.

Shiny Berries

To create the effect of shiny berries it is essential to leave the white of the paper in the area of the highlight. Occasionally highlights look blue, as if reflecting the colour of the sky, but on a small berry white highlights are more effective.

Check the shape of the berry. They are not all round; some are elongated and some have flattened sides. Draw the berry lightly in pencil. Moisten the area of the berry keeping within the pencil lines. Drop in the colour of the berry keeping the paint away from the area of the highlight. When the paint is almost dry, use a brush with a fine point and stipple colour between the bright highlight and the surrounding colour if necessary. This stipple effect can be seen on some berries, but only add the stipple if you can see it on the surface of the fruit.

Look also for the low lights, which occur where light is reflected onto other parts of the berry. Low lights usually show some colour; try lifting out a little colour or use a thin wash of paint. Reflected light which appears on the shadow side of the fruit will help separate one berry from another in a cluster.

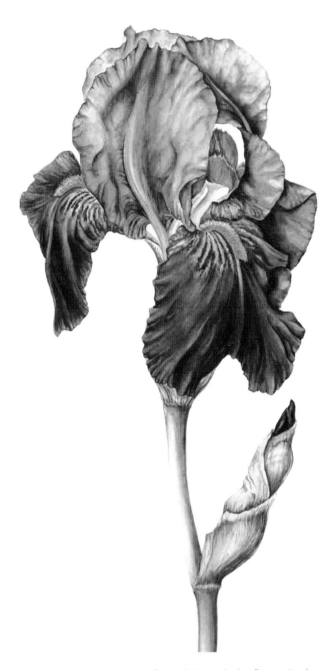

A range of colours are reflected through the flower in the bearded iris. (Judith Pumphrey)

Highlights can be observed on the following fruits:

lords and ladies *Arum maculatum*
black bryony *Tamus communis*
honeysuckle *Lonicera periclymenum*
guelder rose *Viburnum opulus*
elder *Sambucus nigra*
holly *Illex aquifolium*
bramble *Rubus fructicosus*

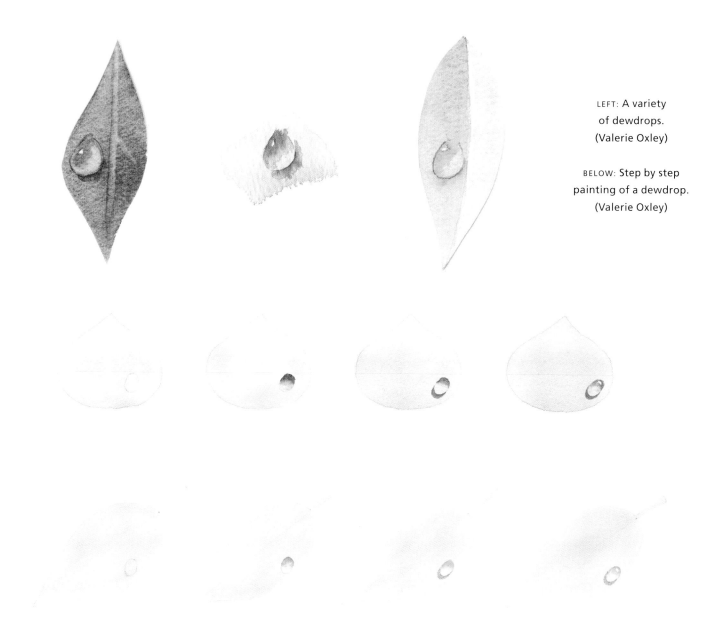

LEFT: A variety
of dewdrops.
(Valerie Oxley)

BELOW: Step by step
painting of a dewdrop.
(Valerie Oxley)

Reflected Light

Reflected light appears on the shadow side of a plant or fruit; it can help describe shape and form. It is particularly useful when describing individual fruits in a cluster. To use the effect of reflected light, remove paint from the shadow side of the fruit; the darkened area of the cast shadow onto the fruit below will help to emphasize the shape.

The Rich Velvety Textures of Flowers

Look for all the colours reflected by the petals and paint them separately so that each layer glows through the next. Build up the layers gradually, as it is the colours reflecting through all the other layers which create the velvety effect. For pansies the effect can be completed by adding a modifying transparent wash of yellow or red violet as appropriate.

Dewdrops

Dewdrops can give a realistic feel to a flower painting, and they are not difficult to accomplish if these easy steps are followed:

1. Draw the shape of the dewdrop lightly in pencil onto the coloured petal or leaf.
2. Remove a little of the paint from within the pencil lines with a moistened brush and allow it to dry.
3. Wet the inside area of the dewdrop and introduce a small

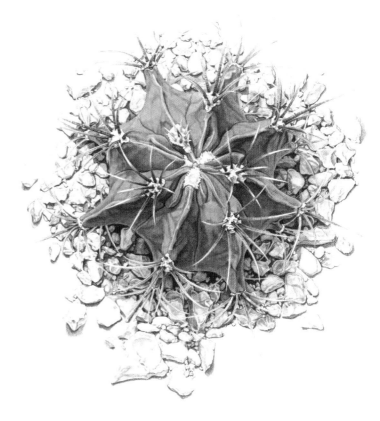

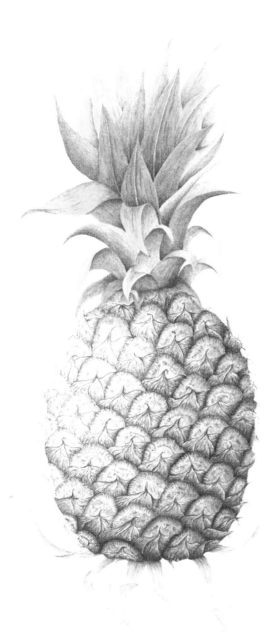

ABOVE: An unusual study of a cactus from above; the small pebbles give added interest. (Sheila Thompson)

LEFT: A pineapple in watercolour showing a spiral pattern. (Eddie Kellock)

amount of paint, darker than the background colour, to the end of the dewdrop facing the light.

4. Tilt the paper so that the colour stays at one end and allow it to dry.

5. When the dewdrop is completely dry, use the appropriate shadow colour and paint the shadow that will be cast on the right-hand side under the dewdrop.

6. Pick out the highlight from the darker end of the body of the dewdrop with the tip of a sharp knife.

Spirals in Nature

Look out for the spiral pattern that occurs in pineapples, cacti, fir cones, and many flower spikes. Plotting the pattern first will help establish the structure of the specimen you are drawing.

CACTI

Cacti are plants which have developed in a special way to cope with extreme conditions. The body of the cactus is a modified stem in which moisture is stored; the spines are modified leaves. To help you to draw the cactus, look for the spirals created by the position of the spines. White gouache may be needed to paint the spines. These can be modelled using the dry brush technique once the underlying paint is absolutely dry. A shadow cast from the spine onto the stem of the plant will add reality.

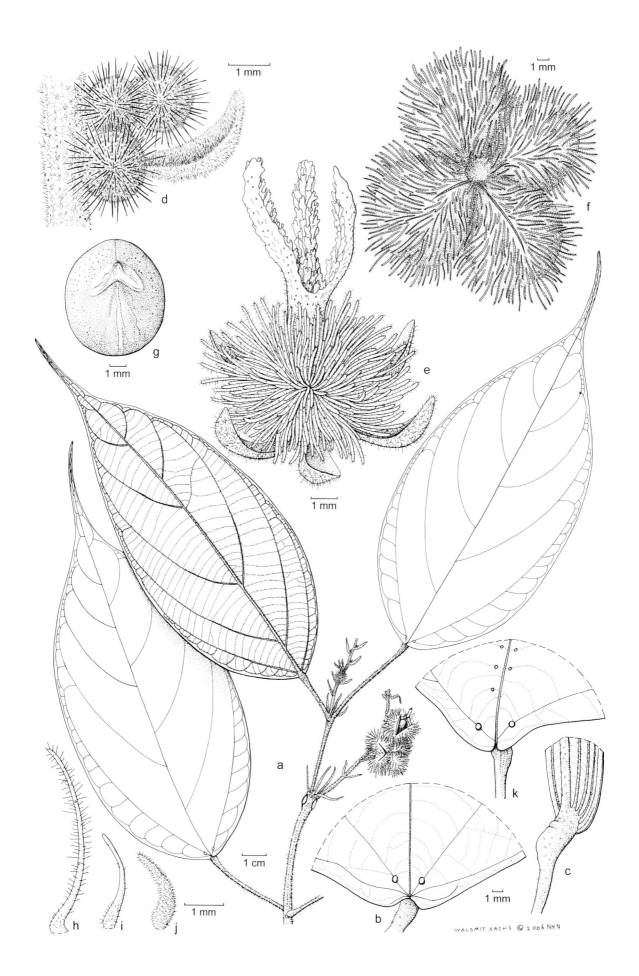

142

ALTERNATIVE MEDIA

Pen and Ink Techniques

Scientific illustrations are usually drawn with a technical drawing pen; these pens have a tubular nib. They are available in a range of sizes: the most popular are the rapidograph and isograph pens with line widths of 0.10mm–0.5mm made by Rotring.

You should use only inks that are recommended for your particular pen; otherwise it may clog and require cleaning. Sometimes a pen may clog if it is not used regularly. To start the flow of ink, shake the pen gently horizontally and test it on a spare piece of smooth paper. Should the problem remain unresolved try shaking the pen vertically with the cap in place and very gently tap it on the table top. A clicking sound may indicate that the ink has dried inside the pen. Tapping too vigorously will damage the tip of the nib. A pen that is still clogged should be taken apart and washed in warm water with a little detergent. The pen should be dried thoroughly before further use.

Scientific drawings are usually executed life-size and include enlarged dissections and details to an appropriate scale. They are usually started in pencil outline and completed in ink. Different sized nibs can be used to indicate light and shade.

Some artists prefer to use a dip pen, which consists of a holder and a replaceable nib. Practice is essential before using the pen for an academic drawing. The nib is more flexible than the tubular nib of the technical pen. A variety of marks and line widths can be achieved by varying the pressure on the nib.

Different methods can be used for shading to create shape and form, texture and pattern. Parallel hatching lines and cross hatching can be very effective but need practice to look tidy. Stella Ross-Craig's *Drawings of British Plants* shows this skill to perfection. Making a range of marks with the pen to create

An academic drawing of *Mallotus spinifructus* prepared for Leiden Botanical Garden, in the Netherlands. Note the different marks made with the pen to describe the texture of the plant.
(Anita Walmit Sachs © Nationaal Herbarium Nederland)

textures and patterns can be useful when describing surfaces such as bark and hairs.

The simplest way to show shape and form is by using stipple shading, which is shading with equal size dots. A technical pen held in an upright position will produce dots that are even in size. Care should be taken that weariness does not cause the dots to become dashes; when dots become dashes they could convey a hairy surface.

The usual light source is from the left if you are right-handed. You can indicate the position of shadows by lightly shading with an HB pencil first before applying the ink. The pencil marks can be carefully erased later when the ink is dry. Place the stippled dots close together to indicate the dark tonal areas and further apart to indicate the light tonal areas. The deepest tonal area can be rendered in solid tone, by joining the dots together. Bear in mind that botanists generally prefer clear outline drawings with minimal shading. Enthusiastic stippling can blur clarity, making it difficult to see the detail of fine structures.

An error can be corrected by carefully scratching it out with a single-edged razor blade or sharp craft knife. Smooth the surface of the paper afterwards by using a bone spoon or the back of a fingernail.

White gouache, process white or correcting fluid can be brushed over an unwanted ink mark. Ensure the brush is washed thoroughly afterwards to remove any stray paint near the ferrule that might build up with use and spread the hairs. Should only part of the drawing require correction, draw the part again on a separate sheet, cut it out and fix it over the spoilt part. These methods work well if the drawing is to be reproduced, but would look messy if original work was to be exhibited.

Drawing from Herbarium Specimens

The first herbarium is attributed to Luca Ghini (1490–1556) a professor of botany at the University of Bologna in Italy, who dried plants under pressure to preserve them for further botanical study. His specimens were mounted on sheets and bound

Drawing of the lesser celandine, *Ranunculus ficaria*, by Stella Ross-Craig showing a variety of hatched and stippled shading techniques in pen and ink. Note the unusual heart-shaped seed leaf.
(Royal Botanic Gardens, Kew)

together in book form. Today dried specimens are usually mounted on single sheets, placed in folders and stored in cabinets.

Herbarium specimens are usually taped or glued to sheets of paper. In the past specimens were often sewn onto the page and examples can still be found in historical collections. The Oxford University Herbaria still use the sewing and strapping method as it allows specimens to be remounted if necessary or removed for further study.

Herbarium specimens are usually flat and brown. Slight distortion and shrinkage may be the result of the drying process, and this should be taken into account when taking measurements. Always check the diagnostic features before proceeding with a drawing. Careless handling of herbarium sheets will result

in brittle specimens becoming detached and broken. Do not hold the sheets by the corners; hold them as flat as possible with both hands by the sides of the sheet. Preserved plants are used when living plant material is not available.

Material for closer examination is often found in an envelope attached to the herbarium sheet. Pieces can be removed for reconstruction or dissection. The distortions due to shrinkage can be corrected by boiling in water from thirty seconds to a minute, depending on whether the flower is delicate or fleshy. Alternatively delicate material can be placed in water with a small amount of detergent until it has softened. Pickled material, if available, is useful for dissecting fruits.

Scientific drawing is usually the result of conversations between the botanist, who is commissioning the artwork, and an illustrator. The botanist will let the illustrator know which parts of the plant are to be included in the final illustration. Generally, the natural habit of the plant is shown, along with explanatory drawings showing parts of the plant in more detail. These could include the front and the back of the leaf showing the pattern of the venation, and enlargements of any particular features such as the attachment of the leaf or presence of hairs. Individual floral parts and fruits may be included and are usually enlarged to an appropriate size to show their structure clearly. The purpose of this kind of scientific illustration is to show all the taxonomic details and not to recreate the living plant as in plant portraiture. Some modelling of form can be included as long as it does not blur the clarity of the structures.

To construct a botanical plate from a herbarium specimen, draw the parts individually onto tracing paper at the appropriate size. Cut the drawings out and rearrange them into a suitable design using a light box for positioning. When you are satisfied with the design, fix it in place with removable adhesive tape before tracing off onto tracing paper. Check the design again before transferring it to the appropriate paper for inking in.

SCALE BARS

Scale bars are used to represent the magnification or reduction in size of the drawing on the paper, compared to the size of the actual plant. Scale bars can be helpful if you want to illustrate a very large plant which cannot be reproduced life-size. The scale bars are usually drawn as a thin line 1–3 cm ($^{1}/_{2}$–$1^{1}/_{2}$in) long and are placed horizontally or vertically, with the measurement represented by the side.

Pen and Wash Techniques

Water-soluble ink and a dip pen can be used to create attractive tonal studies of a more decorative nature. The ink can be applied

to the paper using a dip pen fitted with a flexible nib. Alternatively, ink can be applied directly to the paper with brush. Draw the plant first in pencil. Go over the pencil outline in ink, but before it dries pull the ink away from the line with a wet brush. Ink can be applied directly with a brush and watered down if necessary to increase the tonal range. Two brushes can be used. Ink can be applied directly to the paper with the first brush, and a second damp brush can be used to spread the ink. Pen and wash techniques produce attractive monochrome studies that show shape and form. It is an interesting and successful method for painting seaweeds. Rotring Art Pens or sketching pens, which have a cartridge of ink and a range of nibs, are useful tools for pen and wash studies without the worry of spillage.

Pen and Watercolour Wash Techniques

Pen and watercolour wash is another method of illustrating plants decoratively. Technical drawing pens can be used for the outline. Waterproof ink should be used so that the ink does not bleed when the watercolour is added. Check your ink is waterproof by drawing a line on a spare piece of paper and allowing it to dry before painting over it with a brush filled with water. If the ink is not waterproof the line work could be added after the watercolour illustration has been completed and allowed to dry.

As with other botanical work the first step is to draw the outline of the plant in pencil and check it is correct before moving onto the inking stage. Draw over the pencil line with your pen and carefully add hatch lines or stippling to enhance the shape and form. Keep ink work in the shaded areas to a minimum, so that the finished picture does not look too fussy. It is important to create the right balance between the amount of ink work and the addition of colour.

Check the inked drawing is completely dry before applying the watercolour. Match the watercolour mix to the plant. Continue with a dilute solution of the correct colour and apply the paint to each area using the flat wash method. Wait until each layer is dry before selectively enhancing the shadow areas with a second coat of the mix of the same strength. Blend the edges with a dampened brush. Add more layers in the shadow areas whilst keeping an eye on the overall effect. Stand the picture upright and look at it across the room to see whether more paint should be added. The shaded ink work will be dominated if the

Pen and ink drawings of a variety of leaves in stipple and line to show shape, texture and surface pattern.
(Vivienne A. Brown)

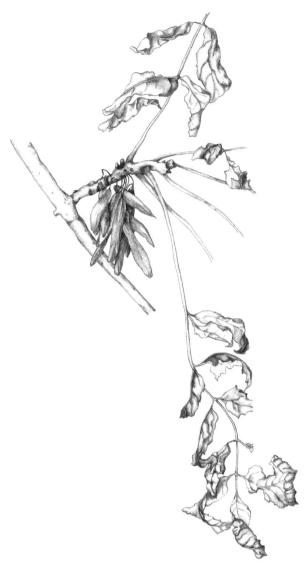

Pen and ink drawing of meadowsweet from a pressed specimen in the herbarium of the Department of Animal and Plant Sciences, University of Sheffield. The scale of the drawing and any further notation could be indicated on an overlay. (Ivy Bell)

A drawing of an ash twig in pen and ink outline, completed with a light watercolour wash. (Vivienne A. Brown)

painted parts are too strong. When the colouring has been completed and the picture is completely dry there is another opportunity to improve the pen and ink shading if required.

Pen with Coloured or Graphite Pencil

Coloured pencils can also be used to enhance an inked drawing. Waterproof or water-soluble ink can be used because the coloured pencils will not disturb the ink on the surface of the

paper. Shading in graphite pencil is also effective; the grey colour of the graphite complements the black ink outline.

Dry Coloured Pencil Techniques

All coloured pencils are manufactured in a similar way to graphite pencils. The coloured cores are held between slats of grooved cedar wood, which are glued together before going through a machine which cuts them into the pencil shapes. The colour core is made from a mixture of clay, organic or chemical pigments, wax and binders. Coloured pencils were not fully

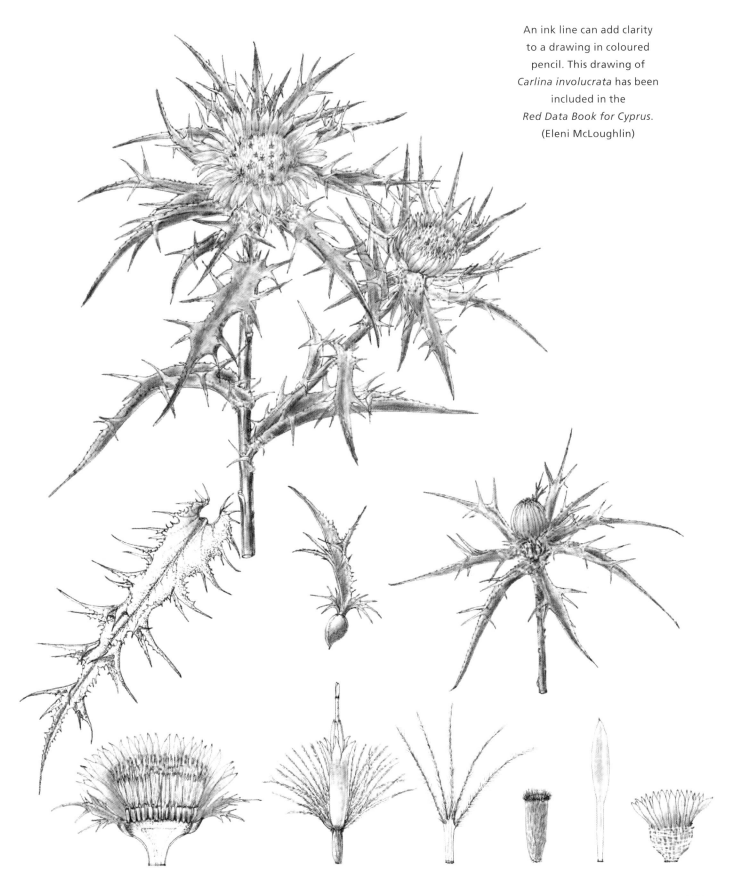

An ink line can add clarity
to a drawing in coloured
pencil. This drawing of
Carlina involucrata has been
included in the
Red Data Book for Cyprus.
(Eleni McLoughlin)

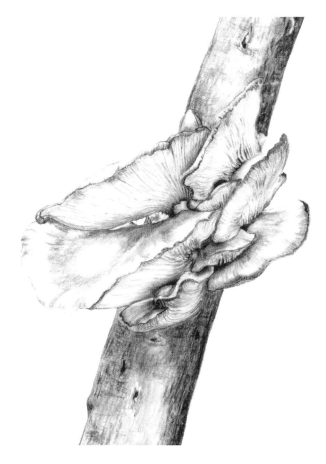

Oyster fungus portrayed on tracing paper. This paper is transparent but it is not as strong or as smooth as drafting film.
(Vivienne A. Brown)

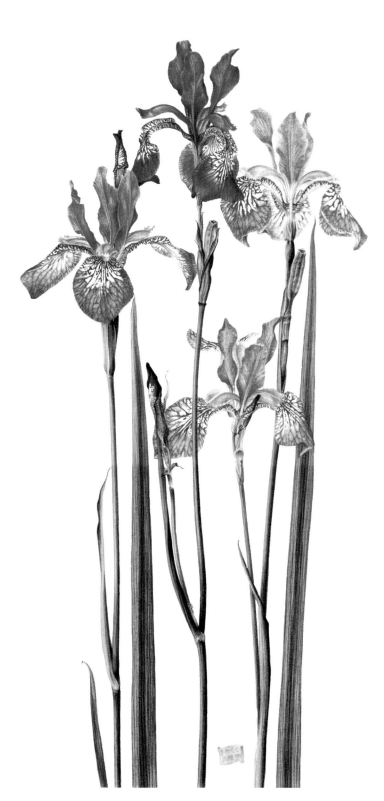

Iris sibirica using coloured pencil techniques. The colours that have been used for the flowers appear throughout the whole illustration, linking flowers and leaves together.
(Susan Christopher-Coulson)

developed until early in the twentieth century and have quickly become a very popular medium.

The application of soft dry pencils gives a textured appearance to most papers; flecks of white paper show through the colour of the pigment. This effect can be minimized by changing the direction of the pencil strokes to fill the gaps. When this is done with different colours they blend together and a new colour emerges. Experiment with your particular range of pencils and record the different blending effects. It is advisable to keep all your samples of work together in a folder, with notes about the colours used and how they were applied to the paper for future reference.

Papers

Coloured pencils can be used on any kind of paper. Papers with more texture will give a mottled effect at first as the colour will sit on the hills of the paper and the valleys will be left clear. This can give a useful textural effect. To flatten the paper for a

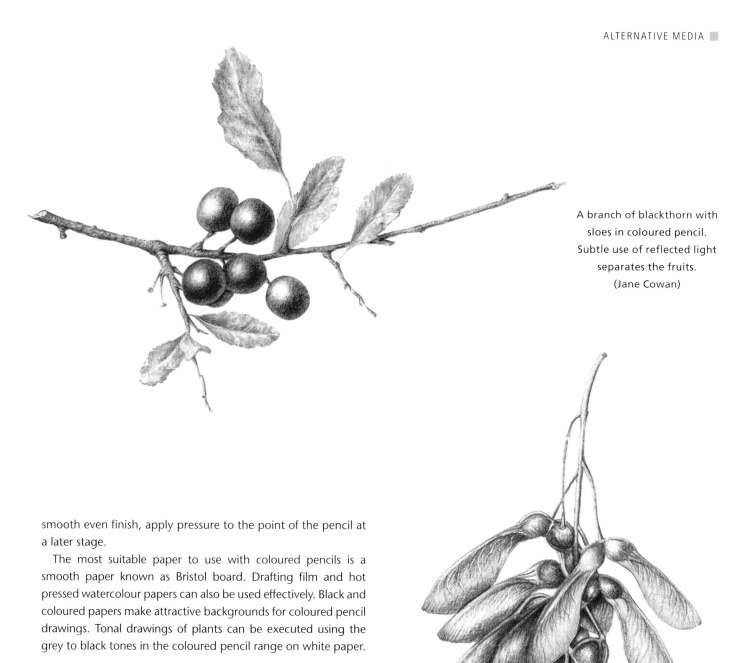

A branch of blackthorn with sloes in coloured pencil. Subtle use of reflected light separates the fruits. (Jane Cowan)

smooth even finish, apply pressure to the point of the pencil at a later stage.

The most suitable paper to use with coloured pencils is a smooth paper known as Bristol board. Drafting film and hot pressed watercolour papers can also be used effectively. Black and coloured papers make attractive backgrounds for coloured pencil drawings. Tonal drawings of plants can be executed using the grey to black tones in the coloured pencil range on white paper.

Drafting Film

Drafting film makes an interesting surface to work on as it is semi opaque. Some parts of the plant can be drawn and coloured on the underside. This makes them look as if they are further away and gives more depth to the illustration. Drafting film can be back-painted behind the image with white acrylic to intensify the colours on the front.

Water Resistant Pencils

There are a number of well-known brands of coloured pencils including Caran d'Ache, Derwent, Stabilo, Faber Castell and Berol. The pencils are manufactured as either soft or hard. Most

An indenter has been used to pick out the veins on this cluster of sycamore fruits. (Valerie Oxley)

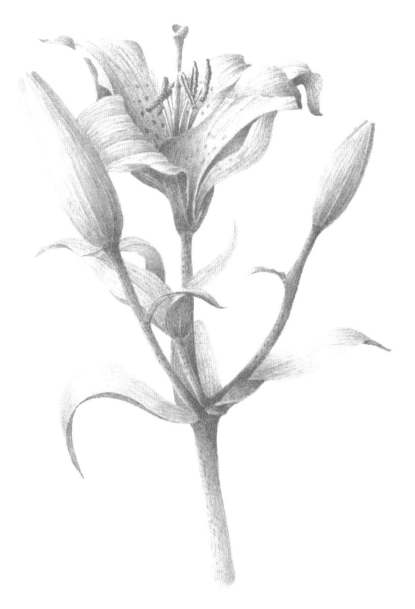

Establishing the light
and shade in tones of grey
is a technique used in
portraiture known
as grisaille.
(Lionel Booker)

makes of coloured pencils will blend well together, but care should be taken when mixing hard and soft pencils in the same piece of work. Always try blending the pencils together on a spare piece of the same paper, before applying to the work in progress.

Erasers

A putty or kneadable eraser can be used to lift areas of coloured pencil from the paper. A battery-operated eraser is particularly useful as it will remove colour without digging into the paper surface. Ensure that the eraser is clean each time it is applied to the paper; otherwise colour could be transferred, which is difficult to remove. Lowtac masking film can be used to remove unwanted pigment. Place a piece of film over the offending area and apply light pressure with the point of a pencil to the part to be removed. The colour is transferred to the surface of the film, which can be peeled from the artwork.

Pencil Sharpeners

A hand-held metal pencil sharpener is suitable for sharpening coloured pencils to a fine point. A two-holed, hand-held sharpener is particularly useful. One opening is for shaving the wood from the pencil and the second opening is for sharpening the point. Coloured pencils can be sharpened with a craft knife, but the softer pencils break easily. Many artists prefer to use a battery-operated pencil sharpener. The pencil can be quickly inserted to trim the point as you work. Should the pencil break

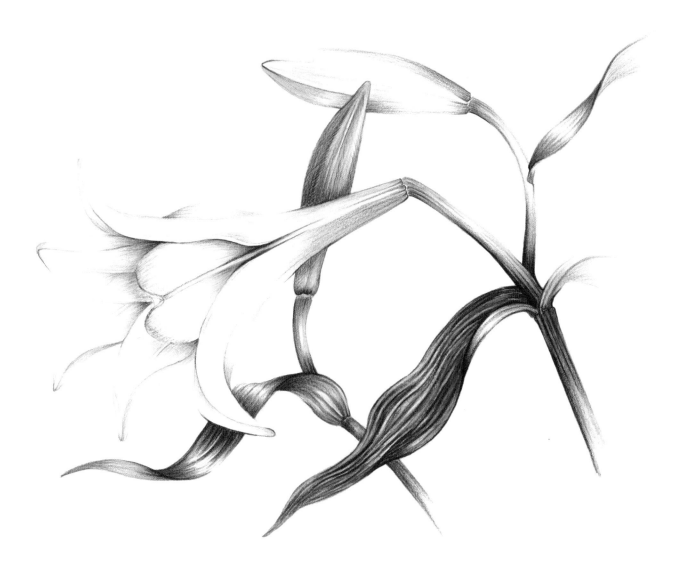

White flowers reflect colours that also appear on the leaves.
Lilium longiflorum. (Valerie Oxley)

frequently during the sharpening process it might indicate that the rod of colour is not aligned properly within the wooden casing. The remedy is to sharpen the pencil using a craft knife. A pencil dropped onto a hard floor may cause the rod to break in several places inside the casing; this will result in the pencil breaking frequently during sharpening.

Blenders

White spirit or turpentine can be used to dissolve wax colours and blend them together on the paper. A substance called Zest-it serves the same purpose. Zest-it can be rubbed into any colour

on the paper with a cotton wool pad or cotton buds. The colour can be pushed around and spread out giving a blended effect. Care should be taken that the room is well ventilated and that fumes are not inhaled from solvents. I do not use these materials in my classes.

Indenters, Embossers and Colours that Resist

The surface of the paper can be indented using a blunt instrument, an indenting tool or an embosser designed for craft work. The tool is used to make grooves in the paper. When coloured

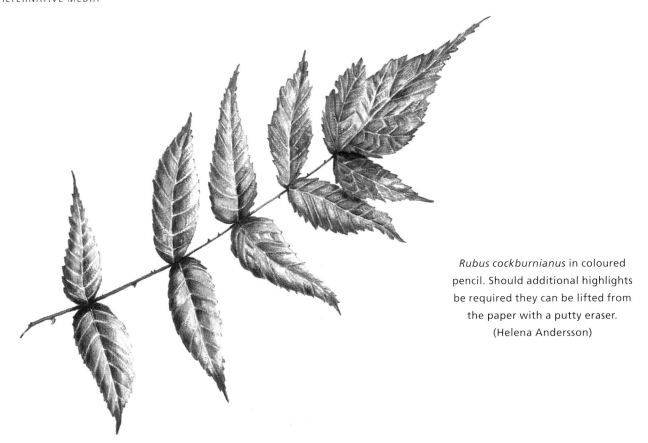

Rubus cockburnianus in coloured pencil. Should additional highlights be required they can be lifted from the paper with a putty eraser. (Helena Andersson)

pencil is applied to the paper over the top of the indented areas the grooves remain white. Where colour is required in the suppressed areas, it can be applied to the paper before indenting. Indenting is a very useful technique for the addition of hairs or veins in a botanical study.

Some colours will resist other colours: yellow and white are typical examples. Other colours applied on top of them slide onto the paper beyond, leaving the white or yellow colour uncovered. This can be used to advantage if you wish to create veins and hairs. Draw in the veins or hairs with yellow or white first, using a little pressure. Lift the pencil swiftly to create a tapered point to a hair or vein. Lay the greens over the top in the usual manner and the white or yellow will usually shine through.

Removing Coloured Pigment

Occasionally, when continuous pressure is applied to the pencil point tiny particles of coloured pigment are sprayed onto the paper surrounding the image. The particles can be removed with a very soft brush. Avoid using your hand to dust away the particles as this may grind them into the paper instead. Occasional stray particles of pigment can be picked up gently with a putty eraser.

Grisaille

This is an early painting technique often used in portraiture. The portrait was under painted in shades of grey to establish shape and form before adding true colour. It can be used with coloured pencils by applying a range of grey tones to shadow areas to help describe the shape and form of the plant. A gradual tonal range from light to dark should be built up leaving the white paper for the lightest tones. This is effective for leaves and stems, but you may wish to use pure colour only for the flowers.

WAX BLOOM

Occasionally a white cast or wax bloom appears on the paper, which looks like the bloom on plums or grapes. It can be removed by wiping the area with a soft tissue.

Methods of Working in Coloured Pencil

1. Draw the plant in detail on tracing paper using an HB pencil.
2. Transfer the image onto the correct paper, using a coloured pencil to go over the graphite lines on the reverse side of the tracing paper. Green can be used for most areas except the flower, which can be transferred in its true colour. Working from the graphite side, transfer

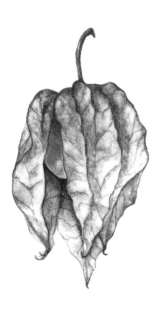

Physalis with orange fruit in watercolour on vellum.
(Wendy Harvey)

the drawing to the final paper using an HB pencil. The transferred outline will be in colour, which will avoid the problem of harsh graphite outlines around the work. Work lightly as too much pressure will create unwanted grooves in the paper.

3. Once the image is transferred to the correct paper apply coloured pencil techniques to build up the layers between tonal areas. Work as lightly as possible to blend colours; use the pencil point and hatching lines or cross hatching. Change the direction of line with each layer so that the wax does not build up on the hills of the paper creating a blotchy effect.

4. Build up the colours from light to dark. Elliptical movements with the pencil can be used to build up and blend layers of tone.

5. Continue to build up colour. It is advisable to make notes of the pencils you have used for future reference. The white of the paper should be left for highlights.

6. Tidy the outside edges using colours from the harder Berol Verithin range. These pencils can also be used to pick out small sharp details. Work from the inside of the drawing so that a harsh edge does not appear around the work. Protect your artwork as you progress by covering the areas you are not working on with a clean piece of paper.

7. Apply more pressure to the final layers to blend and push the colours together. The work can be burnished with white or some of the lighter creamy colours as the drawing progresses. This will blend the colours and give a smooth finish to the work. Where required, more colours can be added after burnishing.

8. Clear wax blenders can be used in the final stage of the drawing to blend and merge colours together. Do not attempt to lay down more colour on top of this waxy layer as it will be repelled and will not stick to the surface.

The finished appearance of coloured pencil drawings will vary with each individual artist. The pencils can be used without much pressure to build up layers of the colour lightly and gradually to give an evenly blended appearance. Alternatively, the colour can be pushed into the paper during the final stages and burnished to give a highly polished effect.

Fixative and Storage

In general it is preferable not to spray coloured pencil drawings with a fixative as it can change the colours slightly. The artwork can be stored between acid free archival tissue paper.

Water-Soluble Pencils

Water-soluble pencils can be blended with a wet brush after the dry colour from these pencils has been applied to the paper. The colour will be enhanced quite remarkably once the water has been applied. To keep the colours clear and bright it is advisable not to blend too many together before applying the water; otherwise the resulting colour will be muddy.

Water-soluble pencils can be applied to a piece of tracing paper and picked off with a wet brush, the tracing paper acting as a palette. Colours can be blended and mixed on tracing paper using this method. Certain textural and decorative effects can be created by scraping particles of colour from the point of the pencil with a craft knife and dropping them onto dampened paper.

Painting on Vellum
Definition of Parchment and Vellum

In general animal skin, soaked in lime then washed, scraped and dried out under tension is referred to as parchment. Fine parchment prepared from calf-skin is known as vellum. The term vellum is also used for the surface of fine paper, and this can cause some confusion. Gradually, over the years the term vellum has

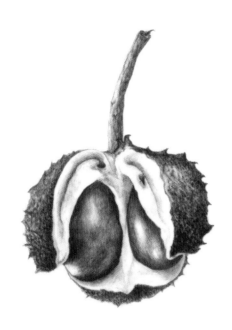

Horse chestnut fruit in watercolour on vellum.
(Wendy Harvey)

become used for any fine parchment regardless of the species of animal from which it was prepared. Parchment is the term still used for prepared sheepskin. The hair side of vellum is used for painting rather than the flesh side. Vellum can be bought as a whole skin or in pieces cut to size.

MANUSCRIPT CALFSKIN VELLUM
Manuscript vellum is prepared for calligraphy and can be used on both sides. It can vary in colour from white to cream.

SLUNK MANUSCRIPT CALFSKIN VELLUM
Slunk is the term used for premature, still-born calves. Skin from young calves is also referred to as slunk; the surface is fine and soft. It is finished for writing on both sides.

CLASSIC VELLUM
Classic vellum is finished on the hair side only and very similar to manuscript calfskin vellum. Less scraping is involved during manufacture, so the skin is not as fine as manuscript calfskin vellum and it is creamier in colour.

KELMSCOTT VELLUM
Kelmscott vellum was originally prepared for William Morris. It was used for the books he printed at the Kelmscott Press and it was popular with the Pre-Raphaelite painters. Kelmscott vellum is prepared with vellum glue and a special chalk filler, which gives it a smooth surface suitable for detailed painting. Pounce or wet and dry sandpaper can be used if further preparation is necessary.

IVORINE
Ivorine is used by miniaturists as a substitute for pure ivory, which is now a banned material. It is made from a cotton-based plastic and is semi absorbent. It can be used for oils and acrylic as well as watercolour.

Preparation of Vellum for Painting

Vellum has a hair side and a flesh side. The hair side is the one usually preferred for detail work. Individual skins can differ; they can vary in colour, thickness and greasiness. Large pieces of vellum can be stretched over a frame and fixed with staples. Smaller pieces of vellum can be taped to a board using masking tape. Small pieces of vellum can be mounted onto stiff card using a very smooth flour paste. The paste is spread across the card using a roller to flatten and smooth it out. The vellum is placed on top. The flour paste sandwich needs to be pressed flat under heavy weights. It will take a few days to dry out.

Pounce

Pounce is a mixture of pumice and chalk. It can be rubbed onto the surface of the vellum with a cloth or fine wet and dry sandpaper to remove excess grease and to raise the nap. This treatment helps watercolour paint to adhere to the surface. Care should be taken not to raise the nap too much as this will make fine brush work difficult. Excess powder can be brushed away with a cloth or soft brush to ensure no particles remain. The above treatments should be applied away from the painting area in case the fine gritty particles of dust get into your watercolours. It could be a health risk if ingested. Preparation of a small piece of vellum should only take two or three minutes rubbing action with pounce.

Storage of Vellum

Whole skins can be stored in a roll or by placing them flat between boards. The skins should be kept in damp-free conditions and not too warm. The air should contain some moisture to allow the skin to remain in good condition. Unfortunately centrally heated rooms are not the most suitable places for storing vellum.

Vellum can vary in colour and thickness. Smaller pieces of vellum are usually fairly consistent, but larger pieces can show markings in streaks and patterns. Visualizing the finished work is very important. You should decide whether any veining and markings on the surface are to be incorporated into the final overall design. Vellum is very sensitive to atmospheric conditions. It will dry out and shrink or even curl up in excessive heat. Dampness causes the skin to absorb moisture. Thinner areas can stretch more than thicker ones and this can cause the vellum to buckle resulting in an uneven surface

Painting Techniques on Vellum

1. Plan the composition carefully, because the surface can be spoiled by graphite and with rubbing out.
2. Use tracing paper to transfer the drawing onto the vellum.
3. Mix the paint and leave it to dry slightly; ideally use the dryer end of a sloping palette to pick up the dry paint. It is essential to use the minimum of paint possible and only a little water to avoid the vellum wrinkling. Allow each layer to dry before applying the next one or the paint will lift off the surface. Once the painted area is dry errors can be lifted with a damp brush, or by scraping with a razor blade, or by rubbing with very fine sandpaper.
4. Once work has started, the vellum should be kept flat. Between painting sessions place it between boards with a weight on top.
5. Work light to dark, building up shape and form gradually. Use the dry brush technique to apply very small brush strokes or stippling. Ensure your brushes have very fine points. Brushes supplied for miniature work are suitable and are designed to hold a good amount of moisture.

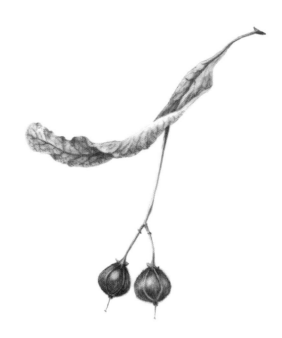

The fruit of the lime painted on vellum. (Jill Holcombe)

Mounting and Storage

Illustrations on vellum should preferably be float-mounted for storage. The vellum is placed on top of a mount board and hinged in place using long fibered Japanese hinges. This will allow the vellum to breath and adapt to the atmospheric conditions of its surroundings. A window mount can be placed on top of the mount board, but the aperture should be wider than the piece of vellum itself.

When vellum is exhibited it could react to a change in atmospheric conditions, contract and buckle.

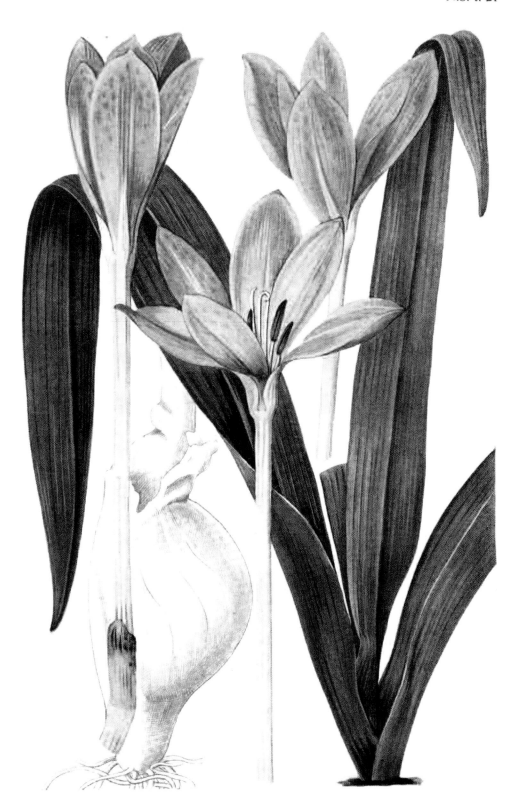

Colchicum lusitanum S. Ross-Craig del.

Illustration of *Colchicum lusitanum* by Stella Ross-Craig (1906–2006). Observe the turn of the leaves, the inclusion of the bulb, and the arrangement of the flowers. The drawing is designed to give as much information about the plant as possible.

(© Royal Botanic Garden, Kew)

HELP! THE PLANT IS TOO BIG FOR THE PAGE

This chapter deals with the placement and design of the plant on the page. Plants are usually shown life-size in botanical illustrations. However this is not always possible as the paper may not be large enough. In this chapter a number of solutions will be offered.

Redouté (1759–1840) was a master of design, botanical accuracy and perspective. By studying his drawings one could probably solve problems of illustrating plants that are too big for the page. A solution is to draw sections of the plant life-size and to re-arrange them on the page in a pleasing and logical design. Bulbous plants are often shown in this way, particularly where the bulb needs to be illustrated along with the flower for identification purposes. Earlier illustrators twisted plant material around the page in an effort to show the whole specimen. Some illustrators even showed long leaves folded in a zigzag fashion to fit them in, similar to the solution for displaying whole herbarium specimens.

Using a larger piece of paper would be the first possible solution to a large leaf problem. For some subjects, such as a gunnera leaf, this would be almost impossible as the leaf would have to be scaled down. A large base leaf could be shown in outline behind a flowering stem, or it could be shown in a natural position but foreshortened to save space. This solution has been successfully used for hellebore leaves. Where a leaf is symmetrical it is acceptable for only half a leaf to be shown; this is often a workable solution for scientific drawings.

Scale

Coping with scale, both up and down, has been a problem for artists and publishers over the years. They have tried to resolve the problem with varying degrees of success. Publishers in the past have inserted folded drawings of plants inside publications, which could be opened up to reveal the true size. This was not always successful because there were problems when the folded illustrations became torn or detached. Reducing all illustrations so they are the same size for publication can be confusing, and publishers have to resort to stating the original size of the plant alongside the picture.

Artists prefer to have illustrations reduced when they are published, and the illustrations are usually drawn slightly larger accordingly. The reduction tightens up the lines and detail, whereas an enlargement tends to emphasize all the weak points in the drawing or painting.

Placement and Design

Placement and design of the plant material on the page is crucial to a good overall composition. The illustrator needs to create balance and harmony, contrast and rhythm within the design. The eye should be drawn into and around the picture. The overall design should not be so predictable that the viewer gives it only a cursory glance. Creating tension within a drawing, to alert the eye and catch the attention of the viewer, draws the onlooker into the picture. The viewer can be alerted by something unexpected, such as a change of colour, the particular direction of a line or a change of shape. Nature is full of contrasting colours and shapes; as an artist you need to take time to observe and select the most interesting material for your illustration.

The purpose of the illustration should be the first consideration. Is the drawing to be an accurate scientific representation of the plant suitable for identification purposes or is it to be a decorative piece? The boundaries overlap, but for commercial purposes botanical drawings are classed simply as either scientific or decorative.

A successful design requires careful observation and judgement. My father, who created wood carvings as a hobby, would stare at a piece of wood until a picture arose in his mind's eye. He would then whittle away at the wood, chipping and smoothing until a three-dimensional picture emerged; it was as if the picture was drawn on the wood before him by some other hand.

ABOVE: An arresting design, the full-faced flower draws the viewer into the picture, and the unexpected snail shell adds a touch of intrigue. (Gael Sellwood)

LEFT: *Iris foetidissima*, the stinking iris. The occasional turn of a leaf and emergence of flowering buds draws the viewer into and around the picture. (Judith Pumphrey)

I have heard students talk of seeing the plant in their mind as a finished picture and they fill in the colours as if painting by numbers. For some people the process is intuitive and designs grow naturally; they seem to know where to place the tilt of a flower or change the lie of a leaf as they progress. For others designing is a frustrating process, and despite staring at the plant and then at the blank page, nothing happens and they do not know where to start.

Levels of Observation

It may seem strange to talk about absorbing the plant material in front of you, but it is necessary to look carefully at your plant and then look again. I am often surprised by the different levels of observation; it seems impossible to see everything first time. At first we may see size, shape and overall colour, but as we look more closely we notice the attachment of leaves, the shape of the stem and the position of the flowers. On closer observation the venation on leaves and petals and surface texture start to emerge. Next we might notice the subtle changes in colour throughout the whole plant, and as we look even more closely we see the flower itself in more detail. Mother Nature it seems loves to catch us out; it is only when we stop looking that disasters occur. Train yourself to be inquisitive, aim to look with understanding at the plant in front of you before you start to draw.

The habit of the plant needs to be captured in a drawing. The natural growth curve should be observed and reproduced in order to create a pleasing representation on the page. Stiff illus-

More than one plant has been used to create this pleasing composition of *Cyclamen coum*. (Polly Morris)

Careful placement of the flowers and buds has brought interest and colour through the illustration. *Fritillaria meleagris*, snake's head fritillary. (Mary Acton)

trations with no life and movement are often the result of too much measuring in the early stages of drawing, coupled with an anxiety to recreate an exact replica of the plant in front of you. Without regard for the natural flow of growth and movement the illustration will look too formal, cold and unexciting.

The Boundaries

When planning a composition think about the boundaries of your work. It is not a good idea to use the edge of your paper as a boundary. To create boundaries rule straight pencil lines about 2cm (³/₄in) from the edge of the paper on smaller works and up to about 4cm (1¹/₂in) from the edge on large pieces. The space between the edge of the paper and the boundary line is

called the margin. The margin is a useful place to make notes about the plant and to try out colours; it also allows space for a mount to be added at a later stage for display purposes.

The Focal Point

Decide on the focal point of your design. When flowers are present they are usually the main focus, so think carefully where you would like the viewer to look first. Turn your plant as you look, and even though plants are usually placed at eye level, consider changing your eye level to create an interesting view. A three-quarter view of the flower may be more attractive and instructional than a head-on view. There may be some interesting colouration on the leaves or stems, which could be shown from

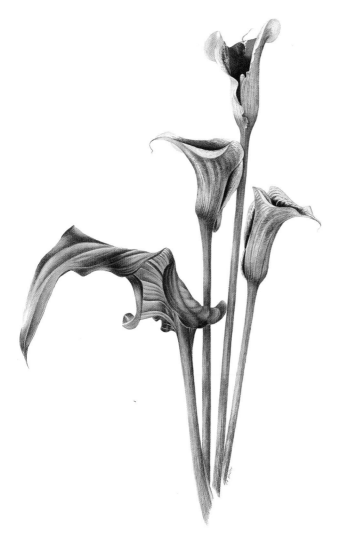

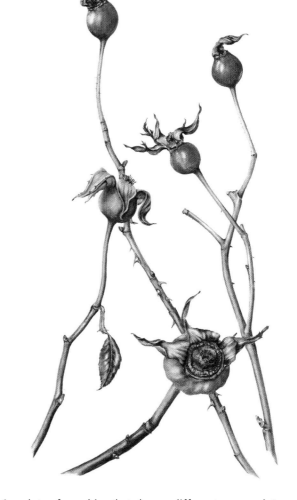

The placement of calla lilies overcomes the problem of portraying tall flowers and large leaves. (Caroline Holley)

A variety of rose hips that show a different approach to coping with crossing stems. (Judith Pumphrey)

another angle. It might be possible to illustrate more than one aspect of the plant to show additional information regarding shape and form. Quick sketches of the plant material from different positions could help you decide on the final composition.

Positive and Negative Space

Before embarking on the final illustration, look at the initial sketch and check whether there is a pleasing balance between the shapes of the plants and the spaces between: that is the positive and negative shapes. It might be interesting to record the shape of the plant as a silhouette on a piece of paper to see the pattern of the positive and negative space more clearly. This is quite a good way to check the balance of the design.

EXERCISE TO ILLUSTRATE NEGATIVE AND POSITIVE SPACE

Draw your plant in pencil outline following the outside edge. Colour in the area within the pencil lines with ink or pencil to create a silhouette of your plant. Look at the pattern of the positive shapes and look at the pattern of the spaces between – the negative shapes – and check whether there is a good balance between negative and positive areas.

Checking the Composition

A time-honoured way to check a design is to hold it up to a mirror. The mirror image often shows up inconsistencies in the balance of a composition. Leaving your work for a day, then propping it up and standing back from it also helps you to see afresh the balance of the design.

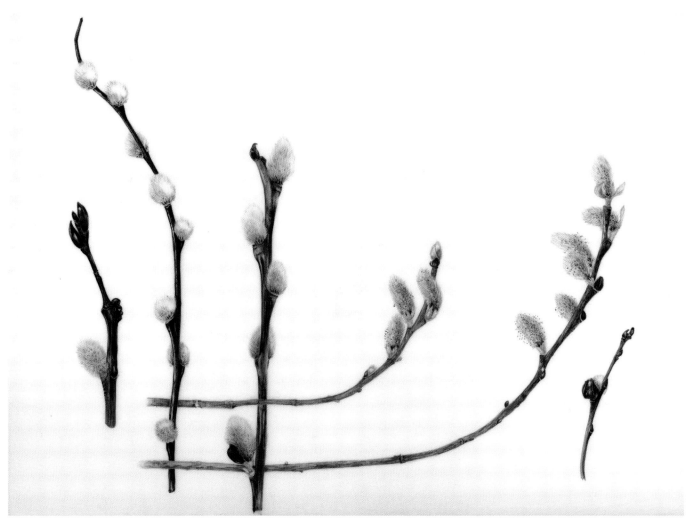

This unusual design on vellum uses crossing willow twigs to
form a weaving pattern and catches the eye. (Gael Sellwood)

Composition of Flowers

Many plants flower at the top of a long stalk. Some thought
needs to be given to composition or the final study could show
a picture of leaves and stalks with a few flowers stuck at the top
edge of the paper. The flowers are generally the most interest-
ing and colourful part of the picture. They need to be placed
where they can be seen. Flowers can be shown from different
angles if more than one is portrayed. Occasionally a flower look-
ing out of the picture and towards to viewer draws in the
onlooker. Think carefully about the composition; otherwise the
head-on flower could look like a lollipop on a stick. A three-quar-
ter view of the flower head can give useful information in a more
convincing manner. Care should also be taken that the centre of
the illustration does not end up as an empty space with all the
flowers around the edge of the paper. The viewer will be left
focusing on nothing in the middle of the picture.

Planning a Layout

Unless you feel confident about your ability to compose direct-
ly on the page it is advisable to plan your composition on draw-
ing paper first. The drawings can be checked for accuracy and
then cut out and rearranged. A light box can be used to
rearrange the cut pieces into a satisfactory composition before
tracing them off onto watercolour paper. This method is essen-
tial if you are considering a scientific illustration, where dissec-
tions may be part of the finished picture. A scientific piece will
often require the life cycle of the plant to be illustrated, so the
separate drawings should be stored until the final artwork can
be completed. This could take several seasons.

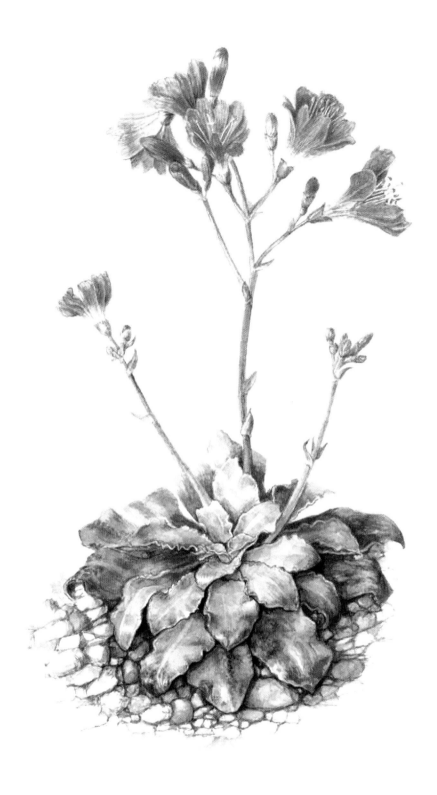

Alpines are often shown with a few pebbles
around the base, as in this painting of a lewisia.
(Sheila M. Stancil)

The Problem of Crossing Stems

The eye follows lines, and the portrayal of long stems can create visual problems. When two flowers have stems which cross in the middle of a page, the eye is drawn to the centre of the cross. I have heard people say one must never have crossing stems but this is an exaggeration of the problem; the stems of some plants cross naturally and often.

The botanical artist needs to be aware of the potential hazard and try to avoid crossed stems appearing in the middle of the composition. Where stems cross, attempt to draw the eye away from the middle of the crossing. This can be achieved by altering the placement of the stems and by varying tone. For example, fade away the stem in the background and paint the one in front in more detail. Contemporary artists who design with plants often use crossing stems deliberately to create patterns on the page.

Leaves and flowers which point out of the picture, in straight or imaginary lines that the eye will follow, can be another problem. Sometimes illustrations of daffodils create particular difficulties because of the shape and angle of the flower heads. The trumpets are often shown pointing to a corner of the paper, one to the left and one to the right, with nothing in the middle except an empty and uninteresting space. Aim to design from the centre outwards.

Composition of Roots

Fibrous roots can be problem if they are in a mass or where they are very long. Many illustrators draw a line across the page and stop the roots at that point once enough of the root has been shown to describe its habit.

When plants grow in clumps, such as snowdrops and grape hyacinths, only one plant needs to show the bulb and root attachment. The rest of the clump can be shown as stopping at ground level, without roots but with soil particles, detritus or pebbles.

Roots were a problem for artists in the past. It would appear that roots were not dug up and observed, so imaginary roots were added to many illustrations. For example, some early illustrations of fungi incorrectly showed them with roots, like a flowering plant.

Describing the base of the plant can cause difficulties where roots are not shown. Flowers that grow from a rosette, such as primulas, cyclamen, dandelions and auriculas, have leaves around the base of the plant which can be used to cover the area where the root emerges. In the past, to overcome the problem plants have been shown growing from a mound of earth. Plants can be shown in a plant pot, but it is important to be able to draw a pot if one is to be included. Drawing the rim of a clay pot

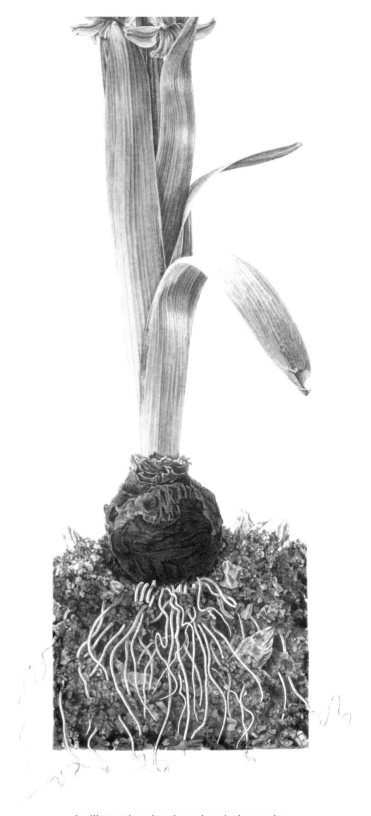

An illustration showing a hyacinth growing in the soil. (Sheila Thompson)

and a little of the sides may look more natural than a drawing of the whole pot.

Habitats

For plant identification purposes wild plants can be shown with a little of their natural habitat. For example wall pennywort and ivy-leaved toadflax can be illustrated growing from a stone wall. Companion plants from a particular geological area can help with identification of a particular specimen. You could take the opportunity to be imaginative and illustrate the main specimen in watercolour with companion plants in graphite, to help focus the eye.

Illustrating Trees

Trees can be a problem for illustrators because of their large size in comparison with the size of the paper. For identification purposes the habit of the tree should be shown somewhere in the illustration, but it can be reduced and shown as a thumbnail sketch with a scale indicated. Artists have been very creative in showing scale for tree illustrations; sometimes a rabbit or a deer or even an artist standing at an easel have been used for height comparison. Illustrating the life cycle of a tree may take a few seasons' work to complete, so use quick thumbnail sketches to record your ideas for the final composition.

Signature and Labels

Finally make sure your signature is neat and tidy and does not intrude or spoil the overall design. Consideration should be given to the placement of the name of the plant. Hand-written labels should be of the same high quality as the illustration.

Reminders

1. Create a boundary to your work by establishing a margin.
2. Consider the focal point of your design.
3. Design from the centre outwards; the eye should be guided around your design.
4. Check the balance of the negative spaces and positive areas.
5. Take care that stems and flowers do not point out of the corners of your paper leaving the middle empty.
6. Crossing stems can add interest, but avoid stems that cross in the middle of the page.
7. Check the middle of your design and make sure flowers are not dotted around the outside edge.
8. Look in a mirror to see your work from a different angle.
9. Your signature and name of the plant are part of the design of the whole work.

OPPOSITE: Navelwort shown growing from a stone wall, its natural environment. (Gillian M. Constable)

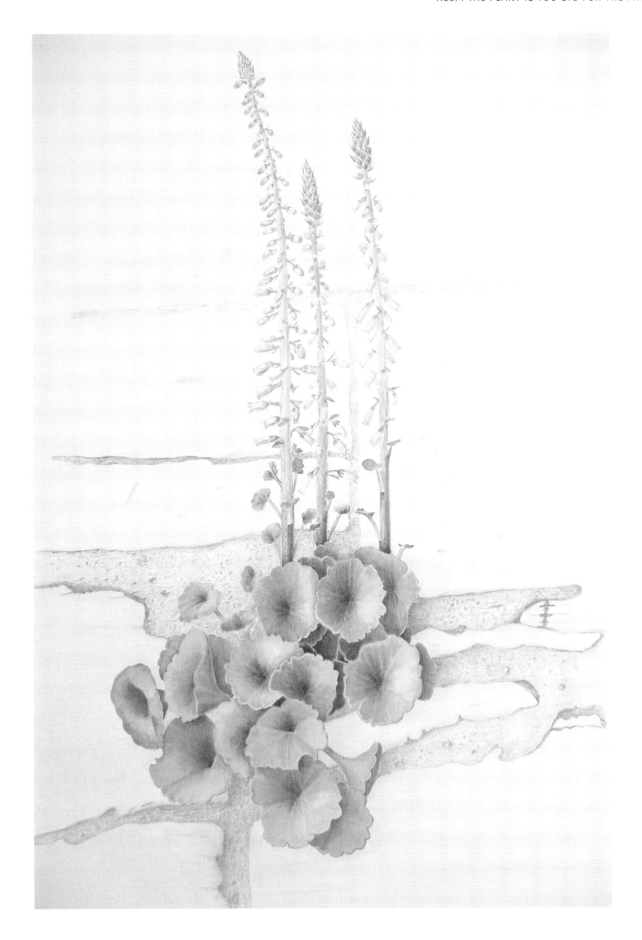

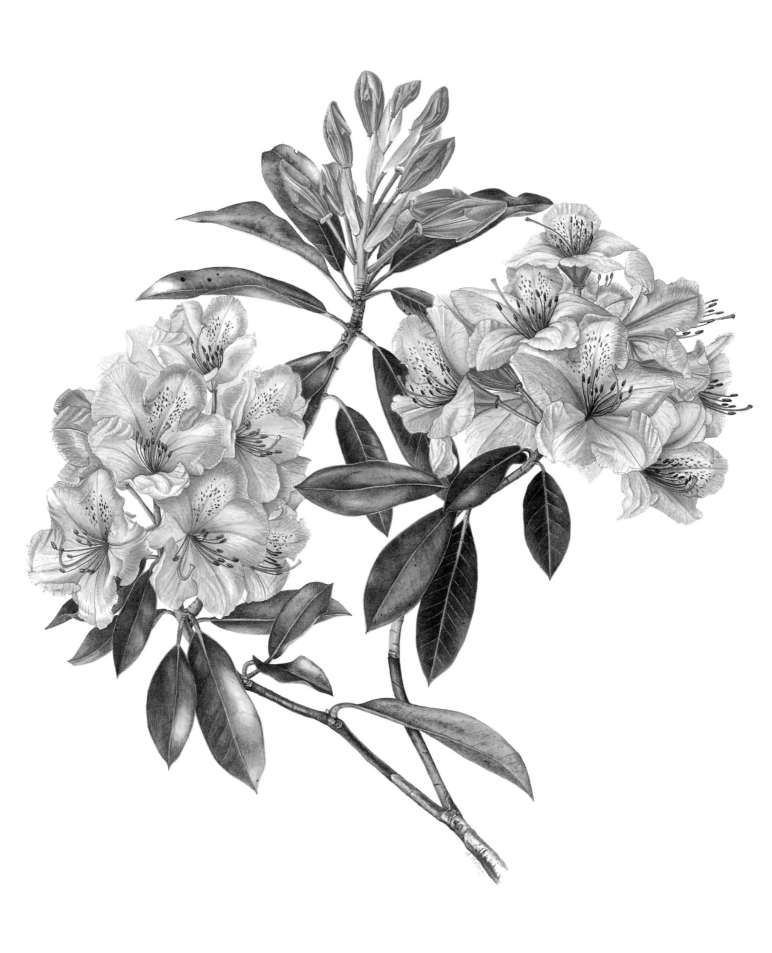

FINISHING TOUCHES

Is it Finished?

It can be very difficult to know when a piece of artwork is complete. Some people continue to add detail until the piece is overworked, and others stop too soon. To help make a judgement, take a break from the painting process and if possible look at the artwork afresh the next day. Place the work in another room at eye level and stand away from it to make your appraisal. Look for the focal point of your painting: where does the eye rest? Detail in this area should be crisp and sharp. Look at the colour balance throughout the work to see if any adjustments are necessary. The areas that recede should have less detail, and areas nearer the viewer should be brighter, painted more intensely and with greater detail. Make sure that all the edges around the work are sharp. Examine them with a magnifying glass for any stray paint. Hold your work in front of a mirror to look at it through fresh eyes to observe whether more detail needs to be added.

Checking the Composition and Detail

Check the overall composition by looking at the areas without paint, known as negative spaces. Look for odd shapes unwittingly created in these spaces, which might catch the viewer's eye. Make sure that leaves have stalks and flowers have stems and that the junctions where they are attached are clearly described. Look again at the structure and position of any hairs, prickles or spines. Light-coloured hairs will look pale against a dark background and dark against a light background. Ensure stems are the right dimensions, and stems that disappear and then reappear are properly aligned. The venation on the leaves should look natural. The veins should be neither emphasized nor too wide. Twists and turns of leaves should be accurately interpreted. On a twisted leaf check the main vein is continuous and does not look as if it has been broken. Check that petals of a flower are correctly attached to the pedicel or flowering stem and are in line with it, for example daffodils. Where flowers hang and droop, for example snowdrops, make sure you have drawn the bend at the right angle and in the right place.

Avoiding Problems

All your art materials should be kept on the right-hand side of your work if you are right-handed. This will avoid stretching across your paper to pick up paint or wash out a brush. There is always the possibility that paint will drip onto your work when avoidable movements are undertaken.

Cover the part of your illustration that you are not working on with a mask. This can be made from paper or acetate with a window opening. An acetate mask is useful as you will be able to see the artwork underneath. Resting your hand directly on the paper may cause smudging or greasy marks. A thin deposit of grease may not be noticed initially, but will be disastrous if paint is repelled at a later stage. The grease will resist the paint and leave a slightly blotchy area on the paper, which will be difficult to disguise. Some people use a knitted square as a mask. It will slide lightly over the paper when the hand is moved, and as long as it does not slide into a damp area it is a useful solution. Wearing cotton gloves with the thumb and first finger cut off to hold a brush is another practical idea. The gloves should be kept clean and should fit snugly so they do not catch.

Finally, cover your work at the end of the day to protect it from dust. Move it out of the reach of small children and the domestic cat. I have a simple rule not to have a cup of tea or coffee or indeed any refreshment on the painting table. It has been known for an artist on leaving the table to nudge a cup and to spill the contents over their work. You should also discourage people looking at your work when holding a drink. A delicate piece of work can be ruined through simple carelessness.

An attractive study of *Rhododendron* 'Pink Pearl' selected for the Twelfth International Exhibition at the Hunt Institute for Botanical Documentation, Pittsburgh.

(Caroline Holley)

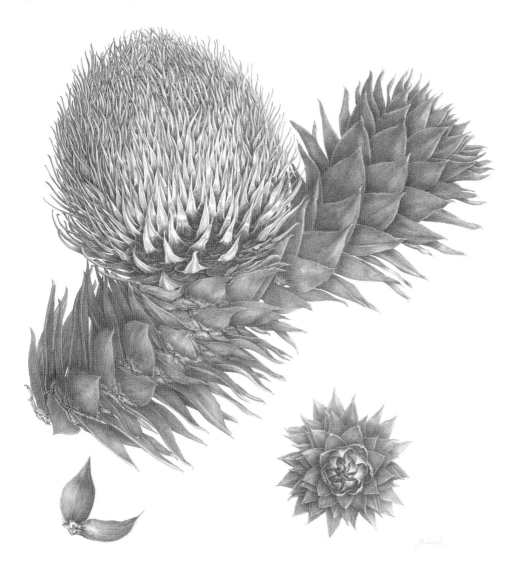

It is important to cover your work as you progress, particularly when working in graphite which smudges easily. The cone of the monkey puzzle (*Araucaria araucana*). (Julie Small)

Erasing Graphite Pencil Smudges and Unwanted Lines

Check your work with a magnifying glass for traces of stray lines in graphite. Removal can be undertaken with a putty eraser using a dabbing or rolling action. Some artists use Blu-Tack, but it is not recommended as it may leave grease marks. Battery-operated erasers are particularly useful and hardly touch the paper, causing little damage to the surface.

Where graphite has been erased at an early stage in the drawing process there is the possibility that the paper will have become roughened. To help remedy this problem, before painting, rub the disturbed paper lightly with the back of a bone spoon or fingernail to smooth it down again. In Sheffield, I was advised to find a rabbit's knucklebone on the moors for this purpose.

Erasing and Lifting Coloured Pencil

Coloured pencil can be removed quite effectively from paper with a battery-operated eraser or with a putty eraser. Another method is to use removable masking film, the type used for air-brush work. The film is placed on the paper over the top of the offending mark. A pencil can be used to rub over the mark through the film. When the masking film is lifted the unwanted colour should appear on the back. This is a useful technique for removing veins from coloured leaves as well as mistakes. In every case experiment on a spare piece of the same type of paper first; do not try any removal until you are confident you have found a successful method.

Removing Watercolour Paint

Unwanted areas of watercolour or splashes of colour dropped onto the page by mistake should be removed as soon as

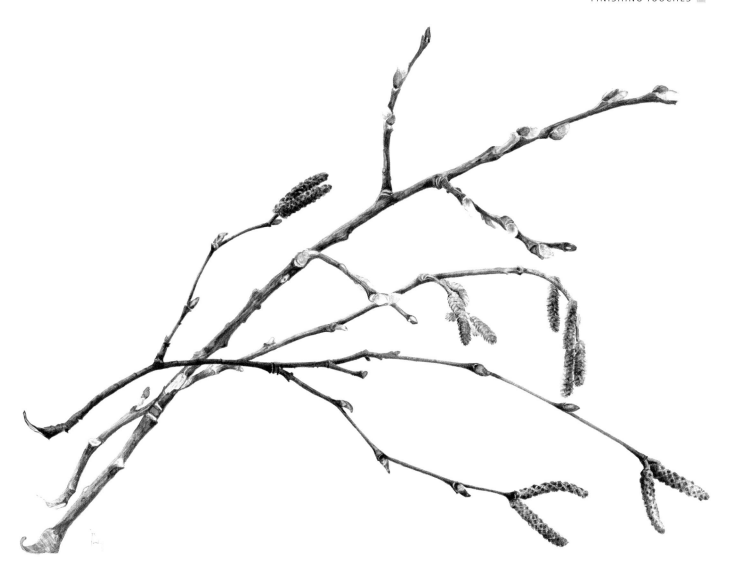

A handful of winter twigs. Care should be taken that pollen from your specimen does not fall onto the drawing paper and cause a stain. (Hannelore B. Mattison Thompson)

possible, preferably before the paper is dry. Have clean water, a brush and clean tissues ready. If paint gets on the paper by accident, using the brush, add a little clean water to the area and leave for a few moments before dabbing dry with the tissues. Alternatively, the colour can be gently pushed or eased from the surface of the paper with a clean, wet hog-hair paint brush, which has firm bristle-like hairs.

Dry paint can be scraped from the surface with a single razor blade, a technique which is effective with inorganic pigments as the particles do not sink into the surface of the paper. Remember that any disturbance of the paper's surface will cause damage, and it may need smoothing down after the removal of the paint.

A layer of white gouache can be painted over an offending mistake if the error lies within the painted area. Care should be taken that the gouache layer is not too thick, or it will appear textured and messy. Wait until the area is completely dry before reapplying watercolours over the top. It is inadvisable to use white gouache beyond the painted image to cover unwanted paint spots, as it will be noticeable and distracting.

Fine sandpaper, or a dampened abrasive stain-removal sponge can be used to remove dry paint. An abrasive stain-removal sponge, known as a Magic Eraser Block and made by Lakeland, is sold for use in the kitchen and not as an art material, but it has been found to be effective for removing paint. It needs to be dampened before use. Test these methods first before applying to any of your work in progress. The sponge should be used carefully as it does break up with continued application, and the surface of the paper will be disturbed. After removal of the paint, allow the paper to dry and smooth over with a bone handle.

When all else fails the time-honoured way to deal with an unwanted paint splash is to turn it into a leaf, flower or insect!

Removing Ink and Correcting Mistakes

Corrections for pen and ink mistakes usually involve gently scraping the surface with a single razor blade and smoothing the area afterwards. Correcting fluid or white gouache can be used on pen and ink illustrations that are going to be copied for publication. In most cases the white corrections will not show up in the printed work.

Removing Watercolour Paint from Vellum

One of the advantages of vellum is that paint can be removed from the surface fairly easily. Use a moistened brush and gently push the paint; the colour should soak into the brush and can be removed from the paper. When this method is not successful try gently erasing the paint from the surface by using very fine sandpaper.

In the nineteenth century Grace Pollock painted the wild flowers of the countryside near Cambridge. Local as well botanical names, dates and places have made her records of great interest today. (By kind permission of Mary Crossley)

Treating Cockled or Buckled Watercolour Paper

Stretching watercolour paper before you embark on a painting will eliminate the problem of cockled or buckled paper at a later stage. However, if you are using the heavier weight papers of 140lb and above there is not usually the need to stretch the paper for botanical studies.

If your paper is found to have cockled or buckled once the painting has been completed the following remedy may help. Ensure that the painted surface of your work is dry. The painting should be placed face down on top of a clean sheet of paper on

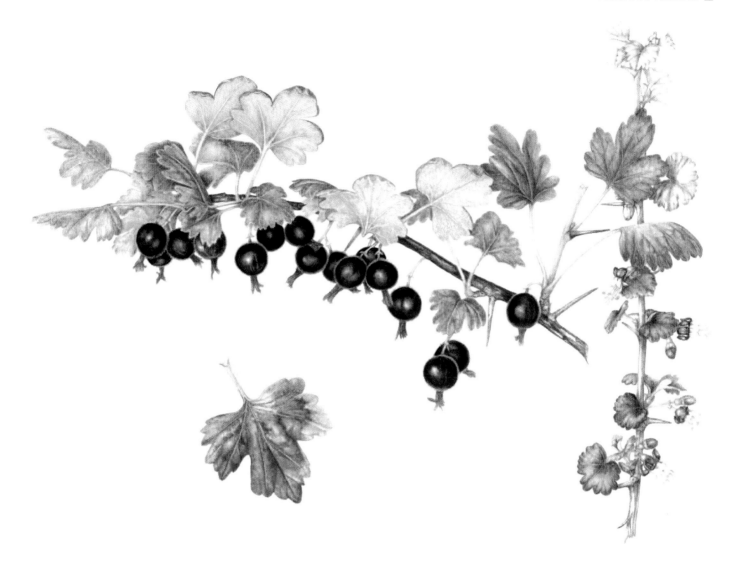

This illustration of the jostaberry was part of a display exhibited at the Royal Horticultural Society, London. The fruit is a cross between a blackcurrant and a gooseberry. (Sylvia Sutton)

a smooth and firm surface. Using a large brush or sponge, wet the back of the paper completely, making sure that none of the water seeps under the edges and onto the front. Place two pieces of clean blotting paper over the wet surface. Put a weighted drawing board on top and leave overnight. If the paper is still found to be damp the next day leave for a few more hours. Fifteen hours is considered the average drying time with this method. When the picture is to be mounted and framed this should be undertaken as soon as possible so that the paper remains flat.

Naming Your Plant

Plants, cultivated and wild, usually have a common name as well as a botanical name. The common name can vary from country to country, and it can even vary in different areas of the same country. Wild flowers are given charming folk names, such as lady's smock or cuckoo flower for *Cardamine pretensis*. Some wild plants have so many local names that identification becomes confusing.

In the past, descriptions and the botanical naming of plants became extremely lengthy. In 1753, the botanist Carl Linnaeus published a book called *Species Plantarum*. This listed all the plants known to him at that time. To try and simplify the lengthy descriptions he gave each plant a binomial name; each name consisted of two parts, which he thought would be easy for people to remember. The first name was the genus and the second name was the species. The binomial naming of plants is still used today, because the plant names are easily recognized whatever the country or the language spoken. The name of the plant is

referred to as its Latin name but this is a little misleading as the names are a mix of Greek and Latin. Other Latinized words have been used such as those to commemorate places and people. An International Code of Botanical Nomenclature has been set up with rules and guidelines to continue naming plants that are new to science.

The first part of the name is the generic name or the genus to which the plant belongs. When written the genus always begins with a capital letter. The second part of the name is the specific epithet; this does not begin with a capital letter. In print the plant name is written in italics; in handwriting it is underlined.

When you are drawing a plant for scientific purposes the following information would be helpful. It can be written in the margin of your work:

NAMING WILD PLANTS
1. The Latin name of the plant.
2. The common name of the plant.
3. The locality where the plant was found.
4. A short description of the habitat.
5. The date of the illustration.

NAMING CULTIVATED PLANTS
1. The Latin name of the plant.
2. The common name of the plant.
3. The source of the plant: private collection, plant nursery or botanical garden.
4. The accession number; this will identify the plant if it is growing in a botanical garden.
5. The collector's number and the date when it was collected if known.
6. The country of origin.
7. The date of the illustration.

The date when the drawing was made and the artist's signature should be added at the bottom right of the artwork. The remaining information can be placed in the margin at the bottom left of the illustration. The notes should be written in pencil so that they can be changed if the information is found to be incorrect.

Mounting and Framing Your Artwork

A conservation mountboard window mount, with a conservation mountboard undermount, helps protect your artwork and give it some rigidity and strength. When you are framing and

Large and small pictures can be exhibited at open studio events, creating opportunities for you to sell your work and receive commissions. (Gael Sellwood)

glazing your work, the mount separates the artwork from the glass and allows breathing space. To ensure your work is visually balanced the bottom margin of the mount is usually deeper than the top and side margins. This is to counteract the illusion that the bottom appears narrower when it is hung. It is easier to cut the aperture with all outer sides equal and trim the difference afterwards. Check the mount is squared before starting to work. It is not necessary to apply this rule to the inner mount on a double mount, this should show about 5mm ($1/4$in) on all sides. There is a school of thought that says this method of mounting dates back to Victorian times when pictures were hung higher on the wall, and it is not necessary today as pictures are hung at eye level. Some contemporary work is framed with equal margins on all four sides.

All materials should be archival in quality. Ideally the work should be hinged with Japanese rice paper and starch paste so that any procedure undertaken can be reversed without damage to your picture. Occasionally botanical artworks are surface or float mounted. Artwork on vellum, or work on special paper, which may have attractive deckle edges, is sometimes displayed in this manner. Care should be taken that the glazing does not touch the artwork.

Traditionally botanical work was shown with cream mounts and narrow gold frames, but fashions change and a wonderful range of mounts and frames is now available to enhance and protect your work. Highly decorative frames and strongly

coloured mounts are not usually suitable for botanical work. Keep the framing simple and avoid framing your work to match the colours in a particular room. Frame the picture to enhance the artwork.

Exhibiting and Selling Your Artwork

Once a suitable level of proficiency is achieved you may wish to exhibit your work with a view to making a sale and recouping some of the expense of the materials. Many local art societies will be happy to exhibit botanical work. Try to avoid having your delicate flower paintings hanging next to dramatic landscapes or strong still life paintings, where they will look overshadowed and overwhelmed. Botanical studies should be hung together away from more dominant pictures. You may be fortunate to live in an area where there are societies specifically for the promotion of botanical art, or you could apply to one of the national societies who have large annual exhibitions.

Pricing the Artwork

Pricing your artwork realistically is crucial if sales are to be achieved. When the work is exhibited in a gallery the owner will usually offer advice on the pricing of the pictures. Good sales can result in a return invitation. Take care that the gallery owner does not dictate the style of artwork, thus compromising the artist and the artwork created.

Attending exhibitions and noting the selling price of work of a similar style is a good starting point for pricing your own work. Prices vary in different areas of the country, and the selling price should reflect more than the cost of the materials. Overpricing does not gain respect; the work simply does not sell. On the other hand undervaluing the work and pricing it too low loses you the respect of fellow artists. They will feel they are being undercut in the struggle to maintain a sensible price for their own work.

There are certain factors that need to be taken into account when pricing artwork. The first is the cost of the materials involved in the creation of the work, including the cost of mounting and framing. The time spent on the artwork needs to be considered; a sensible and realistic figure should be decided for the number of hours involved. This should include time spent on preliminary sketches and research. There are hidden costs such as maintaining a studio and the administration of your business, travelling to and from exhibitions and promoting yourself and your work. It is important to remember that not every piece of artwork that is attempted will be successful or suitable for sale.

Finding a Purchaser

Finding a purchaser may be difficult for specialized work such as botanical art. You can start to build up a mailing list to encourage sales, commissions and opportunities. Countrywide Open Studio events enable artists to advertise themselves to a wider audience. Once you have accumulated a number of suitable pictures it is worth pursuing this idea. There may be other artists producing similar work if you do not wish to exhibit alone or would like to share costs.

Commission Charges

Art societies will sometimes charge a hanging fee and may also take a small commission on sales. The additional costs of setting up an exhibition are usually covered by the membership fee. Galleries usually charge a commission on sale, which reflects the service they provide. The artist should always take the commission into account when pricing work, including any tax that may have to be paid. In general, the commission is about one third of the selling price but this can vary.

Commissioned Artwork

Commissioned artwork usually arises by recommendation or when the potential purchaser has seen similar work by the artist in an exhibition. A price is agreed between the artist and the purchaser. It is advisable to produce a simple contract in writing to this effect, to avoid misunderstandings at a later stage.

Preparing a Portfolio for Clients and Galleries

When you are showing your artwork to clients it is advisable to take your work unframed and in a portfolio which is light and portable. When choosing a carrying case or portfolio consideration should be given to the size, durability, protection and organization of the contents. Presentation is important and each picture should be shown with widow mount and placed in a plastic sleeve. No more than ten to fifteen pieces of work should be included. The best and strongest work should be at the front of the portfolio. Quality is more important than quantity. Only

show work in a style you feel confident you could repeat and do not show any work inferior in quality. When you are showing your work to a publisher put copies of any published work at the front of the portfolio. It is advisable to find out whether your client is interested in black and white or colour work and adapt the portfolio accordingly.

Copyright

Copyright is a right granted to all artists producing paintings and drawings in order to protect their work by law. This right is automatically applied in the United Kingdom and no prior registration of the artwork is required. The artist retains the copyright even when a picture is sold. Original artwork cannot be copied or reproduced without the permission of the artist even if the artwork is sold at an exhibition. Copyright applies to the actual artwork, not to the idea behind it, which is why you may see a new design or idea reproduced in many different ways once it is in the public domain. Copyright lasts for the duration of the artist's lifetime. On death of the artist the ownership of the copyright usually passes to the artist's heirs or beneficiaries for a further seventy years. After seventy years the work enters the public domain and is no longer protected.

Copyright can be sold by the artist, and consequently some financial rewards may then belong to someone other than the creator or first owner. The signature on a piece of artwork usually establishes its creator. Protect your rights by issuing a statement, outlining that you are the creator of the work and owner of the copyright. The artist retains the copyright for commissioned work unless there is an agreement to transfer it to the buyer. It is always a good idea to keep records of your artwork sales. These should include the date of sale, and the name and address of the buyer. It is also useful to keep visual records of your artwork, such as photographs. Protecting your copyright is important; The Design and Artists Copyright Society (DACS) is a membership based organization which aims to protect the copyright and related rights of artists and their heirs in the United Kingdom.

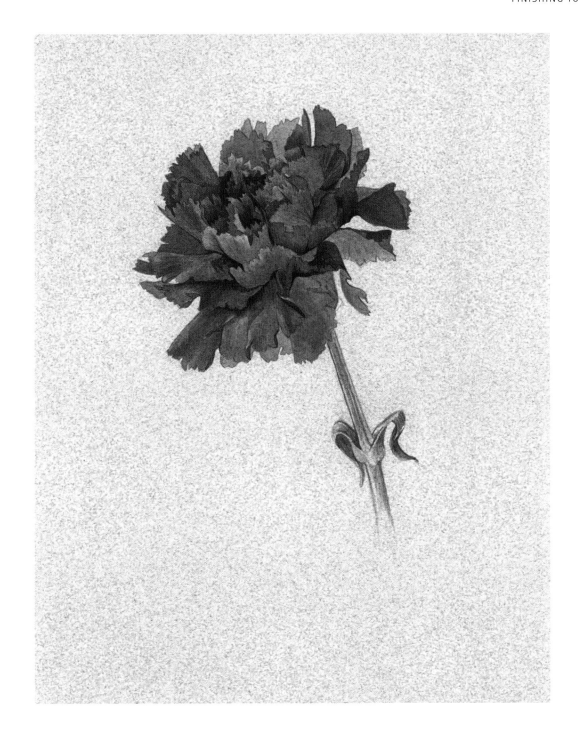

Artwork on tinted papers may catch a client's eye, but only
include artwork in your portfolio that you are happy to repeat.
(Jenny Harris)

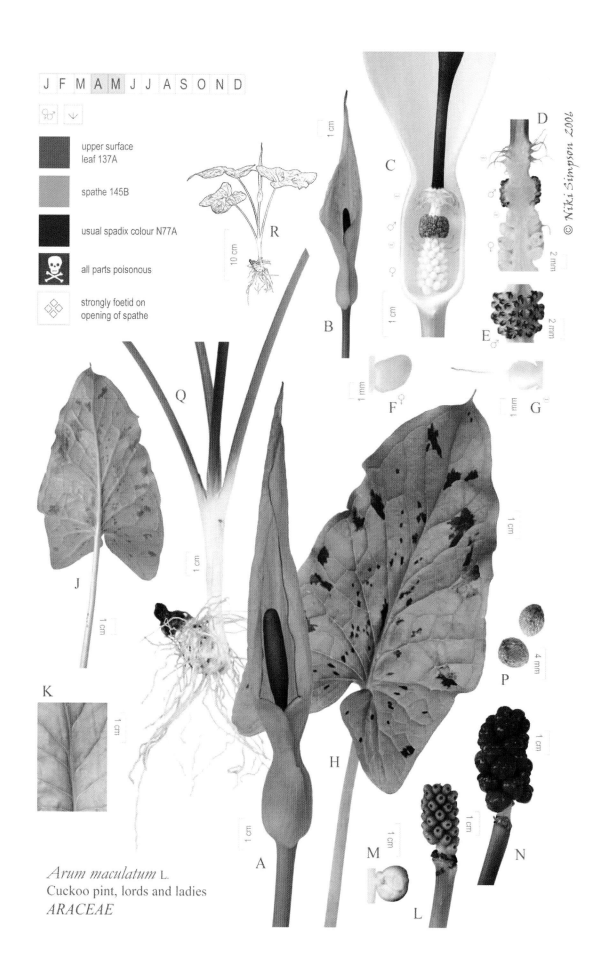

upper surface
leaf 137A

spathe 145B

usual spadix colour N77A

all parts poisonous

strongly foetid on
opening of spathe

© Nikki Simpson 2006

Arum maculatum L.
Cuckoo pint, lords and ladies
ARACEAE

PHOTOGRAPHY AND COMPUTERS

Botanical art is a practical skill and it often takes hours of diligent work to complete a drawing or painting. A plant, being living material, does not stay in the same condition indefinitely and it will constantly move and change. After a period of time it will die and this is most disconcerting if you have not completed its portrait. The short and fleeting life of a plant can be very frustrating because as soon as you settle down to draw or paint the plant is starting to deteriorate.

Digital Photography

With the help of modern technology, and digital photography in particular, we are able to capture a moment in the life of a plant. We are able reproduce a digital image almost instantly, and this has added greatly to the source of reference material that is available to botanical artists.

In the studio a digital photograph of the plant captures the moment the drawing commenced. It can remind the artist what the plant was like at that precise time. Digital photography can help show the plant the moment it was first seen, even before it was picked or changed in any way due to displacement from its natural habitat.

The camera can show the life around a plant and any changes within its surroundings. It can capture both the habit and the habitat. The plant might be drooping in the heat of the day or more upright after rain. It could be above the herbage around it or trying to compete with its fellows in an effort to reach the light. It might be scrambling over rocks or growing in a wood, growing from a crack in a paving stone or nurtured in a flower bed. When we remove a plant from its habitat we isolate it, leav-

Arum maculatum. This is a digitally created composite image, based on the traditional style of a botanical plate, showing the diagnostic features of the plant.

(© Niki Simpson)

ing behind valuable clues. The camera can capture the story of the plant, showing where it grows, companion planting, the time of day and season of the year.

Photographing Flowers in the Wild

There are some occasions when we are not allowed to pick plants, particularly if they are growing in the wild and are protected. In such cases drawings would have to be completed at the site or they could be undertaken later using reference material such as sketches and photographs. The advances in digital photography have opened up a number of opportunities for the artist.

There are a few guidelines that might help if you intend to photograph flowers in their natural habitat as reference material for a drawing later. Whenever possible seek permission to visit a site and do not uproot plants. Some plant environments are quite sensitive to trampling, so it would be better to take the photograph without an accompanying crowd of onlookers. Check the lighting conditions so that your plant is shown without any distracting bright sunlight or confusing shadows. Bright highlights might wash out important details in a photograph. You can check each image as it is taken if you are using a digital camera. Where there is an obvious problem, there is an opportunity for you to retake the picture.

Include as much of the plant as possible to show its height; this may involve taking the picture in a portrait, or vertical, format. It would also be useful to stand back and take a picture of the plant in its wider setting, to show its height in relation to other plants. Remember to adjust the focus on the camera between shots as necessary. When there are a number of plants present, all of the same kind, take a series of photographs showing different stages of the opening flower and development of the seed. Look at the leaf attachments as these might merit a close-up photograph, particularly if you are unable to take a sample with you. Care should be taken not to do too much tidying around the specimen. Sometimes it is necessary to tie back

Do climbing plants twine clockwise or anti-clockwise? Photographs of climbing plants such as the field bindweed, *Convolvulus arvensis*, provide useful reference material for checking the plants have been correctly described.
(Elaine Shimwell)

or move a few stems, but valuable habitat information could be lost if too many stems are pulled away or even broken.

Occasionally it is useful to place a plain coloured background behind the flower to show it in more detail. I used this device when photographing bee orchids which appeared unexpectedly in my garden. It was difficult to take a clear photograph because of the herbage surrounding the plants. Without the background the small flowers would have been difficult to distinguish. A piece of black card placed behind the plant provided the backdrop I required for a successful and informative picture.

Written notes, including measurements, and accompanying watercolour notes should be recorded at the site. It is not a good idea to rely solely on photographic images for accurate colour representation.

Guidelines for Photographing Flowers in the Wild

1. Whenever possible seek permission to visit a site, and do not trespass.
2. Check the lighting conditions are suitable to capture detail clearly; use a coloured board as a background for small flowers when necessary.
3. Take more than one photograph to show the development of the flowers and fruits.
4. Take a portrait (vertical) photograph, to include as much of the plant as possible and to show its height.
5. Take a photograph of the plant in its wider setting showing its height in relationship to other plants.
6. Look for any information which may be useful for reference; for example, leaf attachments and any details from the back of the plant.
7. Prepare written notes about the plant at the site.
8. Prepare colour notes by recording watercolour samples at the site.
9. Take care not to trample or kneel on plants, particularly in scientifically sensitive areas.
10. Always leave the environment as you found it.

Drawing and Painting versus Photography

Previously the artist had the advantage over the photographer by being able to choose plant material selectively, omitting damaged parts and replacing them with perfect alternatives. The artist could portray the whole life cycle of the plant on one page, even though it took some time to complete. Colours could be matched exactly, the size adjusted and enlargements of parts shown. Additionally, views of the back and the front of the flower could be included and fine detail illustrated as an aid to identification. Photography was unable to match this kind of presentation until recently. Technology has moved apace and there are now new ways of recording plants using digital photography for identification and reference.

Digital Imaging

Digital imaging is moving forward and challenging traditional techniques of botanical illustration. In the last few years exciting new work in this area has been developed by Niki Simpson in collaboration with botanist Peter Barnes. Modern technology is being used to explore new ways to continue the centuries-old tradition of botanical illustration. Composite images are based on the traditional botanical plate, showing the diagnostic

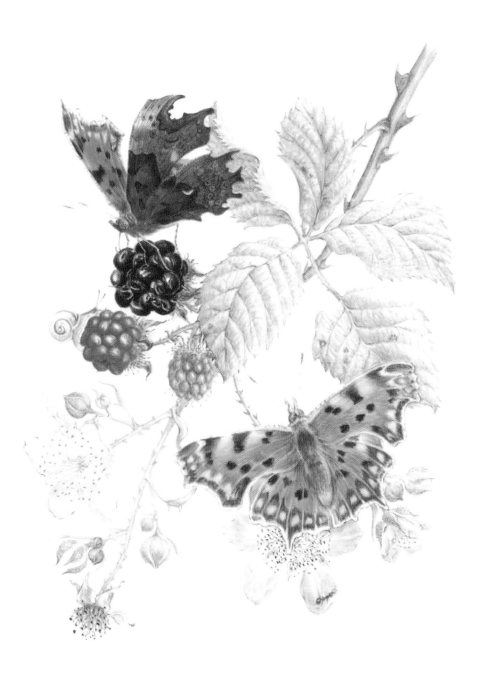

These comma butterflies were spotted in a
Nottinghamshire nature reserve. Photographic
reference material helped the artist to complete
the study. (Shirley B. Whitfield)

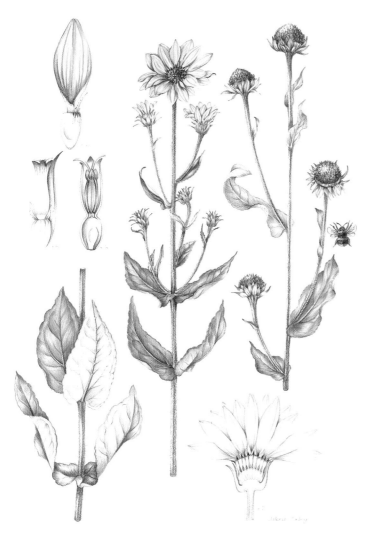

Helianthus mollis, which grows in the Prairie Garden at Sheffield Botanical Gardens. Information on the internet helped to identify structures seen through the microscope. (Valerie Oxley, Florilegium Society at Sheffield Botanical Gardens Archive)

The Internet

The Internet has become another valuable source for reference material, although one has to take care about the authenticity of the material displayed. Recently, I was illustrating a prairie plant, a sunflower *Heliathus mollis*. This plant is not widely grown in England, and no information was available in my reference books. I had examined the plant under the microscope and made a few notes but I needed verification that my plant was typical of its kind. To my surprise when I submitted the name of the plant into the search engine I discovered it had its own website. There is a lot of information available, generated by nurserymen in the United States where the plant is cultivated.

Artists' Websites

Botanical artists create web pages to promote their work. Images of original pictures are shown on website galleries and such displays have become useful digital market places.

features of the plant, using sections and dissections with appropriate scale bars. Digitally created composite images are manipulated and re-arranged so they can be amended and improved at any time. Niki Simpson's particular interest lies in learning from the old botanical plates in order to produce digital images which look both to the future and towards a greater understanding of the science. This new digital work is challenging the role of the traditional botanical artist, but it opens up numerous educational and scientific possibilities for the future.

Virtual Libraries

The British Library and other institutions have created virtual libraries on the Internet. Once the settings of your computer have been checked on-line, virtual books can be downloaded and the pages turned with a click of a computer mouse. The illustrations can be viewed at your own convenience. This is a wonderful way to look at old and rare books which are not available for the general public to handle.

GLOSSARY

Botany

achene	dry, one seeded indehiscent fruit
adventitious roots	roots that arise from an unusual position
aerial root	an above ground adventitious root
aggregate fruit	a fruit formed from several joined carpels
angiosperm	a flowering plant whose seeds are enclosed in an ovary
anther	the pollen bearing part of the stamen
apex	the growing point
apomixis	reproduction by seed without fertilization
arachnoid	cobwebby
axil	the angle between the upper side of a leaf and the stem
axillary bud	the bud within the axil
berry	a fleshy fruit containing seeds
bizarre flower	unusual and strange in appearance
bud scales	scales that enclose a bud
bulb	underground organ with short disc like stem and fleshy scale leaves and buds
calyx	collective term for the sepals
capsule	a dry dehiscent fruit
carpel	part of female reproductive organ, usually consisting of stigma, style and ovary
caryopsis	dry indehiscent fruit with one seed, typical of the grasses
cleistogamous	self pollination within a non-opening flower bud
contractile roots	roots that can shorten in length to pull a plant down into the soil
core	the middle, containing the seeds
corm	swollen underground stem
corolla	petals of a flower
cross-pollination	the transfer of pollen between plants
cypsela	dry indehiscent fruit made from two carpels
deciduous	falling off, like leaves from a tree
dehisce	opening when ripe
diagnostic features	description of the plant or recognizable features
dicot	shortened form of dicotyledon
dicotyledon	flowering plant with two seed leaves
double samara	dry indehiscent, winged fruit
drupe	fleshy fruit with one or more seeds
drupelets	small drupes forming an aggregate fruit
endocarp	the innermost layer of the ovary wall
epicarp	outermost layer of the pericarp of a fruit
epiphytic	growing on another plant
fertilization	the fusion of the male and female reproductive cell
Fibonacci	an Italian mathematician
fibrous roots	thread-like roots
filament	stalk of a stamen holding an anther
floccose	soft, downy or woolly
flowering spike	an inflorescence with stalkless flowers
foliage	all the leaves of a plant
glabrous	without hairs
gymnosperm	plant whose ovules are not enclosed within an ovary
gynoecium	the female reproductive parts of the flower
habit	the characteristic form and shape of a plant
hirsute	covered with rough, coarse hairs
hispid	bristly
hovering insect	insect that lingers near a flower but may not land
indumentum	covered all over with hairs
inflorescence	an arrangement or cluster of flowers

internode	the amount of stem between two leaf joints
lamina	flat leaf blade
leaf margin	edge of a leaf
life cycle	the development of a plant from any one stage and continues until that stage is reached again
lignin	woody substance found in thickened cell walls
lobed	rounded or curved edges
longitudinal	lengthwise
mesocarp	the middle layer of the fruit wall
mid-rib	the middle vein of a leaf
monoecious	with male and female flowers on the same plant
monocot	shortened form of monocotyledon
monocotyledon	flowering plant with one seed leaf
multiple fruit	a collective fruit formed from an inflorescence
mycorrhizal association	the association of fungi with the roots of plants
nectar	sugary liquid secreted by some plants
nectary	a gland where nectar is stored
nitrogen fixing bacteria	a process to convert nitrogen to compounds for assimilation by the plant
node	the joint on a stem where a leaf emerges
nut	a dry indehiscent one-seeded fruit
nutrient	a substance required for plant growth
ovary	the lower part of the carpel which contains the ovules
palmate	(of a leaf) divided into separate leaflets arising from a single point like a hand
pedicel	the stalk of a flower
perianth segment	one of the parts of a perianth
perianth	collective name for the outer parts of the flower
petal	a single segment of the corolla
petiole	a leaf stalk
pilose	soft and hairy
pinnate	separate leaflets on either side of a stalk
pistil	female reproductive organ
pollen	small grains that protect the male reproductive cells
pome	a firm fleshy fruit
prickle	a sharp pointed outgrowth from a stem, and usually removable

prop root	a root that gives support from the stem to the ground
pubescent	covered with soft hairs
ray florets	outer irregular flowers on daisy-like plants
receptacle	the part of the stem which bears the flower parts
rhizome	a root-like stem
root hairs	fine hairs usually situated behind the root cap
root	anchors the plant in the soil and absorbs nutrients
root nodules	small round structures containing nitrogen-fixing bacteria
runner	a creeping stem
samara	a dry indehiscent winged fruit
sap	the liquid juice of a plant
secondary veins	veins emerging from the main vein or mid-rib
seed dispersal	the act of shedding seed by the plant
self-pollination	fertilization of the ovules with pollen from the same flower
sepal	an individual segment of the calyx
serrated	leaves with saw-toothed margins
sessile	without a stalk
shoot	generally the above-ground part of the plant
spermatophyte	seed bearing plant
spine	a sharp outgrowth
sprig	piece of a plant, a cutting
stamen	male part of the plant, usually consists of an anther and filament (stalk)
stellate	star-like
stem tuber	the swollen part of an underground stem
sterile	unable to reproduce sexually
stigma	the part of the carpel where the pollen grains land
stipules	outgrowths from the base of the petiole
style	part of the carpel between the ovary and the stigma
subtended	underneath or close to
tepals	part of a perianth where petals and sepals closely resemble each other
terminal bud	the bud at the apex of the stem
thorn	a short branch with a sharp point
tomentose	densely covered in soft hairs
trichome	technical term for a hair-like outgrowth
vasculum	botanist's collecting box

venation	network of veins, e.g. in a leaf	*helping hands or jig*	device with grips for holding plant material
whorl	an arrangement in a circle	*hot pressed watercolour paper*	very smooth watercolour paper
wilt	another word for droop, generally through lack of water	*indent*	to push into the surface with a blunt instrument
wind pollinated	(of a plant) whose pollen is dispersed by air currents	*internal sizing*	size added to the pulp before the paper is formed

Art

		jig	another name for a 'helping hand' device
acetate film	type of clear plastic material		
acid-free paper	generally paper with a pH level of 7 or above	*kneadable eraser*	soft putty eraser
additive colour	the colours that make up white light	*lightfast*	generally will not fade when exposed to light
body colour	opaque watercolour or gouache	*linear perspective*	makes objects appear smaller the further away they are from the viewer
boundary	a line to indicate an edge		
buckled	crumpled, puckered, wrinkled	*magnifying glass*	a convex lens, which gives an enlarged image
cartridge paper	thick white drawing paper	*masking fluid*	a latex solution used to cover an area of paper with a mask before painting, and removed later
cellulose fibres	plant material		
cockled paper	paper that buckles when wet		
colour temperature	warmth or coolness of a colour		
colour wheel	shows the relationships between colours in a circle	*moist watercolour paints*	modern watercolours developed by Winsor & Newton
colourmen	paint manufacturers		
complimentary colours	opposite colours on a colour wheel	*negative space*	the space between positive or drawn areas
conditioned plants	plants that have taken up water and are fresh	*NOT surface watercolour paper*	watercolour paper with a slight texture (not hot pressed)
damp brush	between wet and dry	*opaque watercolour*	another term for body colour or gouache
distilled water	water with impurities removed		
dividers	hinged measuring tool with two sharp points	*palette*	a porcelain receptacle with recesses for mixing watercolour paint
		paper orientation	the direction the paper is used, landscape or portrait
ellipse	a shape like a flattened circle		
		parallel lines	straight lines which do not converge
florists' vial	a plastic tube with a cap, for holding water	*pin holder*	a flower arranging device for holding plants upright
focal point	the first area where the eye rests when looking at a picture	*portfolio case*	a carrying case to protect and transport drawings
foreshortening	an effect of perspective making an object appear distorted when seen from a particular viewpoint	*positive shapes*	the drawn parts of the design
		primary colours	red, yellow and blue
fugitive pigment	not permanent or lightfast	*process white*	a dense white paint used for covering underlying painted areas
gouache	opaque watercolour, modern 'body colour'	*retort stand*	laboratory device useful for holding large plants

183

rough surface watercolour paper	watercolour paper with a heavily textured surface
shadow colours	obtained by mixing opposite colours on the colour wheel
sizing	gives paper some added strength and resistance to water
soluble	dissolves in water
sphere	a round geometrical shape
stretching paper	a procedure to avoid paper buckling at a later stage of the painting
swatch	a sample
taper	to draw lines gradually converging until they touch

tracing paper	thin paper used to transfer drawings onto watercolour paper and for initial sketches
transparent	surface which allows light to pass through
value	refers to the lightness or darkness of a colour in relation to black and white; yellow has a light value whereas blue has a dark value
Velcro	trade name for self-attaching material
watercolour paper	paper prepared for use with watercolour paints
watermark	mark within paper showing the paper's manufacturer

FURTHER READING

Plants and Plant Identification

Bell, Adrian D., *Plant Form: An Illustrated Guide to Flowering Plant Morphology* (Oxford University Press, 1991)

Brickell, Christopher, RHS, *A-Z Encyclopaedia of Garden Plants* (Dorling Kindersley, 1996)

Bridson, Diane and Leonard Forman, *The Herbarium Handbook* (Royal Botanic Gardens Kew, rev. 1992)

Brightman, Frank, *Plants of the British Isles*, Illustrated by Barbara Nicholson (Peerage Books, 1982)

Capon, Brian, *Botany for Gardeners: An Introduction and Guide* (B.T. Batesford, 1992)

Clement, E.J., D.P.J. Smith and I.R. Thirlwell, *Illustrations of the Alien Plants of the British Isles* (Botanical Society of the British Isles, 2005)

Grey-Wilson, Christopher and Marjorie Blamey, *Cassell's Wild Flowers of Britain and Northern Europe* (Cassell, 2003)

Harding, Patrick and Gill Tomblin, *How to Identify Trees* (Harper Collins, 1998)

Harding, Patrick and Valerie Oxley, *Wild Flowers of the Peak District* (Hallamshire Press, 2000)

Heywood, V.H., R.K. Brummitt, A. Culham and O. Sebeg, *Flowering Plants of the World* (Royal Botanic Gardens Kew, 2007)

Hickey, Michael, *Plant Names* (Cedar Publications, 1993)

Hickey, Michael and Clive King, *Common Families of Flowering Plants* (Cambridge University Press, 1997)

Hickey, Michael and Clive King, *The Cambridge Illustrated Glossary of Botanical Terms* (Cambridge University Press, 2000)

Huxley, Anthony, Mark Griffiths and Mark Levy, *The New Royal Horticultural Society Dictionary of Gardening*, Volumes 1–4 (Dorling Kindersley, 1997)

Marinelli, Janet, *Plant* (Dorling Kindersley, 2004)

More, David and John White, *Trees of Britain and Northern Europe* (Cassell, 2003)

McLean, Barbara and Rosemary Wise, *Dissecting Flowers* (Chelsea Physic Garden Florilegium Society, 2001)

Phillips, Roger, *Mushrooms* (Macmillan, 2006)

Phillips, Roger and Martyn Rix, *The Botanical Garden,* Volumes 1 and 2 (Macmillan, 2002)

Ross-Craig, Stella, *Drawings of British Plants,* Volumes 1–8 (Bell & Hyman, 1979)

Stace, Clive, *New Flora of the British Isles*, 2nd edn. (Cambridge University Press, 2001)

Weberling, F., *Morphology of Flowers and Inflorescences* (Cambridge University Press, 1989)

Zomlefer, Wendy B., *Guide to Flowering Plant Families* (Chapel Hill, 1994)

Books by Artists

Blamey, Marjorie, *Painting Flowers* (Dorling Kindersley, 1998)

Brodie, Christina, *Drawing and Painting Plants* (A & C Black, 2006)

Dean, Pauline, *Portfolio of a Botanical Artist* (Botanical Publishing, 2004)

Evans, Anne-Marie and Donn Evans, *An Approach to Botanical Painting* (Hannaford & Evans, 1993)

Guest, Coral G., *Painting Flowers in Watercolour: A Naturalistic Approach* (A & C Black, 2001)

Martin, Rosie and Meriel Thurstan, *Botanical Illustration Course with the Eden Projec*t (B.T. Batesford, 2006)

Milne, Judith, *Flowers in Watercolour* (B.T. Batesford, 1992)

Milne, Judith, *Wild Flowers in Watercolour* (B.T. Batesford, 1995)

Sherlock, Siriol, *Exploring Flowers in Watercolour: Techniques and Images* (B.T. Batesford, 1998)

Sherlock, Siriol, *Botanical Illustration: Painting with Watercolours* (B.T. Batesford, 2004)

Showell, Billy, *Watercolour Flower Portraits* (Search Press, 2006)

Starcke King, Bente, *Botanical Art Techniques: Painting and Drawing Flowers and Plants* (David & Charles, 2004)

Stevens, Margaret, in association with The Society of Botanical Artists, *The Art of Botanical Painting* (Collins, 2004)

Stevens, Margaret, in association with The Society of Botanical Artists, *The Botanical Palette: Colour for the Botanical Painter* (Collins, 2007)

West, Keith, *How to Draw Plants: The Techniques of Botanical Illustration* (The Herbert Press, 1983)

Wunderlich, Eleanor B., *Botanical Illustration: Watercolour Technique* (Watson-Guptil Publications, 1991)

History of Botanical Illustration

Arnold, Marion, *South African Botanical Art: Peeling Back the Petals* (Fernwood Press, 2001)

Blunt Wilfrid and William T. Stern, *The Art of Botanical Illustration* (Antique Collector's Club, 1994)

Buckburne-Maze, Peter, *Fruit: An Illustrated History* (Firefly Books, 2003)

Butler, Patricia, *Irish Botanical Illustrators and Flower Painters* (Antique Collector's Club, 2000)

Calman, Gerta, *Ehret: Flower Painter Extraordinary* (Phaidon, 1977)

Elliott, Brent, *Treasurers of The Royal Horticultural Society* (The Herbert Press, 1994)

Elliott, Brent, *Flora: An Illustrated History of the Garden Flower* (Firefly Books, 2001)

Hewson, Helen, *Australia: 300 Years of Botanical Illustration* (CSIRO Publishing, 1999)

Hunt Institute for Botanical Documentation, International Exhibitions of Botanical Art and Illustration, 12 Catalogues (Carnegie Mellon University)

Jay, Eileen, Mary Noble and Anne Stevenson Hobbs, *A Victorian Naturalist* (Warne, 1992)

Mabberley, David, *Ferdinand Bauer: The Nature of Discovery* (Merrell Holberton, 1999)

Mabberley, David, *Arthur Harry Church, The Anatomy of Flowers* (Merrell, 2000)

Mabey, Richard, *The Flowering of Kew* (Century Hutchinson, 1988)

Mallory, Peter and Frances Mallory, *A Redoute Treasury* (Dent, 1986)

Morrison, Tony, *Margaret Mee: In Search of Flowers of the Amazon Forests* (Nonsuch Expeditions, 1998)

Norst, Marlene J., *Ferdinand Bauer: The Australian Natural History Drawings* (British Museum of Natural History, 1989)

North, M., *A Vision of Eden*, 4th edn. (Royal Botanic Gardens Kew and HMSO, 1993)

Sherwood, Shirley, *Contemporary Botanical Artists* (Weidenfeld & Nicolson, 1996)

Sherwood, Shirley, *A Passion for Plants: Contemporary Botanical Masterworks* (Cassell, 2001)

Sherwood, Shirley, Stephen Harries and Barrie Juniper, *A New Flowering: 1000 Years of Botanical Art* (The Ashmolean, 2005)

Sherwood, Shirley, and Martyn Rix, *Treasures of Botanical Art* (Kew Publishing, 2008)

Stearn, William T., *Flower Artists of Kew* (The Herbert Press, 1990)

Stewart, Joyce and William T. Stearn, *The Orchid Paintings of Franz Bauer* (The Herbert Press, 1993)

Walpole, Josephine, *A History and Dictionary of British Flower Painters 1650–1950* (Antique Collector's Club, 2006)

Art Instruction and Materials

Dalby-Quenet, Gretel W., *Illustrating in Black and White* (Chelsea Physic Garden Florilegium Society, 2000)

Hickey, Michael, *Drawing Plants in Pen and Ink* (Cedar Publications, 1994)

Hillberry, J.D., *Drawing Realistic Textures in Pencil* (North Light Books, 1999)

Hodges, Elaine R.S., *The Guild Handbook of Scientific Illustration* (Van Nostrand Reinhold, 1989)

Johnston, Beverley, *The Complete Guide to Coloured Pencil Techniques* (David & Charles, 2003)

McCann, Michael, *Artist Beware: The Hazards of Working with Art and Craft Materials* (The Lyons Press, 1992)

Parramon, Jose M., *Light and Shade for the Artist* (Parramon Editions, 1985)

Pearce, Emma, *Emma Pearce's Artists Materials: The Complete Sourcebook of Methods and Media* (Arcturus, 2005)

Seligman, Patricia, *The Watercolour Flower Painter's Handbook* (Search Press, 2005)

Sidaway, Ian, *The Watercolourist's Guide to Art Papers* (David & Charles, 2000)

Smith, Ray, *The Artist's Handbook* (Dorling Kindersley, 1987)

Stevens, Margaret, *An Introduction to Drawing Flowers* (The Apple Press, 1994)

Wilcox, Michael, *The Wilcox Guide to the Finest Watercolour Paints* (School of Colour Publications, updated 2000)

ART MATERIALS SUPPLIERS

Paint Manufacturers

Daler-Rowney, PO Box 10, Bracknell, Berkshire, RG12 8ST, UK.
Telephone: +44(0) 1344 461 000.
Email: web.enquiries@daler-rowney.com
website: www.daler-rowney.com

Schminke and Co, Otto-Hahn-Strasse 2, D-40699 Erkrath,
Germany. Telephone: +49(0)211 25 09 0.
Email: info@schminke.de
website: www.schmincke.de/data/content/uk/uk_index.htm

Winsor & Newton, Whitefriars Avenue, Wealdstone, Harrow,
Middlesex, HA3 5RH, UK. Telephone: +44(0) 20 8424 3200.
Email: info@colart.co.uk. Website: www.winsornewton.com

Paper Manufacturers and Suppliers

Falkiner Fine Papers, 76 Southampton Row, London, WC1B
4AR, UK. Telephone: +44(0) 20 7831 1151.
Email: via website: www.falkiners.com

John Purcell Paper, 15 Rumsey Road, London, SW9 0TR, UK.
Telephone: +44(0) 20 7737 5199. Email: jpp@johnpurcell.net
website: www.johnpurcell.net

R.K. Burt & Company Ltd, 57 Union Street, London, SE1 1SG,
UK. Telephone: +44 (0)20 7407 6474.
Email: via website: www.rkburt.co.uk

St Cuthberts Mill, Wells, Somerset, BA5 1AG, UK.
Telephone: +44(0) 1749 672 015. Email: sales@inveresk.co.uk
website: www.inveresk.co.uk

Two Rivers Paper Company, Pitt Mill, Roadwater, Watchet,
Somerset TA23 0QS, UK. Telephone: +44(0) 1984 641 028.
Website: www.tworiverspaper.co.uk

Pencils, Coloured Pencils, Wax Blenders, etc

Berol, Berol Customer Services, Sanford UK, Parker House,
Newhaven, East Sussex, BN9 0AU, UK.
Telephone: +44(0) 1273 513233.
Email: uk.consumer@sanfordregistration.com
website: www.berol.co.uk

Caran d'Ache, 19 Chemin du Foron, PO Box 332, CH-1226
Thônex, Geneva, Switzerland.
Telephone: +41 (0) 22 869 01 01.
Email: via website: www.carandache.ch

Derwent Pencils, The Cumberland Pencil Company, Southey
Works, Greta Bridge, Keswick, Cumbria, CA12 5NG, UK.
Telephone: +44(0) 17687 80898.
Email: via website: www.pencils.co.uk

Dick Blick Art Materials, PO Box 1267, Galesburg,
IL 61402-1267, USA. Telephone: (+1) 800 828 4548.
Email: international@dickblick.com.
Website: www.dickblick.com

Faber-Castell, West Design Products Ltd, West House, Pent
Road, Shearway Business Park, Folkestone, Kent CT19 4RJ, UK.
Telephone: +44(0) 1303 297 888.
Email: info@faber-castell.com website: www.faber-castell.com

Pens

Edding (UK) Ltd, Merlin Centre, Acrewood Way,
St Albans AL4 0JY, UK. Telephone: +44(0) 1727 846 688.
Email: info@edding.co.uk. Website: www.edding.co.uk

Rotring UK, Sanford GmbH, Schnackenburgallee 45, D-22525
Hamburg, Germany. Telephone: +49(0) 40 8555 0.
Email: via website form website: www.rotring.com

Staedtler (U.K.) Ltd, Cowbridge Rd, Talbot Green, Pontyclun CF72 8YJ, UK. Telephone: +44(0) 1443 237 421. Email: marketing@uk.staedtler.com. Website: www.staedtler.co.uk

Art Equipment

(Battery-operated erasers and sharpeners, putty erasers, wax blenders, stumps and tortillions, etc)

Artscene, 35, Chesterfield Road, Sheffield S8 0RL, UK. Telephone: +44 (0) 114 255 5299

Great Art, Normandy House, 1 Nether Street, Alton, Hampshire GU34 1EA, UK. Telephone: +44 (0) 1420 593 332. Email: welcome@greatart.co.uk. Website: www.greatart.co.uk

Green & Stone of Chelsea, 259 King's Road, London SW3 5EL, UK. Telephone: +44 (0) 20 7352 0837. Email: mail@greenandstone.com. Website: www.greenandstone.com

Heaton Cooper Studio Ltd, Grasmere, Ambleside, Cumbria LA22 9SX, UK. Telephone: +44 (0) 15394 35280. Email: via website: www.heatoncooper.co.uk

Ken Bromley Art Supplies, Curzon House, Curzon Road, Bolton BL1 4RW, UK. Telephone: +44 (0) 1204 381 900. Email: sales@artsupplies.co.uk. Website: www.artsupplies.co.uk

Jackson's Art Supplies & Art Express, 1 Farleigh Place, London N16 7SX1, UK. Telephone: +44 (0) 207 254 0077. E-mail: via website: www.jacksonsart.co.uk

L. Cornelissen, 105 Great Russell Street, London WC1B 3LA, UK. Telephone: +44 (0) 20 7636 1045. Email: info@cornelissen.co.uk. Website: www.cornelissen.com

Rosemary & Co, Artists' Brushes, PO Box 372, Keighley, West Yorkshire, BD20 6WZ, UK. Telephone: +44 (0)1535 600090 Email: rosemary@rosemaryandco.com. Website: www.rosemaryandco.com

T.N. Lawrence & Son Ltd, 208 Portland Road, Hove BN3 5QT, UK. Telephone: +44 (0) 1273 260260. Email: artbox@lawrence.co.uk. Website: www.lawrence.co.uk

The Wheatsheaf Art Shop, 56 Baker Street, London W1U 7BU, UK. Telephone: +44 (0) 207 935 5510. Email: sales@wheatsheaf-art.co.uk. Website: www.wheatsheaf-art.co.uk

Magic Eraser Block

Lakeland, Alexandra Buildings, Windermere, Cumbria LA23 1BQ, UK. Telephone: +44 (0) 15394 88100. Email: via website: www.lakeland.co.uk

Dissecting Instruments and Lenses

Brunel Microscopes Ltd., Unit 2, Vincents Road, Bumpers Farm Industrial Estate, Chippenham, Wiltshire SN14 6NQ, UK. Telephone: +44 (0) 1249 462655. Email: mail@brunelmicroscopes.co.uk. Website: www.brunelmicroscopes.co.uk

Mageyes, Inc., PO Box 293010, Kerrville, TX 78029-3010, USA. Telephone: (+1) 800 210 6662. Email: sales@mageyes.com. Website: www.mageyes.com

Watkins and Doncaster the Naturalists, PO Box 5, Cranbrook, Kent TN18 5EZ, UK. Telephone: +44 (0) 845 833 3133. Email: sales@watdon.com. Website: www.watdon.com

Daylight Bulbs

The Daylight Company Ltd, 89-91 Scrubs Lane, London NW10 6QU, UK. Telephone: +44 (0) 20 8964 1200. Email: customerservice@daylightcompany.com website: uk.daylightcompany.com

Framing

Fine Art Trade Guild, 16-18 Empress Place, London SW6 1TT, UK. Telephone +44 (0) 20 7381 6616. Email: info@fineart.co.uk website: www.fineart.co.uk

COLLECTIONS, GARDENS, SOCIETIES AND COURSES

Botanical Artwork Collections

The Armitt Collection, Rydal Road, Ambleside,
Cumbria LA22 9BL, UK Telephone: +44(0) 15394 31212.
Email: via website: www.thearmittcollection.com

The Ashmolean, Beaumont Street, Oxford OX1 2PH, UK.
Telephone: +44 (0)1865 278000.
Email: western-art@ashmus.ox.ac.uk.
Website: www.ashmolean.org

The Fitzwilliam Museum, Trumpington Street,
Cambridge CB2 1RB, UK Telephone: +44(0) 1223 332 900.
Email: fitzmuseum-enquiries@lists.cam.ac.uk.
Website: www.fitzmuseum.cam.ac.uk

Hunt Institute for Botanical Documentation, Carnegie Mellon
University, 5000 Forbes Avenue, Pittsburgh, Pennsylvania
15213-3890, USA. Telephone: (+1) 412 268 2434.
Email: huntinst@andrew.cmu.edu.
Website: huntbot.andrew.cmu.edu

John Innes Centre, Library and Archives, Norwick Research
Park, Colney, Norwich NR4 7UH, UK. Telephone:
+44 (0)1603 450 000. Email: jic.communications@bbsrc.ac.uk.
Website: www.jic.ac.uk

The Linnean Society of London, Burlington House, Piccadilly,
London W1J 0BF, UK. Telephone: +44(0) 20 7473 4479.
Email: info@linnean.org. Website: linnean.org

National Museum Wales, Cathays Park, Cardiff CF10 3NP, UK.
Telephone +44 (0)29 2039 7951.
Email: via website: www.museumwales.ac.uk

The Natural History Museum, Cromwell Road, London SW7
5DB, UK. Telephone: +44 (0)20 7942 5000.
Email: via website: www.nhm.ac.uk

Royal Horticultural Society, Lindley Library, 80 Vincent Square,
London SW1P 2PE, UK. Telephone: +44 (0)20 7821 3050.
Email: library.london@rhs.org.uk.
Website: www.rhs.org.uk/learning/library

The Shirley Sherwood Gallery of Botanical Art, Royal Botanic
Gardens, Kew, Richmond, Surrey TW9 3AB, UK.
Telephone: +44 (0)20 8332 5655. Email: info@kew.org.
Website: www.kew.org/visitor/visitkew.html

V & A Museum South Kensington, Cromwell Road,
London SW7 2RL, UK. Telephone: +44 (0)20 7942 2000.
Email: vanda@vam.ac.uk. Website: www.vam.ac.uk

Botanical Gardens

Cambridge University Botanic Garden, Bateman Street,
Cambridge CB2 1JF, UK. Telephone: +44 (0)1223 336 265.
Email: enquiries@botanic.cam.ac.uk.
Website: www.botanic.cam.ac.uk

Eden Project, Bodelva, Cornwall PL24 2SG, UK.
Telephone: +44 (0)1726 811 911.
Email: via website: www.edenproject.com

Lakeland Horticultural Society, Holehird Gardens, Patterdale
Road, Windermere, Cumbria LA23 1NP, UK.
Telephone: +44 (0)15394 46008.
Website: www.holehirdgardens.org.uk

Royal Botanic Gardens, Kew, Richmond, Surrey TW9 3AB, UK.
Telephone +44 (0)20 8332 5000. Email: info@kew.org.
Website: www.kew.org

The Royal Botanic Garden, Edinburgh, 20A Inverleith Row,
Edinburgh, EH3 5LR Scotland. Telephone: +44 (0)131 552 7171.
Email: via website: www.rbge.org.uk

RHS Garden Wisley, Woking, Surrey GU23 6QB, UK.
Telephone: +44 (0)845 260 9000. Email: info@rhs.org.uk.
Website: www.rhs.org.uk/gardens/wisley

Sheffield Botanical Gardens, Clarkehouse Road,
Sheffield S10 2LN, UK. Telephone: +44 (0)114 268 6001.
Email: via website: www.sbg.org.uk

The University of Oxford Botanic Garden, Rose Lane, Oxford
OX1 4AZ, UK. Telephone: +44 (0)1865 286690.
Email: postmaster@obg.ox.ac.uk.
Website: www.botanic-garden.ox.ac.uk

Botanical Art Societies

Botanical Society of the British Isles, Botany Department,
The Natural History Museum, Cromwell Road,
London SW7 5DB, UK. Answerphone: +44(0) 207 942 5002.
Email: coordinator@bsbi.org.uk. Website: www.bsbi.org.uk

The Society for the History of Natural History, The Natural
History Museum, Cromwell Road, London SW7 5DB, UK.
Email: info@shnh.org. Website: www.shnh.org

Society of Botanical Artists, 1 Knapp Cottages, Wyke,
Gillingham, Dorset SP8 4NQ, UK.
Telephone: +44 (0)1747 825718.
Email: info@soc-botanical-artists.org
Website: www.soc-botanical-artists.org

American Society of Botanical Artists, 47 Fifth Avenue,
New York, NY 10003 USA. Telephone: (+1) 212 691 9080.
Email: asba@aol.com. Website: www.amsocbotartists.org

Society of Floral Painters, c/o Lissie Ashton, Watermeadows,
42 Wimborne St Giles, Wimborne, Dorset, BH21 5NF, UK.
Telephone: +44 (0)1725 517 694.
Email: membership@socfp.net. Website: www.socfp.net

Florilegium Society at Sheffield Botanical Gardens,
c/o The Secretary, Florilegium Society at Sheffield Botanical
Gardens, Sheffield Botanical Gardens, Clarkehouse Road,
Sheffield S10 2LN, UK.
Website: www.florilegiumsheffield.org.uk

Brooklyn Botanic Garden Florilegium Society, c/o Brooklyn
Botanic Garden, 1000 Washington Avenue, Brooklyn,
New York, NY 11225, USA. Email: pjonas@bbg.org.
Website: www.bbg.org/lib/florilegium

Hampton Court Florilegium Society, c/o Hampton Court
Palace, Surrey KT8 9AU, UK.
Email: info@florilegium-at-hamptoncourtpalace.co.uk.
Website: www.florilegium-at-hamptoncourtpalace.co.uk

Chelsea Physic Garden Florilegium Society, c/o Chelsea Physic
Garden, 66 Royal Hospital Road, Chelsea, London SW3 4HS,
UK. Telephone: +44 (0)20 7352 5646. Website:
www.chelseaphysicgarden.co.uk/garden/florilegium.html

Institute of Analytical Plant Illustration, c/o Dr P.L. Mitchell,
22 Redcar Road, Sheffield S10 1EX, UK.
Website: www.iapi.org.uk

Northern Society for Botanical Art, c/o The Secretary,
Anne Dent, 68 School Green Lane, Sheffield S10 4GR, UK.
Telephone: +44 (0)114 230 2185

Botanical Art Courses

Adult Residential Colleges Association, c/o Secretary,
Janet Dann, 6 Bath Road, Felixstowe, Suffolk IP11 7JW, UK.
Email: arcasec@btinternet.com.
Websites: www.aredu.org.uk and www.timetolearn.org.uk

Field Studies Council, Head Office, Montford Bridge,
Preston Montford, Shrewsbury, Shropshire SY4 1HW, UK.
Telephone: +44 (0)1743 582 100.
Email: enquiries@field-studies-council.org.
Website: www.field-studies-council.org

The Kingcombe Centre, Toller Porcorum, Dorchester, Dorset
DT2 0EQ, UK. Telephone: +44 (0)1300 321 409.
Website: www.kincombe-centre.demon.co.uk

University of Cambridge, Institute of Continuing Education,
University of Cambridge, Madingley Hall, Madingley,
Cambridge CB23 8AQ, UK. Telephone:+44 (0)1954 280 280.
Email: registration@cont-ed.cam.ac.uk.
Website: www.cont-ed.cam.ac.uk

University of Sheffield, The Institute for Lifelong Learning,
School of Education, The University of Sheffield,
196–198 West Street, Sheffield S1 4ET, UK.
Telephone: +44 (0)114 222 7000.
Email: till@sheffield.ac.uk.
Website: www.shef.ac.uk/till

INDEX